The Actor's Job

Defining, Doing and Getting the Work

Cynthia Lammel

Front cover image printed with permission of California State University, Chico.
Photographer Jeff Teeter. Rich Matli (left), Hannah Knight (right).
CSU Chico's Theatre Department production of David Auburn's *Proof*.

Back cover printed with permission of California State University, Chico.
Photographer, Brenden Price. Kevin Muster (left) Bret Colombo (right).
CSU Chico's Theatre Department production of Oscar Wilde's *The Importance of Being Earnest*

Interior illustrations by Annaliese Baker

Kendall Hunt
publishing company

www.kendallhunt.com
Send all inquiries to:
4050 Westmark Drive
Dubuque, IA 52004-1840

Copyright © 2010 by Kendall Hunt Publishing Company

ISBN 978-0-7575-9882-1

Printed in the United States of America
10 9 8 7 6 5 4 3

Contents

Preface

This is a book for people who have discovered that they are genuinely interested in acting and the theatre (and/or film and television) and have bravely taken the plunge. They are curious to try their hand at it and see what it is that so fascinates them about Robert Downey, Jr., or Cate Blanchett (other than the money and fame, of course) and whether or not they are capable of the same magic. The topics I've addressed and the point of view I've taken through much of the book are ideal for a semester's worth of work in an introductory acting course for college theatre majors or a class for committed general education students or community theatre members. The material in Chapters 1 through 7 will usefully serve to reinforce foundational understanding and provide a springboard for the challenges of work in acting courses beyond the beginning level. Chapters 8 and 9 will help students, whether they are aspiring professionals or dedicated amateurs, to bridge the enigmatic gap between the artistic ideals and sense of the studio or classroom, on one hand, and the seemingly mysterious process by which plays are cast and produced on the other.

No one text has all the answers, nor does this one. Hopefully it will be a strong starting point for an actor with little background in the study of acting. Hopefully it will be a useful refresher for someone who has studied acting more thoroughly but would like a very practical method for approaching playscripts, as well as a reminder of the variety of tools and techniques available to get unstuck, inspired, and moving forward again in a given role. It's also a primer for entering into the business.

I'd like first to thank all the actors I've worked with, the directors I've worked with, and most important, my dad Earl Lammel. He taught me to revere the work done in the theatre and that our process was never finished; even closing night was an opportunity to come a little closer to truth in aligning ourselves more closely to the action of the play and reacting to what was being given in the moment.

I thank my family in the east and my family in the west. My sister Julie Fennell and my daughters Abigail and Madeleine have been most encouraging.

I wish to acknowledge and thank all the theatre professionals who agreed to be interviewed for this book: Marc Masterson of South Coast Rep, Zan Sawyer-Dailey, and Michael Legg of Actors Theatre of Louisville; Ruth Ellen Sternberg and Jordan Thaler of the Public Theater in New York City; Kim Sharp of the Abingdon Theatre in New York City; Karen Ziemba, Tony Award–winning actress, Geoff Cobb Nelson and Jonathan Putnam of CATCO, both professional actors and directors of long standing; and Donna Bullock, Howard Sherman, and Bill Tatum, all veterans of Broadway, off-Broadway, episodic television, commercials, and regional theatre. You made this kind of text possible, and many students of the craft will benefit from your knowledge and advice.

Thanks to many of my former students who fearlessly told me about their lives in the theatre, what they had learned, and what they wished they had known. Special thanks to Maeve Martin and friends for their generosity of time and perspective when I was in New York conducting interviews.

I would also like to thank Frank Forcier of Kendall Hunt for contacting me, convincing me this book was a great idea, for calling me, meeting with me, and encouraging me. Many

thanks. Linda Chapman of Kendall Hunt has been very instructive and worked diligently to keep this book on schedule. Many thanks for your good cheer and professionalism.

Annaliese Baker, your work is always so professional and elegant. I thank you so much for agreeing to do this when you had so much else on your plate.

Dr. John Mayer, thanks so much for sharing your thoughts on improvisation.

Last, but not least, I thank my best friend, my husband, Bill. Thanks for believing in me. Thanks for proofing. You are a generous man.

Introduction

What does it take to be an actor, and why would you want to be one?

Marc Masterson, Artistic Director of South Coast Rep, says this about actors:

> *I like actors who are generous, fearless, able to go places that they don't know that they can go, find themselves there and are a little surprised themselves, along with everybody else.*

Notice that Masterson doesn't say that he admires these qualities in *professional* actors. Like Marc Masterson, I take the point of view in this book that the true measure of one's success as an actor has very little to do with whether one acts for $20M a picture in Hollywood or for the sheer love of the work at the local community theatre.

So . . . let's ask the question again: What does it take to be an actor, and why would you want to be one? In other words, what does it mean to have talent, and what should be the measure of your success?

You need to answer this question deeply from your heart as well as your head.

I think many of us come into acting with a lot to express regarding what we know of life. Many come with a desire to explore what they do not know about this life. Some had a teacher who believed in them, and a few stumble into acting for reasons they can't explain. We travel many and varied paths to get to the decision to *study* acting as a craft. If you are reading these words, chances are you have, whatever *your* reason, found yourself in an acting class. The job of the actor starts here. Welcome.

One of the first questions you may be asking yourself is, "Do I have talent?" Talent is a very tricky word to define so let's change the question to, "Do I have an *aptitude* for this particular work?"

Do you have an aptitude for acting? Well

Are you curious . . .

> . . . about the human condition?

> . . . about human relationships?

> . . . about interactions between human beings?

> . . . about goals of human beings?

> . . . about how human beings get what they want from other human beings?

> . . . about how human beings interact?

> . . . about how people lived and what they valued in various historical periods?

Do you enjoy working on your voice or already have a voice that is compelling to listen to for some period of time?

Do you have a good ear? Are you sensitive to language and the nuances of verbal communication?

Are you sensitive to nonverbal communication? Both receiving and sending this communication?

Do you have a rich imagination? Do you ever daydream and place yourself at the center of exciting imaginary circumstances, and do you find that you respond viscerally and in your breathing, despite knowing it's all make-believe?

Do you enjoy working on your physicality? How you carry yourself?

Do you have muscle memory?

Are you expressive vocally, physically?

Do you play well with others? Do you like working with others?

Do you have excellent concentration? Can you focus your attention onstage even though you are in front of many people?

Are you willing to fail and fail and fail to learn and to work?

Some of these *aptitudes* can be developed, but others you probably need to have going for you already. Or at least a desire to have it going for you. This work has to be fun for you on some level or you won't continue to do it. Baseball players have to do batting practice. Basketball players work on their layup shots. Pianists do five finger exercises. We as actors have our work to do as well. Hopefully this book will help you with some of that work.

The measure of our success as actors will shift, depending on the role we are given, the scene we are studying, the vocal technique we are acquiring, the improv techniques we are developing, or the physical techniques we are putting into practice. Perfection can never be the measure of our success because we will never get there. Just like pitching a perfect game in baseball, doing a perfect performance in the theatre is a real rarity. Mostly the job is workaday. We do the best we can today with all the technique we have! We must always be working on process because in our craft *our process is our product*. We don't rehearse one way and perform another. It is the same process; we simply add a component, the audience. We evolve and evolve and evolve. It isn't about perfection. Ever.

In the chapters that follow, I've described an approach to preparing and acting a role in a play that many fine actors and directors find effective, efficient, and adaptable to almost any genre and style of play.

It's important at the outset to clarify exactly what we mean by *acting a role in a play*.

There are many and varied types of live performances, which range widely in form and style. They include popular entertainments such as comedy improvisation, street mime, clown and circus performances, magic shows, and Las Vegas spectaculars, as well as more highbrow interactive gallery installations, mixed-media presentations, and a multitude of other kinds of performance art. These are all theatrical performances that delight and inform their audiences using many of the same characteristics as plays in performance, but they are not plays. For the purposes of our work in this book, we need to define a play very specifically as a *story*, written down as a *text*, and intended to be *acted out* live in front of an audience.

Acting a role in a play requires us to become contributing artists among many collaborators striving to bring a written text to life on the stage. Our commitment must go beyond expressing just *our own* ideas, preferences, tastes, beliefs, and mannerisms.Instead, we combine our efforts with others to tell a more universal story of human behavior in the face of challenging circumstances. Pulling off this amazing task requires actors, like all the other collaborative artists in the theatre, *to base their work on a detailed knowledge of the text.* They must be willing to study the playscript thoroughly and immerse themselves in the material completely. Otherwise they risk sacrificing the truth of the story to the brilliance of their performance and might as well have not done the play at all.

In addition to defining the work an actor does and outlining basic working methods, the following chapters will describe the actor's working relationships with the other collaborators, including a step-by-step guide to the rehearsal/production process. This guide outlines what the actor can expect, as well as what is expected of the actor, at each of the major phases of the production process from the first table reading through closing night.

The final chapters will cover the shift from being solely a *student* of the art of the theatre into becoming also a practitioner of the *business* of the theatre. Often actors learn about craft but aren't clear about what steps they need to take as they leave the study of acting and begin their journey into the profession. I've provided detailed advice about auditions, including monologues, prepared readings, cold readings, commercial auditions, as well as information and suggestions regarding headshots and how to prepare resumes. I've described the work of agents and casting directors, and a few strategies for obtaining representation as well as finding work without representation using the Web and other tools.

Let's start at the beginning. To act a role in a play is to create a theatrical performance focused to animate a written text. Learning how to do that is the first purpose of this book. Let's get to it!

The Actor's Raw Material Is The Playscript

This chapter describes what makes plays different from other types of literature and how specifically to read them for the purpose of producing them on stage.

> *More and more I believe what it comes down to for actors, directors, playwrights and designers is text analysis. If you can do that you can understand where to begin and what to do when pure inspiration fails you.*
>
> Marc Masterson
> Artistic Director, South Coast Rep

Most play productions, other than the very first presentations of a new work, start with a finished, published script upon which the director, actors, and designers base their work. The playwright rarely participates in these productions; instead, he or she, through an agent, licenses the producers to do a faithful rendition of the play as written in the script.

The process is very different, though, for a brand new, never-yet-staged script. In this case the writer is not only present throughout the design and rehearsal periods, but also actively collaborates with the other artists to bring the words on the page to vibrant life on the stage. The playwright, spurred by questions raised and discoveries made during rehearsal, cuts, transposes, rewrites, or creates new pages of script overnight, which the company incorporates into the following day's work, leading to more new questions and discoveries. This act of *playmaking* continues as long as the artists and producers have the will and financial resources to support the ongoing evolution of the *playscript* into the *play* it wants to become. Depending on the project, this process can take months or even years of initial readings, workshops, preview performances, and several full productions before the members of the production team, especially the playwright (or composer and librettist, in the case of a musical), feel satisfied that they have finished their work. At this point, a version of the stage manager's prompt script (which is the authoritative record of the playscript in its final form) is published as the "finished" play and made available for subsequent productions by other actors, directors, and designers.

Pay close attention to the spelling of *playwright* and to the term *playmaking* used in the preceding paragraph. Ask yourself why we refer to the writer or author of the playscript as a *playwright* rather than a play*write*. Understanding that *wright* is an older English word that means a skilled craftsperson or *maker* of things (like wheelwright or shipwright) helps underscore the fundamental theatrical truth that plays are not so much written as they are made.

Does that last statement seem to contradict the quote from Marc Masterson that appears at the beginning of this chapter? It does if we understand his use of the term *text* as meaning the same thing as the text of a novel or a biography or historical study or some other kind of literary or scholarly writing. But playscripts differ fundamentally, *in their essence*, from the works of, say, Charles Dickens, Jane Austen, F. Scott Fitzgerald, and Leo Tolstoy.

What is this essential difference? Well—pick up your favorite novel and turn to any page. Or look at your favorite painting or sculpture. It is finished, complete. Nothing more is wanted to make it more "itself" than it already is. Now picture a piece of sheet music or a blueprint or a map of your hometown. Would you mistake the map for the actual streets, parks, and landmarks of your town? The construction drawings for the building? Or the conductor's score for the sounds of Mozart played by a symphony orchestra in a concert hall? For the same reason, we don't want to mistake a playscript for the sights and sounds of *Hamlet* played by actors in a theatre. Like a musical score or blueprint or map, a playscript is not the thing itself, a finished work of art, but a written, paper notation that skilled craftspeople use to create—or re-create— a finished work. It's certain that William Shakespeare never wrote his text down with the intention of publishing it for a reading public. His sole interest as a dramatist, fellow actor, and shareholder in his professional theatre company was to provide a compelling and entertaining *dramatic story* for the troupe to *make a play* out of, which would attract a paying audience. He gave his one rough copy of the playscript to a scribe, who then prepared a fair or clean copy for the company to stage the play with. The company kept this prompt script to use whenever they wanted to stage the play again. That was it. The only reason there is such a thing as *The Collected Works of William Shakespeare* is that years after his death, a couple of Shakespeare's actor friends thought to gather all those old prompt scripts together.

Playscripts are *not*, first and foremost, works of literature, though great ones can be *also* great works of literature. Most of us read playscripts for the first time in English class and are asked to discuss them according to much the same criteria used for novels and poems. There's nothing wrong in this; plays should be read and enjoyed initially as stories with interesting characters and thematic and rhetorical values. For production purposes, though, they must be read for what they are in essence: the record—or the remains, if you will—of what was once a living, breathing, tangible, three-dimensional re-creation of the lives of human beings in crisis, torment, joy, exultation, victory, and defeat. Key to the actor's craft is learning to examine a playscript *forensically* for the *essential dramatic clues* needed to reanimate the inert print on the page.

You need to read the whole script, not just your scenes, many times. That probably sounds like a lot of reading. It is. The foundation of effective text analysis—and good theatre—is a thorough familiarity with the script that comes with repeated readings. I've heard rumors that Anthony Hopkins (Academy Award winner, *Silence of the Lambs*) reads his scripts 150 times before he goes into rehearsals. Perhaps we are not that committed at this stage, but let's try for fifteen or twenty, okay? How could it hurt our work to know the script really well? Only those with very little technique are intimidated by an intimate, dare we say, carnal knowledge of the script.

First Readings: The Big Picture

Story and First Impressions

The first time you read the playscript, take your time. Allow for two or three hours of uninterrupted time. If you don't take this step, it is not irrevocable, but you might lose the valuable insight of discovering how the play might be experienced firsthand by an audience, and you might lose your initial response to the work as a whole. Allow yourself to access the play intuitively.

For these first few readings I suggest that you read "feline," leaning back. Don't focus forward intently with a pen or marker for your lines. Don't highlight your lines yet. Try to visualize the play as a whole in your mind's eye. Try not to pay special attention to your character. Stay easy, alert and open to your musings. Keep a *pencil* handy to jot in a journal or write questions or question marks in your script, but don't take a lot of notes. Circle a line that puzzles you or write in the margins. All can be erased. Nothing is in stone. Pens are for later. Maybe.

Getting More Specific

As you continue successive readings of the script, start to keep some questions in mind that feed your curiosity and sharpen your focus on the story specifics: place, time, characters, situations, settings, mood, and so on. The more specific and *textually supported* our impressions become at this point, the better our later work will be. Professional actors don't work necessarily *better* than amateurs, but they generally work *faster* and *more thoroughly*. Don't leave it to chance. *Getting specific in our responses is not in opposition to responding intuitively; quite the contrary, it opens up the richness of our ability to fully respond.*

The following questions pertain to the entire story and world of the play created by the playwright. Neither the character, nor the actor portraying her, exists in isolation. Every role must be understood and fashioned within the context of the whole play and in service to telling the story faithfully to the audience. Later, you will ask the same questions from the specific point of view of your character using the analytical rubric in Chapter 3.

• What events have brought the characters to this place?

• Where are they? What are their relationships to this place? Which of them feel at home here; which do not? Who is the smartest person in the room: intellectually, emotionally, intuitively? Is it an emotional atmosphere? Does it feel normal for the characters? Very different? Confusing? Comforting?

• When does the play/this scene take place? How do the characters experience time? Rushed? Comfortable? If the story isn't set in a time period with which you are familiar, make a note to do some research.

• What are the common *things* that characters handle in the world of the play? Which characters are especially adept or clumsy with certain objects?

• *How* do the characters speak? *What* do they say? How do they want it to be *heard?* What do they have in common in their use of language; what separates them?

• What do the characters think but *not* say? (Think about what you yourself think but do not say during the course of a day! Huge.) Write out some of it. Not complete sentences. Just grab an intuitive bit and jot it down. It may open some doors later.

• What are the familiar sights, sounds, smells, flavors, and tactile sensations of the world of the play? What's comforting or unusual or surprising to each individual? Begin finding a sense of truth and belief in the make-believe world of the play by grounding yourself in the sensory palate provided by the playwright.

• What images strike you forcefully as you read? What personal associations arise in response? What visceral sensations do you experience in response?

- What connections do you start to become aware of between relationships, events, and dialogue?

- Think specifically about relationships. What are the significant pairings? What does the web of family and social interrelationships look like? How do the characters' conflicting purposes change the relationships and propel the story from the beginning of the play to the end? Moments of satisfaction? Dissatisfaction?

- What in the play confuses or scares you? Get specific.

Please don't get married to these initial responses. They are important to help you crack open the surface of the text and find a way inside, but once you begin rehearsals, the director and other actors will have an enormous impact on your choices.

Sometimes young actors can be afraid of thinking about a role; they believe that this might become a barrier to the work, a barrier to their own intuitive response to the work. The homework outlined here is not put forward as a limitation, only as an opportunity to fully open ourselves to the work at hand.

Just keep asking the questions, *especially* about the moments that confuse or scare you. Don't worry about the answers. The answers will present themselves sooner or later in a variety of ways. If you are frightened or embarrassed that you don't already know all the answers, you often become afraid of the questions themselves and thereby cut yourself off from your own creativity, intuition, and response. You don't need to have the right answers to move forward, just the right questions, the discipline to ask them, and the courage to follow where they lead. Just keep jotting down your impressions and sensations. In pencil. You are opening yourself to your own genius by asking questions and musing on them. This is homework. An actor's homework.

Next: Read for Action

Here at last is the crux of the particular challenge in reading playscripts for production. Exactly what is *action* and what does it look like on the page? It's not what the movie director means when he calls for the getaway car to screech around the corner, sideswipe the garbage truck, flip over, and explode. And it's not simply physical business or blocking like polishing the silver or crossing stage left to the divan. Aristotle, describing the tragedies he saw in ancient Greece nearly 2,500 years ago,[*1] observed that the stories were executed in the form of action, not narrative, meaning that they were *enacted* rather than described or reflected on: the difference between hearing a recitation of the story of Agamemnon and Clytemnestra from *The Iliad* and witnessing, in person, the horror of the murderous aftermath of Clytemnestra's revenge. Aristotle concluded that tragedy (and for the purposes of our discussion here, any play), was the imitation or *re-creation* of a serious, complete deed of magnitude or consequence, performed in the guise of characters in the present tense through *action*. Moreover, *action* for Aristotle was not the deed of consequence itself, but the *active striving to accomplish the deed*. In other words, *action* in plays is a *verb*. Makes sense, don't you think?

The tricky question for actors and directors in reading playscripts, though, is *where on the page do you find this all important theatrical element?* It had to be present and operating during the

[*1] Aristotle (384–322 BCE): ancient Greek philosopher and avid theatergoer. It's one of the ironies—and beauties— of our profession that, despite the digitized, microchip driven whizbang of contemporary theatre technology, we still, at its core, practice an ancient art form whose basic principles are practically as old as civilization itself.

creation and performance run of the original production the play, the record of which you hold in your hand in the form of a playscript. So where has the playwright or stage manager written it down? Can it be written down? How do we find this action?

This example might help in discerning the action. Take a look at the following sentence, which describes a moment in a hypothetical play about a university acting class:

Because he failed half the class on the last exam and is worried about his teaching evaluations, the professor _____ to the students by buying them ice cream in order to win back their good opinion.

The text of the playscript, somewhere in the dialogue or stage directions—usually both—supplies all the elements of the preceding sentence except the missing blank.

Because he failed half the class on the last exam and is worried about his teaching evaluations {motive},

the professor [character A]

< ? >

to the students (character B)

by buying them ice cream
|activity|

in order to win back their good opinion.

—> objective or goal <—

What goes in the blank? A verb.
Action.

Because he failed half the class on the last exam and is worried about his teaching evaluations, the professor kisses up *to the students by buying them ice cream in order to win back their good opinion.*

Because he is filled with dread and foreboding that he himself is the vile thing that has brought down plague on Thebes, Oedipus browbeats *Teiriseas with taunts and pleas into telling him the truth.*

Because she is bereft at the thought of living without Ross, Rachel goes off *on the airline folks with all her tricks in order to get off the plane to Paris.*

Don't worry about finding the verbs or verb phrases for the action in the text itself. Try as you may, you're unlikely to find the phrase *to kiss up* anywhere in the script about the professor. Nor will you find *to browbeat* written down by Sophocles in *Oedipus Rex* or *to go off on* in the script for the last episode of *Friends*.

Though it is not overtly supplied in the words of the text, *action* is nevertheless implied throughout the text. It isn't the deed being done or even the doing of the deed, but the *striving* to do the deed that is the animating force of a play, the energy of purpose that drives the characters through the events of the story we see onstage.

Animating Force Energy of Purpose Driving Characters Striving to Do

For a playscript to become a play, the missing element in the script is the actor, who in her being, *is* the character striving with purpose.

The job of the actor is to read playscripts for what's missing, specifically, and then supply it themselves.

Finding Action in the Dramatic Structures of the Script

A play is a story that is **acted out** live, in the here and now. The actor's job is to find and enact the actions of the play in the guise of the character. A central part of that task is being able to read the playscript to discover the very particular action that is most necessary for the purpose of re-creating truthfully each successive event in a character's journey through the play.

According to Aristotle, action in a play manifests itself in six tangible forms:

1. Plot

2. Character

3. Thought

4. Diction

5. Music

6. Spectacle

Plot is the first and most important of the forms of action. We define it as *the events from the story of the play that the playwright selects to dramatize, or have enacted onstage, in the arrangement and sequence they are to be shown to the audience.* It's important to make a distinction between the story and the plot of the play. The story encompasses the entire fiction of the world of the play as invented by the playwright, whereas the plot consists only of those events and characters from the story that actually appear onstage. In other words, all the elements of the plot are a part of the story, but only select portions of the story are also part of the plot.

The most common type of plot structure is a linear or causal plot in which, as the name implies, all the events occur in the chronological order of the story, more or less one after the other in a linked chain of cause and effect. Tennessee Williams' *Cat on a Hot Tin Roof* is an ideal example of a causal plot. Every event in the plot from opening to closing curtain is linked directly to the event just before and just after it. The amount of time that transpires in the fictional world of the play is exactly equal to the playing time of the play's performance in the theatre. Most causal plots are not so tightly linked; often a few hours, or even days, can pass in the *story* of the play between adjacent scenes in the plot, but the impression of cause and effect remains much the same for the audience. Playwrights generally use causal plots to tell relatively simple stories with limited numbers of characters, locations, and time shifts, but with a steep, fast rising arc of dramatic action.

In addition to causal plots, playwrights use other types to tell larger, more complex stories that take place over long periods of time in many far-flung locations, often shifting back and forth frequently in time and place.

All plots, whatever the type, are constructed of the same basic structural elements, though their arrangement and sequence can vary widely according to the storytelling needs of the playwright. The important news for an actor is that the central actions of a play are clearly revealed through careful examination and thorough understanding of these elements and how they function together to form the *skeleton or frame* of a plot:

1. **Point of Attack:** The first event of the plot. Where the playwright has the audience enter the story; the first image or impression they have of the world of the play.

2. **Stasis:** The status quo of the world of the play, opposing forces in equilibrium, an ordered dynamic balance.

3. **Intrusion/Inciting Incident:** The first crisis or turning point of the plot; the event that disrupts the stasis or status quo of the world of the play and incites the protagonist to take up the central action/conflict of the play; implies a major dramatic question that will be answered in the climax.

4. **The Complication:** A series of crises or turning points that steadily narrow the possible outcomes/options for resolving the central conflict in the climax; propels the plot forward in an arc of action rising in dramatic intensity.

5. **Major Crisis:** The final crisis or turning point in the plot. The point of no return where the possible outcomes of the central action/conflict are reduced to two and propels the protagonist directly to the climax that has become inevitable.

6. **Climax:** Resolves the central action from the point of view of the protagonist; answers the major dramatic question and creates the conditions for a new, different stasis for the world of the play; the highest point of dramatic intention in the arc.

7. **Denouement:** Falling dramatic arc, the establishment of a new stasis/status quo, tying up of loose threads and unresolved minor questions; hints toward future action.

8. **Point of Termination:** The last event of the plot; where the playwright has the audience exit the story; the last image or impression they are left with; sometimes a cliffhanger.

9. **Exposition:** Events, often spoken confidences, gossip, or news updates that reveal information from the backstory, either before the point of attack or from "offstage" that isn't dramatized but is needed to help justify the unfolding dramatic action for the characters, audience, or both; occurs anywhere prior to the major crisis.

10. **Foreshadowing:** Similar to exposition, but events/discussions point forward to potential future occurrences; helps hold the attention of the audience by promising excitement or revelations; also helps sustain audience's *willing suspension of disbelief* by preparing them to accept as plausible the artifice and necessary contrivances of the make-believe world of the play.

11. **Major Dramatic Question:** Phrased from the point of view of the protagonist and implied by the disruption of the stasis in the inciting incident; must be answered in the climax as Yes/No; Either/Or. No shades of gray!

It can be very useful to visualize the dramatic arc of a plot skeleton by arranging its elements in sequence as points on a graph where the X axis represents the actual time transpiring in the

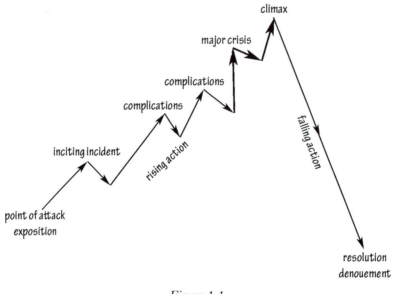

Figure 1.1
Causal plot graphed

theatre during performance (hours/minutes fannies are in seats) and the *Y* axis represents rising dramatic tension. Ideally, you want to plot the plot to resemble something called a Freytag curve. Figure 1.1 shows a graph of a generic causal plot labeled with the elements of the plot skeleton described.

Spine = Central Action = Backbone

The central action of a play (sometimes called the root action) is not an element in the skeleton of the plot, but, like the backbone to an anatomical skeleton, it is the hub, the core, that every element of the play must attach to and be suspended, supported, and organized by. When you succeed in identifying all the elements of the frame of the plot in such a way that they serve to justify and support each other and bring the arc of the dramatic action into clear focus, then you know you are ready to articulate a plausible central action. Conversely, a plausible, well-phrased potential central action will serve like a powerful magnet, drawing out of the jumble those elements that are the most likely to form the spine of the plot.

Always describe a central action using a transitive verb phrase from the point of view (p.o.v.) of the protagonist, the hero (or antihero) of the play. Keeping Aristotle in mind, a statement of the central action should try to express the core *striving* of the protagonist to accomplish the task forced on him or her by the the intrusion (inciting incident).

For example, a plausible central action for the play *Hamlet* might be "to search out proof of the right course of action." This phrasing of action (a verb, *to search out* directed toward an objective, *proof*) certainly underpins much of Hamlet's behavior in the play. In fact, the rest of the major characters in the play engage in variations of the same action.

To illustrate more specifically how identifying and relating these plot elements in the script can reveal *action* in the play, I've done a sample analysis of the plot skeleton for Williams' *Cat*

on a Hot Tin Roof, mentioned before. This is by no means a definitive examination of the play, but the perfect causal construction of the plot can readily be applied to the graph we looked at earlier in generic form.

Point of Attack: Maggie enters Brick's and her bedroom after having had dinner downstairs with the family while he remained upstairs in his pajamas, drinking.

Stasis: Maggie chats up Brick while she brushes her hair and touches up her makeup. He continues to drink and listen to her banter with as much indifference as he can muster, while trying to navigate around the room on unfamiliar crutches. This is Maggie and Brick's life together for some time now: a cool detente in which he tolerates her effervescent presence in exchange for her acceptance of his abandonment of responsibility for or interest in his family or birthright as well as his refusal to have anything to do with her.

Intrusion/Inciting Incident: Maggie forces Brick to listen to her talk about his old friend Skipper. The stasis of wary detente between them is completely shattered by Maggie's violation of the agreement by which Brick agreed to remain married to her: that she never mention Skipper.

(Here's where it gets interesting. After reading the playscript several times, I'm going to propose what I think might be a plausible central action (from the p.o.v. of Brick, who is the protagonist of the play) and a possible major dramatic question to go along with it. As I go through the rest of the analysis, I'll look to see if my proposed action and question satisfy the requirement of the other plot point criteria.) Central Action: Maggie's intrusion into Brick's emotional exile begins his *fight to cope with the truth (about his relationship with Skipper and culpability for his death).* Major Dramatic Question: Will Brick accept the truth of his love for Skipper and complicity in his death and still decide to go on with his own life anyway?

Major Crisis: Maggie's surprise announcement to the entire family that she is pregnant with Brick's child and Big Daddy's exuberant embrace and endorsement of Maggie's bald-faced lie. This event forces Brick either to refute Maggie's claim and forever give up his birthright and inheritance to his brother, Gooper, or to stay silent, allow Maggie's and Big Daddy's victory, and reassume his life and place in the family.

Climax: With everyone's life hanging in the balance on his decision and all eyes glued to him, waiting with baited breath, Brick picks a side in the great family struggle over the inheritance of Big Daddy's legacy: his own and Maggie's. The action is resolved: Brick wins his fight to cope with the truth. And the Major Dramatic Question is answered with a very clear, "Yes!" And a new and very different status quo is begun.

My Central Action and Major Dramatic Question are looking pretty good to me. They seem to help support and make sense of the plot events and character relationships throughout the play and to forge a plausible causal link between inciting incident, major crisis, and climax. If I'm playing Brick, I have very effectively "broken the back" (as some actors say) of the part with this analysis. If I'm playing Mae or Gooper or Big Mamma or Big Daddy or even Reverend Tooker, I have still advanced myself miles down the road of gaining carnal knowledge of script from the point of view of my character. In a play so thoroughly concerned with lies, lying, liars, and the destructive effects of all manner of private and publicdeception , I know that my superobjective is going to be deeply rooted in some variation of a need *to cope with the truth.*

Regardless of the size or kind of role you are playing, your work on character-specific physical action and the character action analysis outlined in Chapters 2 and 3 is relevant and effective in direct proportion to your understanding and investment in the action and dramatic structure of the larger play. In Chapter 2 you will be introduced to the terms super objective, scene objective, and beat objective, but simply remember for now that the superobjective for every character in the play connects to the spine/central action in one of two ways, putting the character either in the protagonist's or the antagonist's camp. Likewise, individual character through lines of action are integral to the dramatic action of the plot and its inexorable arc toward the climax.

In some production situations, you will be fortunate enough to work with a director and company who value the doing and sharing of this kind of careful textual preparation. In others, though, you will need to incorporate into your own actor homework an analysis of dramatic structure and phrasing a plausible central action for the play as whole. Don't skimp. One way or the other, it always shows in the end.

The Actor's Work Is Creating Action

Read through the following list of actors, many of whom you probably recognize from their outstanding performances in the movies and on television. See if you can think of something they all might share in common that sets them apart from many equally prominent and successful screen actors who don't appear on the list.

Kevin Kline

Meryl Streep

Ian Holms

Ian McKellen

Judi Dench

Maggie Smith

Ralph Fiennes

Willem Dafoe

Alan Arkin

Jessica Tandy

Hume Cronyn

Phillip Seymour Hoffman

Sigourney Weaver

F. Murray Abraham

Robert Duvall

Dustin Hoffman

Anthony Hopkins

William Hurt

Jeremy Irons

Patrick Stewart

Robert Redford

Al Pacino

Christopher Plummer

Sean Penn

Sidney Poitier

Geoffrey Rush

Kevin Spacey

Denzel Washington

Forest Whitaker

Julie Andrews

Helen Mirren

Kathy Bates

Holly Hunter

Jessica Lange

Vivien Leigh

Francis McDormand

Emma Thompson

Michael Caine

Olympia Dukakis

Whoopi Goldberg

Catherine Zeta-Jones

Diane Wiest

Tim Curry

Frank Langella

John Lithgow

Derek Jacobi

Ed Harris

James Earl Jones

Alan Rickman

Courtney Vance

Alec Baldwin

Liam Neeson

Michael Gambon

Sam Waterston

Brian Dennehy

John C. Reilly

Gary Sinese

Billy Crudup

Oliver Platt

Liv Schreiber

Laurence Fishburne

Stanley Tucci

Eileen Atkins

Glenn Close

Mary-Louise Parker

Joan Allen

Cherry Jones

Stockard Channing

Anna Deavere Smith

Jennifer Ehle

Jean Smart

Laura Linney

Vanessa Redgrave

Phylicia Rashad

Anne Heche

Swoosie Kurtz

S. Epatha Merkerson

Angela Lansbury

Jane Fonda

Frances Sternhagen

Joanna Gleason

Annette Bening

Christine Baranski

Cynthia Nixon

Lynne Thigpen

Debra Monk

Marcia Gay Harden	Hank Azaria	Warren Beatty
John Cullum	David Hyde Pierce	Rip Torn
Jerry Orbach	Michael Cerveris	Martin Sheen
Barry Bostwick	Bernadette Peters	Morgan Freeman
Raul Julia	Patti LuPone	Edward James Olmos
Mandy Patinkin	Toni Colette	John Mahoney
Victor Garber	Idina Menzel	Eric Stoltz
Jason Alexander	Vanessa Williams	Jude Law
Jonathan Pryce	Kristin Chenoweth	Charles Durning
Keith Carradine	William Daniels	Adam Arkin
Nathan Lane	Rene Auberjonois	Joe Mantello
Martin Short	Anthony Heald	Robert Sean Leonard
Alan Cumming	Ron Rifkin	Kevin Anderson
Matthew Broderick	Bebe Neuwirth	Mark Ruffalo
Christopher Walken	Jane Kaczmarek	Ethan Hawke
Alfred Molina	Brad Whitley	Mary McDonnell
Hugh Jackman	Clarence Williams III	Sarah Jessica Parker

So, have you figured out what all these people have in common?

This list is just a sample of many accomplished actors in movies and television who got their training and start in the live theatre. Doing plays in front of audiences, often eight performances a week, has grounded their work in *action*. They bring a sense of fullness and three-dimensionality to their characters, especially in speaking the dialogue, that is sometimes lacking in film actors with little stage experience.

Many young actors just beginning their study think about acting in terms of screen acting. This is understandable. Most of us only see great acting on film and wish to emulate that acting. But acting for the camera is an exacting craft of its own and requires a significantly different use of an actor's technique than acting in the theatre. Screen acting emphasizes how one looks, literally: facial expressions and eye movements, close-up shots of emotional reaction, snippets of intensely whispered dialogue scattered amid a dozen shots of physical action from different camera points of view. In film and TV the eyes and ears of the audience are where the lens of the camera is focused and the microphone is placed, which puts the control of the actor's performance largely in the hands of the director. In film and TV, the microphone captures every breath if that is what the director wishes to hear. In the theatre actors' voices must reach the ears of each audience member regardless of the size of the space. They must be heard, understood, and still manage to sound natural. In film and TV, the director controls pace by how quickly the shots are edited together and whether it is a master shot with many actors in the frame or a close-up of one face. In the theatre, during rehearsal, the director works with the actors to establish a certain rhythm and pace for each scene; she composes blocking and stage pictures intended to draw the attention of the audience to the important actions and responses of the characters. She will ask the lighting designer to help guide audience focus by

lighting some actors more brightly than others. But, once a performance begins, the stage director cannot control to the same extent as her film/TV counterpart where the audience looks, how quickly a scene is played, or what it sounds like. She can't have the audience "cut away" from one actor to get another actor's response. In the theatre, the audience takes in the entire experience of the actors working together moment to moment in a flow of action and response.

Screen acting is predominantly visual and smaller in scale; theatrical acting is predominantly verbal and much larger in scale. Film and TV are very much the director's medium; the theatre is the actor's. Plays are mostly dialogue; movies are motion pictures. In the theatre speech IS the action. Which brings us back to the list of actors at the beginning of this chapter. They bring to screen performance not only mastery of communication through the camera lens but also the abilities they have developed in the theatre with speaking the text of the play and making the text come alive as *action.*

Action

Obvious as it seems, the creation of action is the main concern of the **act**or's craft. For us in the theatre, action is not what the movie director means when he calls for the getaway car to screech around the corner, sideswipe the garbage truck, flip over, and explode. Rather, actors undertake the *action* of the play as we understand it from our discussion of Aristotle in Chapter 1, by *striving to achieve a goal or outcome of enormous importance.*

Here's a summation of action.

Actors, in the guise of characters, **act** to get what they want.

What actor/characters want is called an **objective.**

They face *obstacles* to getting what they want. Tougher obstacles require actors to use more powerful *tactics* (active verbs) to surmount them. The toughest and most dramatically compelling obstacles are the opposing objectives of the other actor/characters. The clash of opposing objectives between actor/characters produces the dramatic conflict that powers the play forward, event to event, in a linked chain of cause and effect.

That's it.

That's the order of action. Training in voice, speech, movement, dance, singing, and fencing (not the province of this book) provide eloquent means for playing action and communicating the play's themes and images to the audience with theatrical vibrancy. But it is *action* that makes the play *happen* and is the actor's primary concern, first, last, and always.

Before we return our attention to the actor's work with the playscript, we need to deepen our understanding of action from the actor's point of view and plant the seeds of real *doing* at the heart of our craft.

Stanislavski and Action

Konstantin Stanislavski (1863–1938) was an actor and director who lived and worked in Russia in the latter half of the nineteenth century and the first third of the twentieth century. He was dissatisfied with the bombastic, overemotionalized style of acting common at that time, which emphasized the performer at the expense of the play. He dedicated his life to developing

techniques that would help actors to perform truthfully and naturally, in service to the play rather than just their own performances. He never claimed to have invented modern acting, nor did he endorse anything purporting to be the "Stanislavski system." What he did do was closely observe how really good actors worked. The most compelling actors, Stanislavski saw, created truthful seeming behavior and made the fictional world of the play come to life. They concentrated their attention fully on genuinely doing the tasks and meaning the words of the character, *inter*acting spontaneously with the other actors and allowing their emotions to arise naturally as a result. This interplay between inner purpose, physical behavior and emotion, Stanislavski felt, was the key to truth on the stage. He came to understand that our emotional wiring allows impulses to run both inside out and outside in. When we say we are working from the "inside out" we are using emotional stakes to cause physical reactions. When we say we are working from the "outside in" we are using physical actions like slamming a book down on a table or whispering a character's name to help raise the stakes and up the emotional heat in a scene. As Stanislavski worked on understanding what made for the most evocative acting, he found value in both approaches.

The Objective

What you want is your *objective*. A play is far more interesting to watch and listen to if the actors want to complete tasks or accomplish goals onstage than if they don't. It is as simple as that. Otherwise we might just as well watch goldfish in a tank. Oh wait! Goldfish are swimming so that they might breathe! Okay, not as interesting as goldfish in a tank!

For the purposes of creating fully lifelike, truthful behavior that justifies and makes necessary the dialogue of a playscript, though, physical task must be tied to psychological need and directed toward the accomplishment of a goal that will satisfy the need. Most American actors and directors, following Stanislavski, use the term *objective* (or sometimes *intention*) to talk about this in rehearsal. Other common terms include *action, goal, want*, and *need*. Less often you might hear someone ask what the *victory, purpose, desire*, or *aim* is in a scene. The point is that everyone is talking about the same essential topic: a physical action in pursuit of some desired outcome or response, almost always from another character/actor.

So how does this idea of objective work onstage? Well, how does it work offstage in your life? No matter how lofty their themes or erudite their language plays are always at the bottom line struggles between intimates over control of relationship, identity, self-worth, recognition, fear of loss, remorse, forgiveness, tolerance, revenge, you name it. Plays are stories about our lives. So . . . as in life . . . how about forcing your scene partner to prove that you can trust him? Maybe you want to beg her to take you back after you cheated? Or you might need to con or trick or drive so-and-so into breaking up so you don't have to be labeled the bad guy. Try shaming the actor playing your law partner into admitting she lied about you. Or cold-shoulder her into an apology or into coughing up the truth. At the ten-year class reunion you could charm your high school sweetheart into kissing you when her husband leaves to get the car. What husband, wife, child, parent, lover, partner, best friend, sister, brother do you need to punish, tease, mock, put off, dodge, guilt, attract, fetch, grind down or puff up to get them to give you what you need right now to be able to bear living another day? Your job as an actor is to ferret out those objectives you understand and use in everyday life and intensify them to a level of crisis and dire consequence, transposed for service in the high-stakes circumstances of a play.

Superobjective, scene objective, and beat objective

Actors and directors identify different *levels* of objectives to help make sense of the action of a play. As we discussed in Chapter 1, there is the overarching or *master action* for the play as a whole, which the director is responsible for articulating. Each actor should then devise (for his or her character) a kind of master action for the entire play. Stanislavski called this the *superobjective*.

The actors then assign an *objective* to each scene in which their character appears. This objective contributes a step on the way to achieving the superobjective. We can call this objective the *scene objective*. The scene objective may or may not change, according to the progression of the action and how that action affects the character you are playing or the other characters in the scene.

Finally, every *beat* (or unit-of-action) gets an even more immediate objective toward respective scene objectives, thus forwarding the dramatic action from each character's point of view. It seems an unusual word for an action; it is believed that Stanislavski used the word "bit" referring to a little bit of the action, but his Russian accent colored the word and "bit" sounded like "beat" hence our use of the work "beat" to describe the smallest unit of action.

To better understand <u>superobjective</u>, <u>scene objective</u> and <u>beat objective</u> let's use an example from Shakespeare's *Hamlet*. For his *superobjective* the actor playing Hamlet might use "to avenge my father's murder" or something to that effect. Hamlet's *scene objective* for the scene in which the players act out the "play within the play," *The Mousetrap*, might be to "pressure his uncle into admitting he murdered his father."

A single *beat* from the same scene comprises the following exchange:

Hamlet: O good Horatio, I'll take the ghost's word for a thousand pounds. Didst perceive?

Horatio: Very well, my lord.

Hamlet: Upon the talk of poisoning,---

Horatio: I did very well note him.

Hamlet: Ah, ha!

We can see clearly that in this *beat* of the scene Hamlet is *forcing his best friend admit that he also sees his Uncle's guilt*. Hamlet achieves his *beat objective*, and we can see that in his "Ah, ha!" Hamlet wins the point, and he knows it. This a great tip for an actor—we need to know when we *gain* our objective. We also need to know when we *lose*. Wins and losses force us to adjust our strategies in pursuit of our wants. Hamlet, having won this point, now goes on to his next *beat objective* in service to the *scene objective*, in service to the *superobjective*.

The Obstacle

For every *objective* we must identify at least one *obstacle* to that action, usually several. An obstacle is something that gets in our way as we move toward our objective. We know what we want, but what is in our way? What stops us or holds us up in getting what we want from another actor/character? If there were no obstacles to our objectives, we would get what we want immediately, and the play would be over! But the play isn't over; so what are the obstacles?

Chances are the playwright has made the other character(s) in the scene the major obstacle(s) to the goals of your character, Good plays draw from the truth of life and generally provide characters with multiple bumps (obstacles) in the road, some of which are *internal* obstacles. An internal obstacle might be an obstacle you are struggling with such as *what if he betrays me?*, or *what if she rejects me?*, or *I don't want to hurt her feelings*, and so forth.

Let's look again at a possible objective we mentioned earlier: making someone prove we can trust them. What *specifically* might thwart us in achieving our aim? To truthfully play the conflict in this scene, you must decide what success in achieving your objective looks like. What do we want to see and hear when we look for proof that we can trust someone? Steady eye contact? A certain tone of voice? Do we want this person to beg for another chance so we can gauge his or her sincerity? How would we know for certain we could trust someone? It certainly wouldn't be just the words alone that convinced us. Every eye shift, every shuffle of weight between feet, every quaver in the voice, and each glance away is an obstacle to our objective thrown at us here and now by the other actor. We must deal with these obstacles and adjust to them moment to moment.

Playwrights will provide unmistakable obstacles in the form of changing circumstances, characters, and plot events, especially to motivate or cause the big moments of crisis and resolution in their stories. But for the play to maintain dramatic tension and hold the interest of an audience for a couple of hours or more, there must be a continuous parade of obstacles for the characters to wade through and fend off. The playwright has probably not made these problems quite so overt or obvious but, instead, has implied them by a combination of circumstances, events, and relationships, which it is the actors' responsibility to discover and play. If you aren't taking in looks, tones of voice, shifts, or gestures, you cannot possibly respond to them. This is an essential part of your craft.

Tactics

A *tactic* is what the actor *does* from the point of view of the character to achieve the desired outcome of the objective. Tactic is the *doing* at the heart of action. Tactics and obstacles go together like a hand in a glove. The moment-to-moment interaction in the proof of trust conflict, outlined earlier, is a tactical improvisation of search and dodge in which each actor's tactics are the other actor's obstacles.

Tactics are verbs; they name what we, the actors, do to get what we want from the other actor/ characters. The more daunting the obstacle in the way of the objective, the more potent the tactic required to surmount it. Don't let the naming of tactics become an academic exercise in semantics. Choose strong, active verbs that appeal instantly to your imagination and fire your will to *do*. An enlivening, animating, playable tactic is one you understand in your gut as much as your brain. Don't limit yourself to words defined in the dictionary. The best tactics are made up by the actor in the heat of rehearsal or study; they're compound verbs and phrases that are highly imagistic and sensory.

<u>Phrasing a Playable Objective</u>

Much of what actors and directors do in rehearsal can seem tenuous, not grounded, lacking in pragmatic measures of achievement. Unlike our designer and technical colleagues, whose working materials are much more tangible, we work almost entirely with words: the words of

the play and the words with which we speak to each other about the play. These are our tools, and we have to ensure that we use them carefully and specifically. Speaking with one another about objectives and tactics and obstacles can be very useful, but also fraught with the danger of miring an essentially physical and intuitive process in a gummy bog of meandering talk. So . . .

Bearing in mind that an **objective** must contain an *action verb*, the *other* in the scene, and an *outcome*, here is a usefully phrased objective.

EXAMPLE:

I want to *make*	*every student* in this acting class	*invest* more deeply in process.
action verb	who, the other(s)	active verb describing outcome

For <u>each objective,</u> we have one or more <u>obstacles.</u>

The **obstacles** I might face in making every student in this class invest more deeply are boredom, lethargy, fear, superiority, drowsiness, inertia, distrust, pride, peer pressure, stubbornness, reluctance, vanity, insecurity, laziness, smugness, disdain, sophistication, need to impress, showing off, well, you get the picture.

We then use **tactics** to surmount the *obstacles* we perceive as we move toward winning the *objective.*

To make this change in you, to *overcome obstacles* presented to me by you, the members of the acting class, I coax, plead, challenge, encourage, develop, shame, tantalize, define, shape, orchestrate, debate, insist, provoke, snip, cut, worship, adulate, mock, applaud, push, demand, instill, well, you get the picture. I use these *one at a time in response to a specific obstacle* or set of obstacles presented in the moment.

So, For <u>*each beat*</u> we have an <u>*objective.*</u>

For <u>*each line*</u> (or so) we have a <u>*tactic*</u> used in an intuitive OR calculated *response* to an <u>*obstacle*</u> raised by the other or raised internally by ourselves, or both, depending on script and character.

<u>Words we must **never, ever** use in objectives OR tactics:</u>

passive verbs—be, seem, am, are. These lead to choices that focus on you the actor rather than on what you the actor want from the other actor(s) in the scene.

emotional states of being—angry, sad, happy, confused, worried, etc. These lead to choices that focus on you the actor rather than on what you the actor want from the other actor(s) in the scene.

words that imply "delivering a message," meaning there is no need for the other in the scene—tell, explain, show, describe, etc. You can do these things and not need a response. If you don't need a response, then you don't have a strong objective, which is never a good choice for an actor.

The word "try." Using the work "try" admits to a lack of complete commitment to the objective. A weak objective is "try to get a date with this woman." Instead of using try, use an internal obstacle to the action. An objective such as "get a date with this woman" is better served and more specific if you set up an internal obstacle: perhaps fear of coming on too

strong or fear of rejection or fear of acceptance. That internal obstacle combined with the obstacles provided by the other actor make for far more compelling theatre than "trying to get a date with this woman."

Summary

This chapter has been an introduction to the actor's use of action, objective, superobjective, scene objective, beat objective, obstacle, and tactic. We have noted some differences between film acting and acting for the stage, and although "acting is acting is acting," there are some differences we need to be aware of and prepare for. We have examined an actor's work in determining action; an action is comprised of the objective of the actor/character, the obstacle to achieving that objective, and the tactic used to surmount that obstacle. Action is the key to exciting and compelling acting.

The Actor's Method Is Making Context for Action

Contextualizing the Action

Assuming you have read the play several times for story, plot structure, and your intuitive responses to the characters, images, and themes, you are now ready to read the playscript more carefully, searching for detail of circumstances, backstory, and character action. This is the point in the process where you become a detective. Work with pencil and journal at hand and take active notes. You are an archeologist digging through the layers looking for clues to the truth. If you like, you may now highlight your lines in your script. Doing so before a few readings of the play can hamper your sense of the flow of action in the entire script.

During the next several readings of the script, you must scrupulously sift the *facts* about the world of the play from all the other strong impressions that float up to from the page and resonate with you as you read. These facts, or *given circumstances*, include *any information that the playwright gives us about the characters, relationships, history, setting, and conditions of the world of the play*. The other impressions are vital! Don't dismiss them. Jot them down and set them aside in your consciousness. Later, when you have studied and thoroughly grounded yourself in the world of the play as given by the playwright, you may consider all these other impressions fully. If they belong in the world of the play, they will take root there. If not, they will drift away.

For example, in Shakespeare's *Hamlet* we find we are in Denmark and King Hamlet has died a month earlier. His son, Hamlet, has come home after this death to discover his mother married to his uncle. In addition, he finds that his uncle now wishes to be king instead of allowing the throne to pass to Hamlet. These are the *given circumstances*, and we are not allowed to adjust them in any way; to do so would be to betray the purposes of the playwright. We cannot decide that Hamlet is actually really fine about his mother's marriage to his uncle because the playscript does not support this. The actor is allowed many interpretive choices during rehearsal, but the given circumstances are fixed and not open to interpretation.

Character Action Analysis Template

The following is an effective model for discerning and organizing the *given circumstance, story, and action* information in a script for use before and during rehearsal. Use the following questions to dig up and identify all the circumstances invented and GIVEN by the playwright explicitly in the dialogue and stage directions or implied through the dramatic action. Then, throughout subsequent readings and rehearsals, continually revise, specify, and deepen your original answers with a couple of additional questions: (1) In what way is this circumstance significant to the play? and (2) What does it *mean* to me from the character's point of view?

Given Circumstances

1. Who am I

Name, Age/Maturity, Gender/Sexuality, Social Status, Occupation/Economic Class, Education/Intellect, Political Assumptions, Religious/Moral/Ethical convictions, Family Tree, Physical Appearance

2. Where am I?

Broad geographical area (a continent, country, province, or city)
Immediate surrounding area (a specific neighborhood or building or landmark, etc.)
Exact location of action (interior, exterior? Corner of the room/street corner)
What objects surround me? What is the weather?

3. When is it?

Time period, year, season, month, week, day, time of day, time on the clock

4. Who am I with?

Factual details of relationship with *the others*, including the web of relationships

Story

5. What has already happened?

Previous action or backstory: Significant events in long ago past, recently, and in the moment before? Where am I coming from?

Action

6. What do I *want*?

Superobjective for the play; key objectives scene by scene

7. What do I want it for?

What am I fighting for? What's at stake? Consequences of not getting it?
What would that be like for me? It would be *as if*. . .

8. What is in my *way*?

Internal/External obstacles? Circumstances? Relationships? Competition? The other actor/character

Given Circumstances/Context

Here's the same template with some further questions, observations, and explanations of how an actor might continue defining and developing the context and action of the play.

1. Who am I?

- *What do other characters say about me?* List the statements.

 For each statement, decide if the speaker is correct, mistaken, lying, or what personal agenda he or she may have.

- *What do I say about myself?* List the statements.

 What is true? What do I believe is true? What is conscious evasion or a lie?

- *Name*—Write the name.

 This can be a very interesting exploration for an actor. Sometimes the playwright has chosen a name with special meaning for a given character or characters. In David Auburn's Pulitzer Prize–winning play *Proof*, the protagonist is "Catherine," her sister's name is "Claire," and her father's name is "Robert." There is a question in the play over whether or not Catherine wrote a proof that was found after her famous mathematician father died. The name Catherine means "pure." I think it might be a clue from the playwright that Catherine did write the proof as she says she did and that she is innocent of lying. Her father's name, Robert, means "fame," which indeed her father achieved in his career, and her sister's name means "bright," which Claire certainly is; however, she doesn't possess her sister's genius.

- *Age/Maturity*—Write down the age. Write down your estimation of the character's maturity.

 You may have heard the expression, "She's thirteen going on thirty." Sometimes there is a discrepancy between a character's given age and his or her maturity. Some character's psyches are older that the given age, and some character's psyche's are younger that the given age. Is your character the same "age" as stated, or is there some value in exploring this aspect of our humanity? Sometimes in one area of our experience we are very young and in other areas rather sophisticated. In William Inge's *Bus Stop*, the character "Cherie" is very experienced in sexual terms but not very experienced in love and emotionally intimate relationships. This is the heart of her struggle. See if there aren't some ideas here for you to explore.

- *Gender/Sexuality*—This will be an issue in almost every play and often a very rich area for exploration. Is this character unique in his/her sexuality? How? In Christopher Durang's satire *Baby with the Bathwater* the playwright makes gender and sexuality one of the central points in the play. The parents had decided they wanted a girl baby, so they raised their biologically gender-specific son to be a girl, "Daisy." Needless to say, much therapy is needed for "Daisy," and one of the primary journeys in the play is the son coming to terms with his gender and sexuality. Even a character often played as gender neutral (Puck in Shakespeare's *A Midsummer Night's Dream*, for example) still requires a choice to be made and explored. For various reasons, several of Shakespeare's female characters adopt male personas. Do they do that well? Where are they stronger in this adopted identity than they are in their own gender identity? Weaker? Do they enjoy the subterfuge? Is it clear in the dialogue where they like and/or dislike playing this gender role? Get specific.

- *Social Status*—In the United States social status almost always has to do with money, but in days past there were social circles strictly governed by a very real genealogical, hierarchical system. In England and in countries with an established royalty it is very easy to see this genealogical, hierarchical system clearly. Kings and queens are at the top of the pyramid, royal princes and princesses next, then the dukes, marquises, and so on down the line. We can see in Jane Austen's novels and adaptations that it is very important to be the daughter of a gentleman, meaning your father has enough land or resources that he doesn't have to work for a living. In the United States, even though we have no established "royalty," we can easily

see in adaptations of Edith Wharton's novels, such as Scorsese's *Age of Innocence,* the social structure in New York City society at the turn of the nineteenth century. We can also see this social structure in the film *Titanic.* We see the desperation of a mother possessing a good name in the social registry pushing her daughter marry a wealthy suitor. The suitor wants her social status; the mother wants his wealth. A fair exchange, except Rose, the daughter, doesn't like being the currency.

- *Occupation/Economic Class*—Although this is closely connected with social status, there is a bit more to be mined here. In our current society there is often much weight placed on what we do for a living. A common question soon after meeting anyone is, "What do you do?" Often we rank others based on what they do for a living. Medical doctors, diplomats, judges, and CEOs are pretty high on the list. Some blue collar trades are not as respected as white collar careers, even though the financial rewards might be greater: waste disposal engineers, plumbers, real estate agents and construction contractors, for example. Create an awareness of the community within the world-of-the-play and recognize its assumptions about employment and pay. Be sure to explore a society's predispositions and the significance of those predispositions in reference to the world-of-the-play and the play's purposes.

- *Education/Intellect*—Don't confuse the two. We all know some highly educated folks who aren't very bright at all, and we know some folks who haven't made it past high school and are wicked smart. Sort out these differences. See if there's a point.

- *Political Assumptions*—There are few issues more loaded than this. The old adage, "Never talk about religion or politics," comes to mind. There is a reason we don't talk about politics: It is a hot-button issue. We may come from generations of family supporting a certain party or have had arguments within our families over issues of political controversy. Perhaps the play never mentions a character's political views, but that doesn't mean you shouldn't choose where they reside on the continuum. The choice could give you a lot of power, energy, and depth. If you think it useful, you could also try to discern what the party affiliations are for other characters in the play. We tend to make so many judgments about folks in the other parties. Could give you lots to work with.

- *Religious/Moral/Ethical Convictions*— Check to see if they are noted or discussed. A character's religious, moral, and ethical convictions might determine the political assumption in the preceding category. The play may or may not detail these issues for the character you are playing, but you, the actor, must determine this. You must know what center the character comes from in deciding his or her actions—in deciding what is right and what is wrong. Characters make choices about action based on their convictions. If a character does not base his or her decisions on convictions, that says a great deal about the person as well, doesn't it?

- *Family Tree*—Who are your parents, grandparents, and siblings, and what are those specific relationships? Mother, aunt and grandfather are names of relationships, but need to be understood within the context of the action. You can't even begin to do a play like Henley's *Crimes of the Heart* without fully exploring the family tree and the implications of those relationships. We never meet the mother of the three daughters, but we know she killed herself. If you pay attention to the dates Henley offers us, you can figure out roughly what age the daughters were when the suicide happened. That information could give you a lot to reflect on should you play one of the daughters. We likewise never meet the character "Old Granddaddy," but there

is enough said about him to formulate clear and distinct relationships among the daughters and thereby illuminate some of the actions the daughters and their cousin take. Not all plays will require the same amount of work in exploring a family tree, but to serve the plays that do demands this effort, you must be prepared to delve into it.

- *Physical Appearance*—Has the playwright commented specifically on physical appearance? Do any of the characters make reference to the appearance of another character? Does the playscript make reference to whether a character thinks she is attractive? Unattractive? Does that perception of attractiveness, or lack thereof, change during the course of the play? What does he think is a good physical feature? What might be a feature that is embarrassing? In *Cyrano de Bergerac* by Edmond Rostand, Cyrano is acutely aware his nose is huge, but no one is allowed to speak of it in his presence. In Chekov's *Uncle Vanya*, Sonya laments the fact that she is plain, and she blames her unhappiness on that fact.

 - We know that costume and makeup have a strong impact on physical appearance in some productions. This may or may not be one of those productions, but regardless, you must make choices about what physical appearance means to the character. If a physical characteristic is not explicitly mentioned in the playscript, you may have room for interpretation in this choice. You may have an opportunity to discuss with the director and costume designer your "take" on a given role and how you think the character might present herself. An example of this is found in Simon Grey's *Quartermaine's Terms*. During the course of the play the husband of the character "Anita" is sleeping with another woman. If "Anita" is costumed as a frump, then it is obvious why her husband might stray. If, however, she is the most beautiful woman in the city, then the reasons for her husband's betrayal are more complicated. Given that Anita's appearance is in no way noted in the script, which choice serves the play, or this production of the play, best? What makes you more excited to play the role? You, the director, and designer must choose.

- *Physicality/Physical Center*—This is critical to an actor's work. Does the playscript say "she is like a big, eager, cocker spaniel"? Well then you know the playwright has given you a powerful clue as to who you are and the ways in which you express yourself physically. Maggie, in Tennessee Williams's *Cat on a Hot Tin Roof*, is described by Williams as just that: a cat on a hot tin roof. What an image to work with! From the first day of rehearsal the actor playing the role should work with cat movements and images. Look for clues in the script. In Ibsen's *A Doll's House*, Torvald constantly refers to Nora, his wife, as his "little singing bird" or "squirrel" or "skylark." This is a strong clue for the actor playing Nora. In the first act, when Nora is trying to please Torvald and mold herself to behave as he wishes, she might find many moments to work with these animal expressions and images. This is a part of the dance between them sexually and psychologically; clearly this is how he prefers to see himself in relationship to her. He is dominant and enjoys the small, joyful creaturelike expressions of his "doll." Nora may attempt to execute the suggested behaviors in the second act, but might find herself under duress and not capable of performing her animal roles with him at all well or consistently. She finally discovers herself incapable of being his little bird or squirrel in the third act as she realizes that there was no real love invested in those animal games on his part.

 - Explore the notion of physical centering and images and allow them to transform you as you work in rehearsal with the other actors and with the playscript. If the images don't

seem obvious, keep working with perceptions that come to you in rehearsal or in your reflective moments of study. Find your animal! No one has to guess it, but you should know and work with this idea and the possibility of transformation through this imaginative study and practice. Does the playwright suggest that the character lead with any particular part of his or her body? Does the playwright suggest that a character has a predominant characteristic? Where is the character's energy located? In the hips? This might suggest a very awake and alive person sexually. Or, on the other hand, is the sexual energy of the character low or disconnected? How might the actor move then? Maybe lead with the forehead? This might suggest a person who is always lost in thought. Lead with their chest? This might suggest a braggart or person who thinks rather well of himself. If it is a woman, perhaps she thinks her breasts are her best asset, and she leads with that part of herself so as to identify her power base. Does the character lead with the chin? Is the character aggressive and asking for a fight? Lead with the nose? Does he think that he is better than most? Go ahead and open up to this idea using different body parts to help create the physical nature and predominant physical characteristics of the character you are playing.

2. Where am I?

• *Broad geographical area* (a continent, country, province, or city; or "The Alps" or "The Amazon," etc.) Duh. Important information, either because of how much information the playwright provides or how little. In most plays, the characters' sense of themselves—energy level, comfort, wariness and so on—is conditioned by knowing where they are in the world (or galaxy on *Battlestar Gallactica*). London, the Australian outback, Haiti, New York, or New Caprica each call up a different feel and influence a character's perception of obstacles and choice of tactics. On the other hand, in "absurdist" plays, sometimes it is important *not* to know where you are, or perhaps you don't care where you are, or you are frightened because you don't know where you are. Either way, it matters.

• *Immediate surrounding area* (a specific neighborhood or building or landmark, etc.) It never fails to surprise me that I feel so different in a specific part of a city or town. Or the very fact that I am in a city or a town as opposed to an estate or the seaside. Get unambiguous here and see what it does for your imagination. It is certainly no accident that *A Streetcar named Desire* is set in Louisiana. Not only Louisiana, but New Orleans. Not only New Orleans, but the French Quarter. And the trolley used to arrive at this destination is the streetcar named Desire. It all makes a very rich tapestry that we are either drawn toward or repelled by. Why are you comfortable? Why uncomfortable? Rich details to work with.

• *Exact location of action* (interior, exterior? Corner of the room or Corner of 23rd and 9th, etc.) Continuing with Tennessee Williams's *Streetcar Named Desire*, we find ourselves in an apartment, a one-bedroom apartment on the ground floor in the French Quarter. The apartment is not upscale; people of wealth do not live here. It is a bit shabby but cozy. Stanley and Stella live there and find it homey, comfortable, and comforting. From the point of view of the visiting Blanche, clinging to the lost gentility of Belle Reve, the apartment is shabby and coarse. The lack of privacy unnerves her, and she finds it difficult to feel in any way at home there.

• *What objects surround me?* In any setting there are questions to ask. What has the playwright insisted must be present? What is immediately available to you as an actor in this space?

A table? A bed? A place to put your things? Is the table dirty? Does it smell funny to you? Smell is fun to work with. The weather is hot and sticky. Do you feel suffocated in this hot, small, stifling space? Use everything around you. If you live there it is intimate; you can be relieved to be safe again, you can wish you had tidied up, you can wonder why no one else did. Lots of reactions. If we are walking into an unfamiliar place it can really make an impression. Great opportunity. Have we always wanted to see this person's home? Never wanted to come here? We rarely go into anyone's home without an attitude or judgment. We're human. We have color preferences, clutter tolerances, and much, much more. Characters in plays also react and form attitudes. It is good to have a reaction to a place! You don't need to "indicate" this, but it is part of what makes the atmosphere onstage rich and alive! Even if you are working on a bare stage, the *character* is in a location and has a reaction to the location, whether the audience can see the location or not. The character's response to the location is the part of the story the audience wants to see!

3. **What time is it?**

- *Time period*—Certainly we need to know this to know the world in which we live. We need to know if we are in the France of Louis XIV or in the Great Britain of Maggie Thatcher. Study and understand your world. In Caryl Churchill's play *Top Girls*, it would be next to impossible to understand the play, characters, and purposes if you were not clear in your study of the political struggles in Britain in the late 1970s. We would be at a loss to understand the rights of women, or the lack thereof, if we did not study European Victorianism in Norway in 1879, the year that Ibsen wrote and set *A Doll's House*. You would need to study the period in depth to understand how Nora could stay in the marriage as long as she did, as well as to justify Torvald's behavior to Nora during the course of the action. The time period in which the playwright has set the play is of extreme importance in understanding the play's meaning, purpose, and context.

- *Year*—Yes, this goes with the above, but 1944 is quite different from 1945 in England. In 1944 the British were battling for their very lives. In late 1945 the war had ended and the rebuilding begun. So, yes, World War II in England, but that isn't close enough. Think of the United States and the difference in our country and the context in which the world was experienced between 2001 and 2002. Get specific.

- *Season*— The playwright set the play in a certain season for specific dramatic reasons, which can be a gift to your imagination and genius. A crisp fall day affects us differently than a muggy hot summer day. Is it so muggy and hot you have to move slowly? Is it so chilly you walk fast but stiffly? This is a very fruitful exploration—we are all affected by the weather, some of us more strongly than others. Remember that seasons are different in different parts of the world at different times of year. Supported by the text, bring these choices regarding your senses into rehearsal.

- *Month, day*—November 21 in the United States of 1963 is quite a different time than November 23 of that same year. President John F. Kennedy was assassinated on the 22nd of November, 1963. A play may have little to do with the assassination specifically. Characters may have no dialogue that even mentions it. But if a playwright places her characters in that time frame, she means to play on the audience's personal associations with those days. As an actor, you must incorporate associations for the character that are specific to the dramatic needs of the scene.

- *Time of day*—Again, if it is important to the playwright it is important to you. If she says early morning what does that mean to *you*? *What mig*ht it mean to the play? Is it a symbol? How do you make it a reality? I*s this* character a morning person? Not? Regardless of what *you* are, you must adapt to the *playwright's* vision. If *you* can't stand early morning yourself, then you must work *as if* it is your favorite time of day to gain the right energy and perspective on the action if that is what the play requires.

- *Time on the clock*—Is it mentioned? Then it's important. If you are playing an anal retentive person, they are nearly always a clock watcher for themselves and everyone else! Do you think the playwright has made a choice about this? If you are not a clock watcher, then how do you perceive time? Very fluid? Are you surprised by how fast time moves or how slowly? If you are about to be late for an appointment the time matters a great deal. If you are waiting for your lover, then time matters a great deal. Sometimes the exact hour and minute on the clock matter for a character, and sometimes they don't. Be aware. Make a choice!

4. Who am I with?

- *Factual details of relationship with the others, including the web of relationships.*

 What are the respective ages of the characters? Does that affect the relationship? Are you related? In what way? If not, how long ago did you meet? Where? Has your relationship changed since first you met? What changed it? Do you respect this person? Are you jealous of this person? Does the playwright lay any of this out? What? Note every fact or point of view the playwright has given you on each relationship you have in the play. In *Proof*, Catherine believes that her sister didn't do her share of the work in taking care of their father. Claire, her sister, thinks that Catherine has some mental instability. The playwright is clear about both positions. Are they both right? Figure out the relationships. Look for the tensions and conflicts. That is the stuff of good theatre.

5. What has already happened?

- *Previous action or backstory*: Significant events in the long ago past, recent past, and the moment before? Where am I coming from? Write them down in chronological order as the playwright has laid them out. Create a timeline. What is most significant in past events? How do they connect to the actions of the character you are playing? Which ones are most useful to you?

6. What do I want?

- *Superobjective for the play*? Overall life objective for the period of time in which the play takes place. "I must avenge my father's murder" might be Hamlet's superobjective in Hamlet.

- *Key objective in this scene*? In the scene where Hamlet is having the players perform *The Murder of Gandalgo* or *The Mousetrap* for Claudius he is determining whether or not his uncle is guilty of the murder of his father. " I will "pressure my uncle into admitting he murdered my father."

- *Immediate objectives, beat by beat*? In the brief scene with Horatio after the play has been stopped by Claudius, Hamlet's objective could be to "force Horatio to corroborate what I

saw." Hamlet wants to check his own responses before he takes his next action. The actor could also choose to "make Horatio celebrate with me" after having forced the guilty reaction out of his uncle. There is tolerance here for either choice, so long as you are serving the script and the rest of your actions are consistent with the choice.

7. **What do I want it for?**

• *What am I fighting for? What's at stake?* Consequences of not getting it? Hamlet's might be, "If I don't avenge my father's death, then I can no longer continue my life, as I will have shamed him and myself."

• *What would that be like for me?* It would be *as if* . . . I watched a loved one die and did nothing to help him.

8. **What is in my way?** (These, of course, must be specific *moment by moment.* The internal obstacles are supplied by your analysis of the scene and your own imagination. The external obstacles are given to you by the other actor/character in the scene. Here is a list of distinct, supportable possibilities.)

• *Internal obstacles* In *Hamlet,* Hamlet's internal obstacles at various times during the course of the action include doubt, conscience, fear, shame, superstition, his love of his mother, and the idea of hurting Ophelia among others.

• *External obstacles?* External obstacles can be very simple. Ophelia won't meet my eyes. Claudius won't let go of my arm. These are easy obstacles to experience and process. You can do something very physical about them immediately: You can shrug off Claudius's grip or wrest your arm away from his grasp. You can grab Ophelia's face and force her to look at you. Other external obstacles are more subtle. Horatio doesn't want to admit he saw Claudius's face turn white during the play. Ophelia is hiding something. My mother is afraid. Horatio can't smile at me. These kinds of external obstacles are more difficult to pinpoint and experience; therefore, you must be very clear about exactly what you want to recognize as obstacles to your desire.

* In addition

If the playwright has not addressed a character's *use of space, posture, tempo/rhythm of movement,* or *tempo/rhythm of speech,* you need to consider these aspects of the circumstances/context and gather any clues you can to make choices that support the playscript and the playwright's intent.

• *Use of Space*—Start becoming aware of the textual clues to how your character and others in the play use space. Exploring the character's use of space can be very instructive as well as a lot of fun. As a general rule men use up more space than women. Some business executive pundits have concluded that to gain the respect of men, businesswomen have to take up more physical space at meetings—perhaps putting an arm across a chair, claim more physical turf at the table with their notepads, pens, gadgets etc. Notice how different people you see during the day use space. Get specific in your observations of the situations in which they use a lot of space and the ones in which they don't. Maybe they don't use much space at work but use lots at home, or the other way around? Perhaps they consciously or subconsciously maximize or minimize the space they use around only certain people. What about you? How do you use space? How does the character you are playing

use space? How does your character react to the use of space by others? Does she get annoyed when someone puts his books too close to where her books are on a table? Leaves his things around the room? So many fun things to explore and think about!

- *Posture*—Oh so important. You'd better have your *own* posture under control before you presume to take on a character's posture. If every character we play has our posture, we aren't really making choices, though most choices don't have to be as huge as those required of an actor taking on the title role in *The Elephant Man,* who must twist his body into an extreme contortion mandated by the playwright. Usually the demands of most plays are more subtle. In Henley's' *Crimes of the Heart,* which we mentioned before, Meg, the middle sister, certainly sees her most valuable asset as her physical attractiveness and would probably move and pose with a confident sexuality. Lenny, the oldest sister, is described by Babe, the youngest, as getting more and more like Old Grandmamma. She might move a bit more slowly in relation to the other sisters and perhaps be out of alignment in some way. She certainly can't parade around proud and completely erect. The lawyer hired to represent Babe is Barnette Lloyd. He states that he went away to boarding school and then went on to Old Miss and then Harvard. We might assume that if Barnette went to boarding school in the South in the late sixties that he went to a military boarding school and that his posture should be perfect. None of these choices are givens, but they are plausibly implied in the text and contribute to the specific playing of character action. Your own posture might be fine for the role, but don't take the path of least resistance. Ask the question.

- *Tempo/Rhythm of Movement*—This is one of the most difficult things for an actor to adjust for a character. Does the playwright mention the physical tempo of the character? Many of us have our own very specific tempos and feel very off center and false when we make an adjustment to a differing tempo. Some characters are birdlike and flit about, and other characters are like bears and lumber about. We must be sensitive to the patterns of rhythm and tempo in a play and our character's part in them. It is essential to ensure you are specific and clear in your work physically. If you have difficulty moving well in your life outside rehearsal, you will probably have difficulty moving with ease in rehearsal. The exception makes the rule, of course, but if you realize that you do need to become more flexible, centered, and graceful, get yourself into a yoga class, dance class, or fencing class. Some actors are gifted in movement; others are not. If you are in doubt, watch yourself on tape or ask a trusted mentor what they think you need to work on. Sign up for a class.

- *Tempo/Rhythm of Speech*—Again, this can be tough for actors to switch up. If you normally speak quickly it may be difficult to speak slowly and feel any sense of truth. It may be more difficult to find shifts in rhythm that are not naturally your own. If you always speak in a monotone it may be difficult to use variety in pitch. It just takes work, even if you are gifted with a great deal of sensitivity and flexibility in your vocal work. If you are not naturally gifted with vocal freedom and sensitivity, you need to get into a voice or oral interpretation class, read out loud every day, and make this work a part of your daily actor practice. You also need a sensitivity, either conscious or intuitive, to what the actors/characters around you are doing vocally. Never pick up the tempos of the actors around you! It is crucial to hold on to each character's distinct tempo. If we are not sensitive to the vocal patterns around us, we will end up in productions where the entire play is at one tempo/rhythm vocally. Can you imagine a symphony on one note and one tempo? Even with a variety of instruments, we would be hard pressed to listen for more than about a minute! Pay attention!

Metaphor Games—complete this list and add to it if you like!

What kind of animal am I? What kind of fruit am I? What kind of instrument am I?
What kind of color am I? What kind of pitch am I? What kind of body part am I?
What kind of center am I? What kind of space am I? What kind of touch am I?
What kind of main course am I? What kind of dessert am I? What kind of drink am I?
What kind of landscape am I? What painter am I? What natural force am I?
What wave am I? What shoe am I? What kind of house am I? What kind of lawn am I?
What kind of furniture am I? What kind of walk am I? What mineral am I?
What herb am I? What flower am I? What pattern am I?
What kind, body, pool of water am I? What geography am I? A mountain? Hill? Valley? Crevasse? Ravine? Plateau? etc. What flavor am I? What texture am I? What book am I? What kind of paper am I? What kind of teacher would I become? What voltage am I?
What university/college am I? What kind of novel am I? What kind of present am I?
What kind of bird am I? What kind of computer am I? What tree am I? What lightbulb am I?

Summary

In this chapter we have examined how the actor might read the playscript after the initial readings for story, plot, and action. We have explored how subsequent readings could allow for us to dig deeper into the work and how we might proceed with that kind of work. This is not meant to stifle our intuition but to wake our imaginations up in service to the playscript at hand. We have established that this is the actor's homework and that this is an integral part of an actor's work.

The Actor's Toolkit—The Essential Tools and How to Use Them

Marc Masterson of South Coast Rep says this about actors:

> *I like actors who fight like hell to find the path out when they get stuck. That can actually lead to great things; the struggle to be good and the struggle to be honest with yourself and not to accept faking it, which is easy to do—to know your own limits and then to go beyond them.*

I find this observation by Marc Masterson incredibly reassuring in that this director, who has directed over 200 or more plays in the past 30 years, *sees actors get stuck.* It isn't just *you!* This director doesn't despair over an actor getting stuck. He doesn't throw up his hands and say "Well, that's that!" Masterson likes to see actors work hard to find their way into the work and believes that struggle can lead to great things. Inevitably, the way back is action, either finding stronger action or creating a more compelling context for the actions we've chosen. Action is where we start and where we return when we get stuck.

Actors create and contextualize action using many different tools to work effectively throughout a rehearsal and performance process. Much as a carpenter might look at a toolkit and select a given tool for a specific purpose in building a cabinet, so an actor looks over the tools available and selects a tool for a specific purpose in building a role. Not all roles require all the tools to the same extent, but it is good to know where to find them and be reminded that you do have a wrench, saw, crowbar, hammer, nails, and the like, only actors call their tools subtext, expectations, discoveries, personalizations, public solitude, and so on. Some tools will seem familiar because you use them all the time; others you might only use in certain kinds of roles, when you find yourself stuck or the work seems stale. Pick them up if you haven't used them and give them a try. See what works best for you.

Actor Toolkit

Method of Physical Actions

Stanislavsky came up with "the method of physical actions" as a consistent and reliable way for actors to engage in truthful, emotionally full behavior onstage without having to depend on inspiration, chance, or the whim of their moods from performance to performance. He understood that if you slammed a book down on a table as you were speaking to another actor/character that action alone could change the way you experienced the other and yourself in that moment. If you repeated the action more or less the same way every night, you could count on those same energies to manifest between you and the other onstage with you. Just as important as overtly physical action, the same principle holds true from performance to performance for the manner in which you consistently give vocal energy to the same operative words in a dialogue.

These physical movements and physical approaches to empowering lines with actions can be discovered spontaneously in rehearsal or while studying the script and then tried out in rehearsal.

Use the give-and-take of the process to create a physical/vocal score of your journey through the entire play. Persist in searching for the next vertebrae in your spine of physical action, and fill it with spirit and will.

The method of physical actions gives you, the actor, some control over mood, emotion, and the daily ups and downs of inspiration, illness, life crises and the like. It allows you to trust the work you have done to guide you through your performances instead of hoping the "muses" show up. If you commit your energy and attention to playing the physical/vocal score of actions throughout the performance you will find, without having to over intellectualize, that you are opening yourself to genuine, in the moment, physical/spiritual interaction with the other and moving through the play with *inspiration. Invite* the muses with your hard *work.*

Traits and Touching Points

I think this may be one of the most difficult concepts for the young actor to comprehend. Many ask, "How can I be spontaneous, truthful, in the moment, trust myself in the work, and then be told that that isn't necessarily serving the play?" Well, the answer to that question is that you may not share all the same traits as the character you are playing, therefore *your* gut response to a moment may not be what the *play* needs at that moment. It may be true for you and *your* given circumstances in *your* life, but perhaps not the *play's* given circumstances and call to action at that particular moment. Say the character you are playing cries at spiders being killed, but in your own life you gleefully smash them. You are going to have to sensitize yourself to this different perception of the world. On the other hand, where you are similar to your character, say you both just scream at spiders, then you have a *touching point* and can trust your intuitive responses to serve the needs of the play at that moment.

Here's an example. In a production I directed of Beth Henley's *Crimes of the Heart,* there is a moment in Act I where one sister, Meg, is trying to get her younger sister, Babe, to open up and tell her why Babe shot her (Babe's) husband. It is a moment in the play when the audience needs to have compassion for Babe. The audience has just discovered, along with Meg, that Babe had been beaten by her husband. In this production, because the actor playing Babe was actually a very strong person and her relationship with the actor playing Meg was not a warm one, early in rehearsals, in response to this plea from her sister, she gave "Meg" an unkind, quizzical look and a curt reply. Although this was an honest gut reaction on the part of the actor playing Babe, this self-possessed, cold response to her sister would have undermined the audience's belief that Babe had allowed herself to be beaten by her husband for years without breathing a word of it to anyone. On the contrary, this Babe would have seemed fully capable of establishing boundaries and clearly wouldn't have taken anyone's crap! So, even though the actor was saying the right lines and being true to her own instinctive relationships, she was not serving the play at that moment.

To help realign her through-line of actions to support the dramatic action, "Babe" made two lists: on one were all the *traits* she and the character shared in common; on the other were the places their respective given circumstances differed. Simple awareness of the *non-touching points* between her and the character she was playing was all it took to support truthful adjustments in her reactions to "Meg." Try this simple exercise the next time you feel out of sync with the part you are playing.

Another useful tool to help you with this kind of awareness is the Meyers Briggs Type Indicator (MBTI) test. Based on the theories of Carl Gustav Jung in his book *Psychological Texts* (Jung, [1921] 1971), this questionnaire is used to measure psychological preferences in how people experience the world and make decisions.

Once when directing a summer stock production and working very quickly, I asked the cast to fill out two of these questionnaires, one for themselves and one for the character they were playing. The actor playing the lead realized that according to the Myers-Briggs profiles he and the character he was playing were exact opposites in all the areas that mattered for the play. He ended up doing a wonderful job but had a lot of work to do: first, to identify what instincts of his own he could trust to serve the play, and second, to find and nurture emotional/psychological equivalents to substitute for the instincts and qualities where he and the character had no touching points. (More on this when we discuss *personalization*.) Just because you are not a perfect match doesn't mean that you cannot play the role assigned. It might be a trifle more challenging, but also more exciting as well. We're actors. That's what we do. It's also why typecasting is not antithetical to good theatre. (More on that in Chapter 9.)

Personalization/Substitution

Plays (and films and TV), if they are worth one's time, tell stories that ensnare their characters in the most extreme situations and circumstances facing insurmountable obstacles to their impossible goals with the direst consequences for failure. *Oedipus Rex* by Sophocles and the movie *Sophie's Choice* come to mind. It's highly unlikely that many actors have led such large and heroic lives that they have a majority of immediately accessible touching points in common with most characters. The techniques of personalization and substitution are key in helping an actor bridge the gap between his or her world and the world-of-the-play.

Personalization is the process of contextualizing a particular moment, situation, relationship, or dilemma in the script by using your own life experience to understand it. Just about every actor does some version of this as a matter of course, but may not necessarily have a name for the process. Certain aspects of this work, for example, affective or sense memory have been associated with the worst excesses of "The Method," where actors recall memories of past traumatic events for direct use on stage. Not so here. Personalization for Stanislavski, or what he came to call substitution, uses our own past experiences to contextualize a difficult given circumstance of relationship or identity, for example. We use personalization to make those circumstances, relationships, or identities specifically evocative for us, specifically connected and grounded to something authentically alive and true in us.

Personalizations do not necessarily lend themselves to nobility of character in ourselves or the characters we play. As with objectives, expectations, and assumptions, the more personalizations arise from those places in our souls and psyches that are petty, jealous, grasping, fearful, and ego-protecting the more effective they are as an acting tool! Perhaps this work sounds distasteful. The ironic fact is that it is often the smallest parts of us that drive the largest ambitions and accomplish the most. Much in the history of our civilization bears out the truth of that fact. So, generally don't look into yourself for the halo, unless you are playing Joan of Arc. No, wait a minute, not even then! She wanted God to love her most and best and treated everyone else as a sibling in this rivalry. (Only children might not be able to find a touching point there.) She didn't want to let a parent (God) down because she couldn't face him if she

had. We as children, however complex our family circumstances, understand this and can use it to contextualize. When did you let a parent down? How badly did it hurt them? What was the nature of your shame? Did you get caught? What was your punishment? What would you do to avoid it again? An actor must feel free to access and use these private, hidden places in service to the greater good of the play, especially when playing a saint! There are many ways to get specific; this is one. It will fill you onstage so that every moment is bursting and you have no space to worry about how you are doing or if the audience likes it or if they think you are a fraud. Just do the work.

I like to think about doing this work until I "grok" the situation. This term comes from Robert Heinlein's *Stranger in a Strange Land*, a science fiction novel written in 1961. However dated, he used this term for lovemaking, but lovemaking on an essential spiritual and intellectual level as well as the physical. Kind of like lovemaking in addition to a type of spiritual Vulcan mind meld. A complete knowing of another. I like to grok the circumstances so well by the time the production previews that I am not thinking about it anymore; I simply move out from this knowing. The given circumstances are not simply memorized, they are living and have a source inside me, albeit an imaginary source, but one I have made full and three dimensional to myself.

Magic If

What if I were in Hamlet's situation? What would I do? Again, this is a prompt for your imagination and yet another way to get a resident visa to the world-of-the-play, rather than remaining a foreign tourist. Stanislavski, in his search for the best acting we are capable of, found that the "magic if" was a means of understanding what propels a character into action. If you are cast as Hamlet, the following question/response is part of your homework: What would it be like *for me* if my dad died while I was away at school and my mom got engaged to his younger brother, my uncle, before I even got back home? It would be *as if....* This is a very difficult "as if" to work with. It takes time to center down and go to the places an actor needs to go to if the actor wants to imaginatively and deeply explore action and relationship. If you are playing Iago in *Othello* and you use the "magic if," you must ask yourself, "Who do I think deserves to die? Who am I willing to destroy? What does it feel like to kill?" *For me it feels as if....* Grotesque as it may appear, good actors, on some level, get satisfaction from this kind of work! You must, again, on some level, enjoy imagining these situations and yourself inside them.

I've always associated this technique with spelunking. Spelunking is a term used to describe caving or exploring caves. Spelunking can involve a very complicated entrance into a cave via descending ropes and pulleys or it can be as simple as getting good hiking boots and walking into the cave. It is potentially dangerous. You must go to dark places with little light and explore the unknown. Finding your relationship to the "magic if" of a circumstance in a playscript is like spelunking in your imagination. You must make time for it. It's like exercise. Just do it. You must bring the work inside you. You must contextualize the given circumstances with the "magic if."

Listening with Objective

As important as it is to discover and phrase a strong, playable objective, you must genuinely, actively listen to the other actor with the objective in mind if it is become more than an intellectual idea and truly animate the interaction between you. To listen with objective is to really

want your goal from the other person and gauge whether or not you are getting warmer or colder, closer to or farther away from your objective. Some actors hammer away at a tactic so determinedly that they don't allow the other person into their consciousness. They are always on "send" and never on "receive." You must receive with objective. You must listen and look. Are you closer? If you don't know, how do you get to the next moment?

This is a bit reductive, but look at each moment in the play with the idea that you are giving and taking in different moments. Of course, you are always doing both, but it is valuable to check out that process and those possibilities. What do you receive? What do you take? What do you give back? What do you give that is not received by another? Do you try again? Do you do something else to make them receive it? What do you refuse to take from another? Just notice.

Expectations

This idea is really just another aspect of listening with objective. We do have expectations. When we come home from a day at school or work, we have expectations of each of our apartment mates or family members. When we wake up in the morning and walk into the kitchen, we have expectations of everyone we live with. Did someone leave a dirty bowl in the sink again? Did they wash it and put it away? Is this good news or bad news to you? Well, that depends on what you want from this other person and what you expect to get. It's the same with characters in plays.

The fact is we mostly expect, or at least hope, to succeed in our actions (as do dramatic characters) because the consequences of failure are unappealing to us. Conceive your objectives as expectations of success in solving the problem that plagues your character. Imagine specifically what that success looks and sounds like. We must know what we *expect* to happen to understand our reactions to, or perceptions of, the behavior of the other actor/character reacting to us. In our real lives we don't know what comes next, so our reaction is genuine, or at least spontaneous. Listening with an active expectation of succeeding in your objective is the best way to invite that spontaneity on stage. In fact, go so far as to expect and really listen for the exact opposite of the reaction you're going to get. Allow surprise and shock.

The end of *Romeo and Juliet* falls a little flat if Juliet wakes up in the tomb already expecting to find Romeo dead beside her. Ho hum. Just another day in fair Verona.

Assumptions

Okay, these are similar to expectations but they are less admirable Truly mentally healthy folks don't "assume" (because it makes an "ass" out of "u" and "me"); still, we find ourselves making bald-faced assumptions all the time. Listen to talk radio. A Republican might assume that liberals are bleeding heart, lazy, dependent, fiscally unrealistic, commie loving, godless drinkers at the public trough. A Democrat might assume that conservatives are war for profit, cheat the little guy, self-serving, gun-happy, equivocating, Dirty Harry worshipping owners of the public trough. Both sets of assumptions are untrue, but that doesn't stop us from making them and repeating them on TV. It is not admirable, but most often neither are the characters we play, even the good guys, who are in crisis and under stress (even more than you and I, hard to believe) and are not altogether mentally or emotionally healthy and well balanced. Consequently, assumptions are very useful in helping actors create strong objectives.

We also make assumptions about individuals. Perhaps we assume our boss likes us till one day we walk into his office and he is cold. We might assume everyone does their job, and we come to find that folks are not doing their jobs as described. We could assume everyone cheats the Internal Revenue Service only to find out that most folks are squeaky clean. We assume that the boss is going to give us a raise and she fires us. We assume our mother will be happy about her birthday present, and she won't even mention it or meet our eyes.

What are the assumptions your character makes in this playscript? In Henley's *Crimes of the Heart,* Meg assumes that her cousin Chick will not be happy to see her, and her assumption is right. Chick assumes she can guilt Lenny into making half the phone calls about old grand-daddy, and she is right. She has to fight for it, but she wins. She later assumes that she can put Meg down in Lenny's presence, but she is wrong. Listening with strong assumptions can fuel powerful objectives because even the most innocent have their roots in pettiness and prejudice. Good things when setting up the conditions for drama and, especially, comedy!

Subtext

We use subtext every day. We experience others using subtext every day. Subtext is simply the underlying meaning to any words we say to another person or persons. The line in the script might be, "How are you?" The tone and quality of voice color the words to evoke a variety of meanings:

How are you? *Good to see you!*

How are you? *Where were you last night?*

How are you? *You don't look so good.*

How are you? *Can I help?*

How are you? *Have we met?*

How are you? *Why haven't you answered my calls?*

How are you? *Do you remember what you did last night?*

How are you? *I've been so worried.*

How are you? *I love you.*

How are you? *Are you hurt?*

How are you? *What happened?*

How are you? *How long has it been?*

Not only do we furnish subtext to others, but we also sense the subtext of others as well, or we think we do! Sometimes we are predisposed (see expectation and assumption) to hear a given person in a particular way. They might say, "How are you?" and genuinely care for our well-being, but we might hear them as merely being polite or, in fact, mocking us. So noting *how* we hear the subtext from the other is important, too. It will affect the *causal response* given to the *causal prompt* in the line or action. The "truth" as each character sees it from their own point of view is the source of much of the conflict in the play.

Operative words carry the gist of the meaning or sense that a line hangs on and are powerful communicators of subtext. The meaning conveyed depends on which words get the emphasis.

Say the following lines out loud to yourself or a partner giving emphasis to the words in all caps. Describe or write down the specific meaning that each reading conveyed.

WHY don't you tell your friend you have company?

Why DON'T you tell your friend you have company?

Why don't YOU tell your friend you have company?

Why don't you TELL your friend you have company?

Why don't you tell YOUR friend you have company?

Why don't you tell your FRIEND you have company?

Why don't you tell your friend YOU have company?

Why don't you tell your friend you HAVE company?

Why don't you tell your friend you have COMPANY?

Do you sense a marked difference in the subtextual meaning with each new emphasis?

Try each line again and use a different quality of voice to supply the emphasis. Try word stress, tone, inflection, lilt, duration of sound, pitch, loudness, softness, and so on. Do you find even more nuanced variations of meaning in this speaking? Working on operative words in this way will refine subtext, specify objective, and clarify sense, especially in plays with dense and/or complex language.

Sometimes you might receive line readings from a director, and you have to work backward to find the subtext and action she is looking for. "Oh, she wants *this* subtext," and go from there. Try to leave the "line reading" and get right to the change in the subtext of the line, or you'll never get the director out of your head!

Unspoken Truth

This is a given circumstance, often within the history of significant relationships, which informs a character's entire journey throughout the play. The character may not be aware she feels this way. It is not necessarily conscious, but in fact deeply buried or denied. As the old saying goes, "the actor must know; the character must not."

In Anton Chekov's *The Seagull,* the character of Arcadina, an actress, protests that she loves her son Kostya, when in fact she is incapable of loving anyone but herself, a fact she is either unaware of or in denial about. Although it is never spoken outright in the play, the knowledge of this truth must inform the actor's choices at every moment of the play. Even as Arkadina cares for his head wound, a failed attempt at suicide, she is really reveling in the performance of her *role* of "mother" and not experiencing empathy for Kostya at all. Another example: In the play *Summer and Smoke* by Tennessee Williams, Alma Winemiller has sexual feelings for John Buchanan, but she is unwilling, perhaps unable, to acknowledge these feelings even to herself until the end of the play. However the feelings are there from the very first moment of the play. The actor must internalize this unspoken truth so that John's presence, scent, body movements, and tone of voice become increasingly tortuous obstacles to her as the play moves forward. Understanding the unspoken truth of Alma's attraction to the character, John, should prompt the actor playing Alma to start sensitizing herself early in rehearsal to these sensual triggers from the actor playing John.

Conscious/Subconscious

We have touched on this a couple of times, but let's make it clear here. We the actors always know more than the character we are playing. It is not always necessary or desirable for a character to be conscious of everything that they want and/or how much they want it. In Ibsen's *A Doll's House*, Nora knows that she wants Torvald someday to guess her secret (she calls it the "wonderful thing"), to respect her, and thank her for saving his life. What she does not know about herself is that she will leave him should that not happen, should she discover the "miracle" won't occur and that he has never respected her. The actor knows; the character must not.

Earlier we examined Tennessee Williams's Alma in *Summer and Smoke*; she is not conscious of her physical desire for John. If she were aware and executed her actions with that knowledge, she would be quite unlikable, and we would distrust her as Williams's protagonist. It was not the playwright's, Williams's intent that she know her desire until the end of the play; her discovery of her desire is the climax of the play. Indeed, playwrights routinely have characters, consciously or not, lie to themselves and others about their true motivations and intentions until the unspoken truth is *forced* out during an obligatory confrontation at the major crisis of the plot, leading to the climax and resolution of the action.

This is an enormously difficult challenge for an actor: finding a through-line of action that you can play through the plot, for all intents and purposes pursuing the character's wants while "unconsciously/subconsciously" possessing a *true objective* that runs counter to the character's outward behavior. Probably the most effective technique for using an unspoken truth to create high stakes without acknowledging or otherwise "playing" the tension (which can quickly tip over into indicating) is to find an objective that urgently attempts to accomplish the opposite of the buried want. In the case of *Summer and Smoke,* the actor playing Alma can consciously and vigorously play to "*force John to live up to his potential*," which works for both the conscious and subconscious aspects of her character. It is natural to fight for those we care for *to live up to their potential.* Alma knows she cares for John as a potential force for good in her world; the energy of her suppressed sexual longing fuels the urgency with which she justifies the passion of her friendship. "Alma" must also have set herself up imaginatively and through personalization of the character's subconscious desires for "John" to respond sensually to the actor playing John. When he is close she feels the heat from his body or his breath on her neck. Is that uncomfortable for Alma? Does she need her handkerchief? Fan? She can find herself looking at the actor playing John and finding, to her, his most attractive qualities. The line of his nose might seem noble and aristocratic. He might press his handkerchief on his upper lip, and that might appeal to her sense of good manners and draw her attention to his lips. Those things can serve to stimulate the actor playing Alma into an awareness of John physically. An ability to be become responsive to what the actor playing John is doing without forcing a conscious knowledge until Williams forces her realization that she is not hungry for spiritual love alone. We as the actors need not be afraid of this subconscious versus conscious knowledge. Experiment and play with how you might best find ways to work through this while giving your all to the pursuance of the conscious objective at hand.

Justifications/Character Advocacy

We must always be on our character's side. If we are playing Regan or Goneril in *King Lear,* we cannot play that we enjoy ingratitude or love being evil; we have to work along the lines that we deserve better than this and we are going to finally get it, with or without our spoiled sister, Cordelia. We

would have to work on the evidence that the King always loved our little sister best and that it still has the power to make us jealous and impel us to get what we want.

If we are the actor playing Claudius in Hamlet, we would not focus on how horrible we were to kill our brother and marry our sister-in-law; we would focus on how our brother nearly lost Denmark because he did not know how to deal with Fortinbras. We would focus on our long hidden lust for our sister-in-law, who by rights should have been ours to begin with had our brother not been heir to the throne. We need to give ourselves reasons to have taken the actions we have taken and to justify those actions. No one believes he or she is acting against their own self-interest!

Polar Attitudes/Polarities

This is the difference between your character's view of the world at the beginning of the action and your character's view of the world at the end of the action of the play. Not every character you play has a different view of the world at the end of the play versus the beginning of the play, but you would be remiss not to ask the question. This question will be one of many methods you can use in determining the arc of your character, in determining the transformation of your character during the course of the play.

Jocasta's Polar Attitudes

One of the clearest examples is found in Sophocles' *Oedipus the King*. At the start of the action Oedipus has just heard an oracle that disturbs him. Jocasta, Oedipus's wife and Queen, tries to comfort Oedipus by telling him that oracles have no power and are not to be trusted. She proves this to him relating that a long ago oracle foretold that her infant son would kill his father, her former husband and King, Laius. She derides the oracle for two reasons; one, because her son died as an infant after Laius had his ankles pierced and pinned together and then had him cast away on a mountainside, and two, because her late husband was killed by highwaymen, by bandits, five of them, and none of them native to Thebes. This is her belief at the start of the play. However, we discover during the course of the action that indeed Oedipus is her son; he had not died as an infant and that he had indeed killed his father, her late husband Laius; the witness to the murder had lied and said it was a band of robbers. At the end of the play Jocasta believes in the oracles. Her polar attitudes have changed. Were you working on the *arc* of her character, you might start the arc at the moment she first states her opinion of the oracle and then track her growing suspicions as they mount and lead us to her ultimate discovery that all she has come to fear is verified.

Transitions/Shifts

How we move from beat to beat or moment to moment or objective to objective involves what has come to be called a transition or shift. It is a transition or shift in the action, or in the course of the action. This may be the moment where we give up the objective of *getting him to prove he loves me* and shift to *convince him I'm worth this work*. Why that shift? Why now? How do we get from one to the other? There are an infinite variety of ways to move from one action to the next. We could try picking up the dinner dishes. Getting up from the couch. Folding laundry at a faster pace. Pouring a drink. Pouring out a drink. Walking out of a room and walking right back in. Putting on hand cream. Cleaning our eyeglasses. Turning off the television or radio.

Turning them on. Crossing your arms. Uncrossing your legs. Making a cup of coffee. Take a bit of an apple. Lean on a counter. Or just moving on with the scene with a different energy, tempo, vocal change, or focus change. You get the idea. There is no right way. It may be a conscious choice or an unconscious choice on the character's part. Try it both as conscious and unconscious. Deliberate or intuitive. Try to flesh out the most apt choices for this production, given the text, actor(s) you are working with, director, set, costumes, and props. The worst thing you can do here is to take a pause. You only get a few per show. Save them for the big discoveries or the big transitions. Using the pause for all transitions is a huge mark of an amateur. Not creative. Too easy. Very boring. Keep exploring.

Discoveries

Oh, this is the most fun! And a mark of good technique. Go through the script and determine any information your character has not known previous to the start of the action and discovers during the course of the action. Or perhaps the character knew certain information but had not put it together with other thoughts and come up with a new idea or context. In Henley's *Crimes of the Heart,* it is a huge discovery when Meg finds out that her sister has been beaten by her senator husband for years. In Shakespeare's *As You Like It,* Rosalind discovers that her love, Orlando, is in the forest and composing rhymes to her; she is flabbergasted and over the moon. These are very prominent and obvious discoveries in a script, and much should be made of them. Some discoveries are much smaller in contrast but are just as exciting for the richness they bring to a production and performance.

Not all discoveries are textual, although they must be supported by the text. In any given moment in a play we can certainly learn something about ourselves, another, or situation. Naturally it must be in line with the playwright's intention, but given that, is it by the expression on another's face that we discover they are in love with us? Perhaps we had suspected, but now we know? Is it the tone of voice a boss uses with us that prompts us to think we might get fired that day? We have to respond in the moment and make those realizations as we progress through rehearsal and performance. We are text driven in many cases, but we also need to know how to *set up the truth of that text/action and not simply let the words do it for us.* The discoveries we make need to take us to a new place and not leave us where they found us.

Builds

A good playwright writes these into the work so that you know how to craft your work based on the playwright's construction. One actor will "top" the other actor in her attempt to win the point. Topping can mean getting louder than the other actor on the following line, getting more intense than the other actor on the following line, or in some way raising the stakes to win the point. We've all heard that kind of escalating exchange, if not been a part of one, at some point in our lives. We have to earn this, but remember, most plays happen on the most important day or days of a character's life. Most characters cannot wait to get out of the play! Even with a happy ending, there is conflict, uncertainty, and strife. Topping and building can mean a variety of things, but the energy must increase with each progressive line until you reach the top of the build. Someone wins or loses, and a new beat begins with a new tactic and/or a new objective. This is used for comic effect in plays such as Neil Simon's *The Odd Couple* or Murray Schisgals's *LUV* or to dramatic effect in Caryl Churchill's *Top Girls.* There can also be a build

within one speech of any given character very much like there are builds within pieces of music for a solo instrument. Look for this kind of construction in monologues or soliloquies. Analyze the climax of the piece and construct the build around that. (See more on this subject in Chapter 9, the chapter including audition and monologue. The same principles apply.)

Upgrades/Getting the Stakes Higher

This term refers to getting the stakes higher. We upgrade the verb. For example, we go from *showing* to *proving*. There is so much more at stake when you *prove* something to someone instead of *show* them. We become so much more involved. We need the other actor/character in the room, and we will know then when we have succeeded in *proving* something to them. How do we know when we have succeeded in *showing* the other actor/character something? Too easy. When we simply *show* another something, there is almost nothing at stake. That kind of a choice isn't very brave or compelling.

We get the stakes higher by upgrading the verb. Shift the verb from *suggest* to *demand*. From *flirt* to *tantalize*. From *explain* to *confess*. From *unsettle* to *decimate*. Needless to say these tactic and objective verbs need to be in line with the playwright's purposes. You might start with *suggest* and move to *demand* on the next line if you don't get what you need. You can try on more powerful verbs in rehearsals and see how they affect the actor(s) you are working with.

You might find a director who responds to your choices (or lack thereof!) by saying things to you such as "be more angry," or "the scene feels flat," which obviously is not speaking to an actor in actor terminology. Be that as it may, it is your job to translate that into, "Oh, he wants me to raise the stakes!" Then, instead of simply throwing some generalized energy at the scene or fuming at the director for not giving you enough specific direction, you upgrade the verb. Just try it. You do not have to be right. Keep working.

Physical Task/Ancillary Action

This is so important. Whenever possible bring a physical task with you on stage. It is a very strong method for quieting your nerves, getting you into the physical moment, and allowing for improvisatory physicalized listening to others on stage. Most of the time folks in their everyday life are doing something physical. So you could try drying dishes, folding laundry, sketching something in the room, making a cup of coffee, cleaning your nails, drinking a coke, reordering a deck of cards, paying the bills, bringing in the mail, arranging flowers, wiping the table or counters, arranging the messes around a bookcase or a desk, putting a newspaper back together, putting on makeup, combing your hair, checking to see if there are chunks of broccoli in your teeth, finding all the change in your purse or wallet, changing your shoes, changing your shirt, alphabetizing books, changing your socks, tying your shoes, chewing your cuticles, picking dirt off the dishes that your roommate or spouse did not get when she washed it, finding keys, finding something in a drawer, doing sit-ups, eating a sandwich, making a sandwich, setting the table, pleating your handkerchief, rearranging a drawer, finding a stamp, sweeping the floor, eating a cookie, checking to see what is in the refrigerator, seeing if a book is in the bookcase, filing a folder, packing a box, making iced tea, scrubbing the dirty spots on the floor, tidying up, putting away all the pens, rubbing your feet, finding something you lost on the floor; clearly the list is endless. Having a task will change you physically onstage and change the way in which you relate to others. You will also have made an exploration of character and opened

yourself up to discovery. You do not have to be right the first, second, third, fourth, or any time. Stay open to the exploration.

Ancillary action is referred to also as *independent activity* because the task itself is not required for the playing of the scene and can be accomplished whether the scene takes place or not. This quality of the independent activity makes it an exceptionally effective aid to the creation of the *illusion of the first time.* Woefully often, actors enter the stage with the sole objective of playing the next scene. It's all preplanned and preordained. No tension, no mystery, no outside chance that things might not go exactly as rehearsed. But within the world-of-the-play, you can't come in *here* onstage without having left *there* offstage. Exactly what and where *there is* is a part of the imaginary circumstances, and you, the actor in the guise of the character, need to furnish yourself with a reason for leaving *there* and a purpose for coming *here.* Make your purpose a physical task to accomplish. Choose something that arises plausibly out of the given circumstances that is important and relevant to the character's circumstances and that you can continue purposefully doing if no one else shows up but that has absolutely nothing to do with the scene in the script. In fact, choose a task that provides some opposition or misdirection to the arc of the scene itself so that the scene feels as if it happens by accident, kind of by the way: "I came here to do this important thing and then you showed up and interrupted me and we ended up having this big argument, which I never intended!" Use this technique to help you get past the need for "intellectual" control of your *performance* and to try to get into your body/mind just living in this world. Use it!

Physical Destination

Know where you are headed onstage. Okay, the exception proves the rule, but most of the time aimless wanderings are the mark of an amateur. That two steps to one side and two steps to the other side or crossing to one end of the room and staring off into space is a certain giveaway that the actor has little training. A good director can do so much for you in this area, but if you are doing scene work on your own, find some purpose to your movements. Walk to the fridge. Walk to the bookcase. Walk to the table with folders on it. Walk to the light switch. You don't have to get there in one cross or even get there at all. You can be interrupted by another person onstage and stop and settle something with them and then continue on your way. You can do this a couple of times if you are very accomplished! Walk toward a person. Know where you are headed. The exceptions to this rule are instances where you need to think something through, and you move to keep your thoughts focused, or you move to see if the other will follow you, or you move because you do not want the other to see your face, or you move because the other is offensive to you, or asked you to, or you are so distracted you cannot even remember why you came into a room or what you want. Other than that, know where you are going.

The Moment Before

An actor must be clear about the moments before a character enters the stage, the action. Where has the character come from? Unless we are asking the audience to acknowledge that the actors are in fact actors, an audience wishes to believe that the character the actor plays has an offstage life. If they hear a car door slam and the actor then comes onto the stage, the audience wants to believe the actor got out of the car before walking onto the stage. We all know there is no car backstage or driveway, but we offer our imaginations and wish it to appear so.

So, are you eager to get onstage after driving up in the car? Is this a place you are eager to enter? Did you dread the drive and drive slowly so you wouldn't have to arrive so soon? Did you drive fast so you could get here on time because you were running late? And then want to appear relaxed so you slow your walk down on the way to the door? Is it cold and you forgot your coat? Hot, so you left it in the car? Do you hope you are alone? Do you hope someone is here to meet you? Do you have news? Good? Bad? Do you expect news? Good? Bad? Did you dress up for this event? Did you forget to bring something and hope you don't get caught? How soon do you have to leave? Do you like this part of town? The country? How do you usually feel when coming here? Has it changed? Or have you never been here before? Is it what you expected? So many questions you can ask of yourself to make and keep this entrance full of life.

Endowments

This particular exercise is used to apply the actor's creative imagination to handling and relating to all the props, set pieces, costumes and so on with as much specificity and sense of truth as possible within the imaginary circumstances of the world-of-the-play. Carefully endowed treatment of the objects onstage can create a magical sense of belief in both the actors and the audience. Try thinking of your favorite coffee or tea cup at home. Does it change day to day? Who gave it to you? Where did you buy it? Why is it special? Or, instead, imagine that you are drinking from some strange cup. Do you like the shape? Is it a cup you'd ever choose? Where did you get this pair of jeans? Are they your favorites? Why did you wear them today? Why this color shirt? The costume designer may have selected them for the production, but as the character in the world-of-the-play you pulled them out of your closet this morning *instead* of the others. Own the choice. Make it *yours* and use it. Rarely are these things in your life random— don't allow them be to be random for the life you wish to create onstage.

Public Solitude

Stanislavski insisted emphatically that an actor needs to be able to draw his or her attention into a state of private focus sufficient to shut out the extraneous distractions or concerns about the judgment of the audience that invariably led to either paralysis or the urge to pander for its favor. The most effective object of focus, he felt, was a physical task compelled by an urgent purpose toward the other actor/character on stage. I have always thought that this conscious attention on an object or action or the other(s) onstage was the most creative place from which to work. I called the perception of my focus the "tip of the iceberg." So much of an iceberg is underwater and we only see the tip—perhaps the top seventh of the iceberg. I try to think of my focus as an actor the same way. Six-sevenths of my consciousness is focused on the action, on the other actor and on what I am receiving. One seventh of my consciousness is aware that I am in a theatre, holding for reactions from the audience, and aware of what the other actor is sending me. I am aware of how the scene is playing, tempos, and so on. Most of our consciousness is focused on the objective, but the tip of the iceberg in your consciousness could be described as the part of you that is conscious of the audience and the conditions in the theatre or playing space. Is there a fire on stage? Did an actor lose a line and you have to figure out where you are? Is the audience in tune with the performance of the playscript? Are they listening?

In rehearsal it is very useful to work with the following strategies should you find your concentration slipping. Bring yourself back to the moment by engaging any of the five senses. Breathe.

Notice your breath. Touch a chair and feel its texture. Touch a counter and sense its temperature. Can you feel a faint breeze on your skin? Do you want a sweater? What sounds can you listen for? Steps in the rehearsal hall? A train's whistle in the distance? Expand that awareness to include another actor in what Stanislavski calls the second circle of concentration. What is the other in the scene doing to you? Wanting a response? Frowning? You must take it in. Focus on it. Keep your focus on it.

Want To Do/Have To Do

So as in life, so is it on stage—there are things that we do every day that we want to do and things that we do every day that we have to do. Studying the script decide what your character wants to do and has to do. This examination could be a strong indicator of obstacles as well as general character makeup. REALLY nice payoff here. Do you want to do the dishes or have to do the dishes? Do you want to make dinner or do you have to make dinner? Do you want to fold the laundry or have to fold the laundry? Do you want to eat dinner or have to eat dinner? Do you want to mow the lawn or have to mow the lawn? On and on. Fun.

Summary

Many strategies for entering into the imaginative work of the actor are listed and described here. Again, not all roles require all the tools to the same extent, but it is good to know where to find them and be reminded that you do have a host of useful applications that will help you bring yourself to the character in service to the playscript. These tools can help you flesh out your connection to the given circumstances and become more specific about the world-of-the-play and the context of the action. Have fun playing in this sandbox.

To be is to do.—Plato

To do is to be.—Socrates

First say to yourself what you would be; then do what you have to do.—Epictetus

As we are so we do.—Emerson

Charting the Action

Now that we have explored action, objective, obstacle, tactics, and character analysis, we're ready to *score* the script or chart the action. This is standard work for actors, and there are many forms the scoring could take. For the purposes of this text I am annotating quite a bit and offering some contextual and analysis asides that support the choices made in this sample score.

We are using a short excerpt from Ibsen's *A Doll's House* and will be examining the actions of Krogstad. For those not familiar with this playscript, I suggest reading it; it is one of the most significant plays in the history of the modern theatre. If you have read it, the following brief summary of the relationship between Nils Krogstad and Nora Helmer should refresh your memory. If you haven't read the play, the summary should at least lay the groundwork for examining how action and character analysis work together to create a score.

The play is in the public domain and available to read in its entirety on line. Just type in *A Doll's House* by Ibsen, and you'll find a host of sites. The translation here is William Archer's (1889).

Summary of Nora Helmer's and Nils Krogstad's relationship in Ibsen's *A Doll's House*

The year is 1879 in Norway.

Torvald Helmer, a lawyer soon to be promoted to manager of a local bank, is married to Nora. They have three children. Nora borrowed a large sum of money some years back so that Helmer might go to Italy to recover from a serious illness. Helmer did not approve of borrowing money so to protect his pride and still ensure he went to recover in Italy, she lied to Helmer. She said the money they used for this lifesaving journey was money her father, who had recently died, had left her. Not only did Nora break the law by borrowing the money without her husband's consent, but she also broke the law by forging her father's name as surety for the loan just days after his death.

Nils Krogstad is the man who arranged the loan for Nora. Krogstad is described as a morally corrupt man by another character in the play, Dr. Rank. Krogstad, a widower, has had a shady past but has tried to clean up his image for the sake of his young sons. He has behaved in a moral and respectable manner for the past eighteen months, working at the bank where Helmer works and where Helmer will soon manage. He is fearful that he will lose his job at the bank and therefore all chance of a respectable life for himself and his sons.

Krogstad comes to Nora's home and blackmails her into getting Helmer to keep him at his job and not fire him. He tells her for the first time he knows of her forgery, and she confesses that it is true. He says if he cannot keep his job with the bank, he will expose her crime to Helmer and possibly the court.

At the start of the scene Nora's childhood friend Christine, whom she has not seen in years, has just left Nora's home. Christine is recently widowed, poor, and in need of a job. The irony here is that Christine and Nils used to be in love, but Christine left Nils and married another, a then-wealthy man whom she did not love, to support her mother and brothers.

The Sample Score

We always look at the *moment before* the scene. How did Krogstad get here?

Krogstad was sitting in a nearby restaurant. Was he waiting until Helmer left to go in and coerce Nora to make Helmer keep him on? As he was sitting in the restaurant Krogstad saw Christine Linde walk down the street with Helmer. His past involvement with Christine complicates and heightens the action. Nora has time to start only one game with her children before Krogstad appears unannounced in her home. He has moved quickly and with purpose to arrive so soon after seeing Helmer and Christine. Imagine his experience of this happy home with its creature comforts when he lacks a wife, mother to his children, and financial security.

The actor must justify and create the circumstances to give him the impetus to show up in Nora's home and ask these questions. The questions are not arbitrary—they are to the point and carry years of suffering, anger, and injustice in their wake.

I am using tactic verbs here for both Krogstad and Nora; not that I presume to know what any actor might do with these lines, but I want to give a sense of what actors do in *response* to what they perceive. Tactics used to surmount obstacles exist in a *causal* relationship. If Nora were perhaps to *plead* her first line "Well," perhaps the actor playing Krogstad might *appease* Nora on "-with a lady." Tactic verbs are always dependent on what obstacle is being presented, or perceived to be presented. As such, a tactic is difficult to determine without actors authentically bringing this text and action to life. However, for the sake of providing a sample score, I am presuming a *causal* interactive relationship between Krogstad's tactics and Nora's tactics. Because Krogstad is the character we are focusing on, I will place parentheses around Nora's tactics, as they would not be present in the actor playing Krogstad's score.

We pick up the scene here:

This is the *event*: Nils Krogstad comes to Nora Helmer's home in a bid to keep his job at the bank where her husband is soon to be promoted to manager.

Objective for scene: I want to force Nora to convince Helmer to allow me to keep my job.

First beat objective: Make Nora confirm it was Christine Linde who just visited.

External obstacle: Nora is abrupt and challenging in her answers.

solicit	KROGSTAD. I was sitting in the restaurant opposite, and I saw your husband go down the street-
(interrupt)	NORA. Well?
placate	KROGSTAD. —with a lady.
(spur)	NORA. What then?
test	KROGSTAD. May I ask if the lady was a Mrs. Linde?
(confront)	NORA. Yes.
interrogate	KROGSTAD. Who has just come to town?
(hurry)	NORA. Yes. To-day.

_____ beat change _____

Krogstad has assured himself that Christine Linde is now in town.

This next step is a cognitive and intuitive hunch on Krogstad's part. How could he know that Christine needs a job and that she came here looking for one? This must be a part of the actor's given and imaginary circumstances, because clearly he puts these ideas together. We must assume then that he has followed Christine's fortunes, knew she was a widow, knew she had no children, and knew she needed work. He knew that Nora and Christine used to be good friends. In Krogstad's character analysis, the actor would be sure to create the imaginary circumstances that allow for this hunch on Krogstad's part.

Second beat objective: I will make Nora confess that Christine has been hired at the bank.

Internal obstacle: If Christine gets a job, Christine will want me, Krogstad, to be let go because Christine sees me as unsavory. This will give Helmer even more reason to fire me. I don't want to destroy her chances but I can't disappoint my sons.

External obstacle: Nora insults me, condemns me, and makes me beg.

cross examine	KROGSTAD. I believe she is an intimate friend of yours.
(endorse)	NORA. Certainly.
(disparage)	But I don't understand—

(Note: Earlier you saw that Nora has changed tactics *within* her line. *First* she endorses her friend, *then* she puts Krogstad down by disputing his right to even dare ask her these questions. Never be timid about a shifting a tactic change with a given line of text if it tells the story more clearly. Look for those opportunities. Makes for very specific and interesting acting! Another reminder— actors should always write the finish to a line that has been cut off by another character in the playscript. Finish Nora's line. "But I don't understand *what this has to do with our business.*")

confide	KROGSTAD. I used to know her too.
(judge)	NORA. I know you did.
deride	KROGSTAD. Ah! You know all about it. I thought as much.
demand	Now, frankly, is Mrs. Linde to have a place in the Bank?
(demean)	NORA. How dare you catechize me in this way, Mr. Krogstad—you, a subordinate of my husband's.
(educate)	But since you ask, you shall know. Yes, Mrs. Linde is to be employed.
(impress)	And it is I who recommended her, Mr. Krogstad. Now you know.
defend	KROGSTAD. Then my guess was right.
(intimidate)	NORA. [Walking up and down.] You see one has a wee bit of influence, after all. It doesn't follow because one's only a woman— When people are in a subordinate position, Mr. Krogstad, they ought really to be careful how they offend anybody who—h'm-
mock	KROGSTAD. —who has influence?
(convince)	NORA. Exactly.

_____ beat change _____

This is the end of the beat. He has achieved his objective and found that Christine will be hired at the bank. Also Krogstad believes he makes the *discovery* that Nora is the one at fault should he lose his job because she is the one who influenced Helmer to hire Christine. (We find out later Helmer has his own shallow reasons for getting rid of Krogstad, but Krogstad does not know this.)

Nora has said she has influence, and he will twist her words to get what he wants. He changes tactics to force her to help him keep his job; he accepts his "subordinate position" and plays by her rules.

Third beat objective: I will force Nora to "use her influence" with her husband to keep me on at the bank.

Internal obstacle: Difficult to grovel when I hold the cards I hold.

External Obstacle: Nora claims she has no influence, she is lying, she is unafraid, she doesn't get the picture.

advise	KROGSTAD. [Taking another tone.] Mrs. Helmer, will you have the kindness to employ your influence on my behalf?
(disparage)	NORA. What? How do you mean?
instruct	KROGSTAD. Will you be so good as to see that I retain my subordinate position in the Bank?
(reprimand)	NORA. What do you mean? Who wants to take it from you?
caution	KROGSTAD. Oh, you needn't pretend ignorance.
blame	I can very well understand that it cannot be pleasant for your friend to meet me;
accuse	and I can also understand now for whose sake I am to be hounded out.
(appease)	NORA. But I assure you—
judge	KROGSTAD. Come, come now, once for all:
demand	there is time yet, and I advise you to use your influence to prevent it.
(mollify)	NORA. But, Mr. Krogstad, I have no influence—absolutely none.
test	KROGSTAD. None? I thought you said a moment ago—
(rebuff)	NORA. Of course not in that sense.
(ridicule)	I! How can you imagine that I should have any such influence over my husband?
goad	KROGSTAD. Oh, I know your husband from our college days. I don't think he is any more inflexible than other husbands.
(defend)	NORA. If you talk disrespectfully of my husband, I must request you to leave the house.
intimidate	KROGSTAD. You are bold, madam.
(defy)	NORA. I am afraid of you no longer. When New Year's Day is over, I shall soon be out of the whole business.

threaten	KROGSTAD. [Controlling himself.] Listen to me, Mrs. Helmer. If need be, I shall fight as though for my life to keep my little place in the Bank.
(rebuke)	NORA. Yes, so it seems.

_____ beat change _____

Here Krogstad shifts again. Although he caught Nora in her own trap by asking her to use the influence she insisted she had, Nora has presented an obstacle: she will not back down nor will she agree to use her influence with Helmer. He *discovers* she does not understand what he could do to her life. He *realizes* she thinks he has only come about the money she owes because she rebuffs him and says she will pay it off soon.

At this moment he could pull out the big guns and could threaten her immediately with disclosure of the loan and the forgery, but he chooses next to enlist her aid by gaining her sympathy. This could be a calculated and cold choice on Krogstad's part or the actor could choose to genuinely confess Krogstad's need to Nora in hopes she will do as he asks freely and without further coercion. Alternately, the actor could choose to offer this bit of information to convince Nora how very serious he is in pursuing his respectability. The playwright determines that at the end of the scene Krogstad does make a final threat to reveal Nora's forgery of her father's name should she not prevail in getting Helmer to agree to keep Krogstad employed at the bank. How the actor playing Krogstad makes these choices probable and ultimately necessary is up to him as he makes use of discoveries in rehearsals and in his own text analysis.

Fourth beat objective: I will enlist Nora's sympathy and draw on her love of children to save my family.

Internal obstacle: I abhor admitting my past. I detest being vulnerable.

External Obstacle: I loathe her judgment of me when she is no better in the eyes of the law.

She claims no influence.

defend	KROGSTAD. It's not only for the salary: that is what I care least about. It's something else—
confess	Well, I had better make a clean breast of it. Of course you know, like everyone else, that some years ago I—got into trouble.
(condemn)	NORA. I think I've heard something of the sort.
assert	KROGSTAD. The matter never came into court; but from that moment all paths were barred to me. Then I took up the business you know about.
protest	I had to turn my hand to something; and I don't think I've been one of the worst.
supplicate	But now I must get clear of it all. My sons are growing up; for their sake I must try to recover my character as well as I can. This place in the Bank was the first step;

attack	and now your husband wants to kick me off the ladder, back into the mire.
(insist)	NORA. But I assure you, Mr. Krogstad, I haven't the least power to help you.

_____ beat change _____

Nora will not use her influence with Helmer to protect Krogstad's family. Krogstad now raises the stakes and finally puts Nora on notice that if she cannot meet his terms he will expose her loan and forgery. That action beat will carry on through the end of the scene.

Summary

This is the manner in which you score a script. The actor breaks down the action of the scene and uses the given and imaginary circumstance to support the action. Obstacles are made firmer and tactics are discovered to overcome them. Beats end not always with victory, but with a clear need to move in a new direction to attain the scene objective. This is a process, and don't expect it to look as neat and clear cut as it does on these pages. It isn't. It is messy! It is wise to write on your script in pencil! An actor writes new blocking, unearths new tactics, obstacles, subtext, and discoveries in the script at every rehearsal. You might not be able to see the text if you didn't erase the ideas you discarded!

Just for fun, I've included a mock-up of what a page of our imaginary actor's script might really look like, including notes, blocking notations, and some snatches of subtext. Enjoy!

NORA. Exactly.

advise KROGSTAD. [Taking another tone.] Mrs. Helmer, will you have the
kindness to employ your influence on my behalf? X 2 DSR O

NORA. What? How do you mean?

instruct KROGSTAD. Will you be so good as to see that I retain my ↰ 2 Nora
subordinate position in the Bank?

NORA. What do you mean? Who wants to take it from you?

KROGSTAD. Oh, you needn't pretend ignorance. I can very well ↓ X C
caution understand that it cannot be pleasant for your friend to meet
blame me; and I can also understand now for whose sake I am to be ↰ 2 Nora
hounded out.

accuse NORA. But I assure you- *Cut her off!*

judge KROGSTAD. Come come now, once for all: there is time yet, and I ↓ X 2 steps L
advise you to use your influence to prevent it. *demand*

NORA. But, Mr. Krogstad, I have no influence- absolutely none.

test KROGSTAD. None? I thought you said a moment ago-
her NORA. Of course not in that sense. I! How can you imagine that I ↰ 2 Nor
should have any such influence over my husband?

goad he KROGSTAD. Oh, I know your husband from our college days. I don't x ↑ X
mock T think he is any more inflexible than other husbands.

NORA. If you talk disrespectfully of my husband, I must request
you to leave the house.

intimidate KROGSTAD. You are bold, madam. *SLOW/QUIET!*

NORA. I am afraid of you no longer. When New Year's Day is over,
I shall soon be out of the whole business.

threaten KROGSTAD. [Controlling himself.] Listen to me, Mrs. Helmer. X L 2 Nora
If need be, I shall fight as though for my life to keep
my little place in the Bank. *don't push me*

NORA. Yes, so it seems.

KROGSTAD. It's not only for the salary: that is what I care least
defend about. It's something else-Well, I had better make a clean ⟩ X C P
breast of it. Of course you know, like everyone else, that some
confess years ago I- got into trouble.[1]

[1] Ibsen (1879)

Figure 5.1
Example of written score

Chapter 6

Working from the First Table Reading Through Closing Night

This chapter outlines what you should expect as an actor at each step of the production process: table readings, blocking rehearsals, working rehearsals, run-throughs and notes, technical and dress rehearsals, preview performances, opening night, maintaining the run, and closing. This is also an outline for what is expected of you at each stage in this process.

Table Readings

Who's There? What happens?

A typical first table read of a play varies from production to production but usually goes something like this. The director or stage manager introduces all the collaborators to one another. You are expected to say your name and what role you are playing. The director generally shares some thoughts about the play, including his or her measure of success, and introduces you to the design team, stage management, and any others that the director has invited to the reading. Often the set, costume, lighting, and sound designers bring the cast up to date on the work they have been doing in preparation for the production. The costume designer may show renderings of the costumes for the characters in each scene; from the set designer you might have a three-dimensional model of the set to look at and perhaps a rendering as well. Finally, the director will ask the actors to read through the script. It's a good idea to bring a journal or notepad with you to keep track of the things you don't want to forget: phone numbers, important dates, interesting things folks have said, and questions you want to ask. If you are union (Actors Equity Association, the union of professional actors and stage managers in the United States) there will be paperwork and a vote for the Equity deputy for the production. The deputies are the go-to people for any questions you have about your union rights and expectations in terms of your contract with the theatre. They do a brave job and are your union liaison for the production.

First Read

This first read is always a bit stressful. You might feel the need to prove to the rest of the cast, director, designers, and stage management that you deserve the role and that you will serve the good of the play in this part. The first time that a cast puts voice to the work feels like a big risk. The director will probably tell the cast that they are not to worry, that this is a simple read of the play and no "acting" please. Marc Masterson, artistic director of South Coast Rep, thinks that what he and other directors mean by this is that there will be no evaluation of your work at the reading; still, the director and other actors will want interaction. You want to have a strong sense of the script, the relationships, and the style in which you are working. Don't make huge choices, but do know what you want, react to what you are given, and make eye contact

with the other actors in the scene. Jot down discoveries and questions you want to explore further on your own or in rehearsal.

Prior to the first read, try wrapping your lips around the text without voicing the words, just mouthing them, to get a sense of how they feel. If you do it this way, you won't run into the danger of preparing a fixed reading but you will feel more flexible and more ready to open yourself to the text and the other actors. On the other hand, you might want to read the text out loud if it requires an accent or special vocal tick to help you get used to the sound of your own voice meeting the text. In any case, don't rehearse a "reading" in advance; just begin your own opening process before you are in front of others and/or beginning to react to other's work.

Enjoy this first read. You will learn much and offer much to your fellow collaborators. Further table reading will encourage the company to explore the script in more depth.

How Many Table Readings?

Some directors like extensive table readings; others will only have that first read of the script around the table. The thinking behind these differing choices for readings is often time driven. A short rehearsal period makes it more likely that there will only be one table reading. If there is more time and/or a dense script, there will likely be more readings. The director should tell you what the expectations are at each subsequent reading. If the director doesn't, try to gather by the director's questions what to focus on. Your own personal goal is to clarify your character's relationships in the play and to stay connected to the other actors around the table. Read in relationship.

Blocking and Blocking Notation

Blocking is the way directors move actors within the ground plan of the set to physicalize the psychological action of the play. The director either gives the actors their blocking or works with them to discover it. Most directors use a combination of the two methods.

There are many different styles of director (which we will discuss in more detail in Chapter 7) and many different styles of blocking. Some directors give you not only entrances, crosses, and exits, but also prescribe the blocking eyebrow lift by eyebrow lift. Others ask you to move on your instincts and impulses and shape the scene more improvisationally. Both approaches are valid in the hands of a competent director. No matter how it was arrived at, good blocking communicates to both actors and audience a physical understanding of the wants and relationships between characters in a scene. You may prefer one style of working over another, but you will need to collaborate with the director effectively either way.

The notation of blocking is individual, but some guidelines are useful. To notate the blocking, you first need to know and understand the type of stage on which you are performing. Broadly speaking, three main types of stage configurations govern the physical relationship between the actors and the audience: proscenium, arena, and thrust. Even should you find yourself working on a theatrical venture outside an actual theatre, these arrangements of the

audience's relationship to the actors are pretty standard. Though the principles of blocking are generally similar in any space, the method of notations can differ significantly.

Proscenium

This is a stage in which the audience sits on one side of a picture frame facing the actors on the other side. In the past, stages were built on *rakes* or inclines so that the audience could see the action of the play more clearly. To move from the front to the back of the stage, and actor actually had to walk uphill. This tradition led to our use of the terms *upstage* (the area furthest away from the audience in this configuration) and *downstage* (the area closest to the audience). For our purposes, we further break down the stage into nine playing areas: stage left, stage right, center, upstage left, upstage right, up center, downstage left, downstage right, and down center.

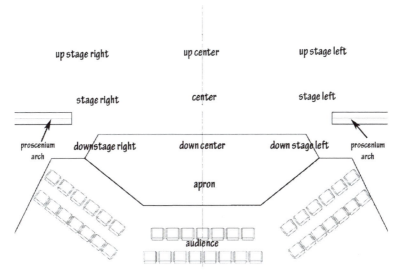

Figure 6.1
Proscenium Stage configuration, notation, and relationship with audience

So when the director says, "Cross up left center to the chair," you know where that location is on the grid of the stage. You also know how to notate the movement by writing X *ULC 2 chair* in your script next to the line indicated. Notating blocking in this way will help you remember direction when you review your blocking at home, preparing to rehearse the scene again.

In addition to notating the areas of the stage in a proscenium configuration, an additional notation is needed pertaining to the actor's body position in relationship to the audience. If we notate a *one-quarter position*, we are describing a position in which we see one-quarter of the actor's back and three-quarters of the actor's face as she faces downstage at a roughly 45-degree angle to the right or left. If we use the term *profile* the actor faces right or left at a 90-degree angle away from the audience. The toes of her feet should be pointing directly stage right or stage left in the right or left profile position. If we say *three-quarter position*, we

are describing an actor position in which we see three-quarters of the actor's back and only one-quarter of his face as he turns upstage right or left at a roughly 45-degree angle to the back wall of the theatre. If we use the term *full back*, an actor's back is facing the audience, and we do not see her face. If we use the term *full front*, we are describing a position in which the actor is facing the audience directly, and we do not see his back. In Figure 6.2 you can see ideas for notating these body positions as well as some possible methods of notation for blocking and positioning on the stage. Remember, stage right and stage left always refer to the *actor's* right and the *actor's* left as he or she faces the audience.

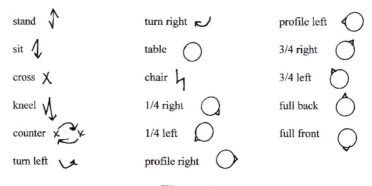

Figure 6.2
Ideas for notating blocking and body position

I cannot emphasize too strongly the need to write the blocking in your script. Write the blocking in your script. Write the blocking in your script. Few things are more annoying and disruptive in rehearsal than an actor who cannot remember where to go. Very unprofessional. Yes, the stage manager should have it all down, but it is the particular responsibility of the actor to execute and justify the blocking. The blocking may change six times. Write in pencil. Write the blocking in your script. In pencil. Bring erasers. If you are not sure about a particular moment, check with the stage manager during a break or at the end of rehearsal. Just a particular moment, not the whole day's work. Part of your technique is writing, remembering, sometimes creating, and always justifying, as best you can, the blocking. There is no excuse for failing to do this most basic part of your job.

Arena or Theater in the Round

This stage configuration resembles an island of sorts. If the audience were an ocean, the arena stage would be an island surrounded by the audience. The shape of the island can vary considerably between perfectly round or oblong to different kinds of squares, rectangles, or polygons. We adjust the notations used for blocking on a proscenium stage to suit the new configuration.

Because there is no traditional upstage/downstage/right/left relationship in an arena or round configuration, some directors will block the actors using the points of a compass to describe how they want the actors to move. They might say, "Move Northeast to the table," or something like that. Other directors will use the face of a clock to determine that communication. These directors might say, "Move from two o'clock to six o'clock," or something of that fashion. Each director will have decided on a scheme and explained it to you before he or she begins blocking. No one way is the right way. It's just a tool in communication between the director and the actor.

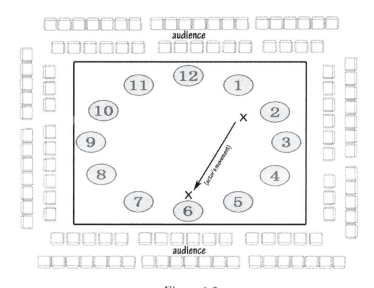

Figure 6.3
Arena Stage configuration, possible notations, and relationship with audience

Thrust

This stage configuration is something like a peninsula in that the actor is surrounded on three sides by the audience. It makes use of the best features of both the proscenium and arena actor/audience relationship. The notations for blocking here are usually very similar to proscenium stage notations. Some directors will use a combination of approaches to communicate blocking on a thrust stage, depending on its particular configuration. There are many types of thrust stages, and you will find yourself adapting to them easily.

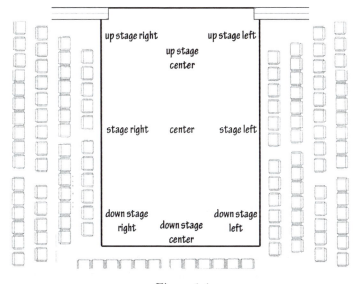

Figure 6.4
Thrust Stage configuration, possible notations, and relationship with audience

First Runs of Scenes, Acts, and Productions

When the director is through blocking a scene, you are expected to run the scene *exactly as blocked* the next time through the scene. The director will be looking to see if the blocking is telling the story well. You need to have given it some thought and justified the moves as best you can. Do it the director's way at least seven times before making a counter-suggestion. *Never, ever* say, "My character wouldn't do that," even if you think that is true. If you do offer an alternative to the director's blocking, make sure you are genuinely trying to clarify and intensify the dramatic action and not just dodge a move that feels uncomfortable to you. Discomfort can be exactly what a moment calls for! You might try to approach the director like this: "Everything is great till I come to this moment, then I leave the action to execute the move. Could we try such and such to see if it helps me stay in the scene?"

The process is the same following the completion of blocking for each *act* and then the entire show. The director is looking to see if the story is being told well visually and verbally. This first complete run-through, in particular, is a very sensitive time for both directors and actors. Everyone is feeling vulnerable, exposed, and evaluated. Often the design team attends the first run-through to gain insight on how the show is progressing, where the lights need to be hung and focused, what costume needs might have changed given the blocking, and so forth. The actor's job is to support the blocking and action choices and do his or her best to justify and make them necessary. Your job at this moment isn't to impress everyone in the room; it is to stay focused on the psychological and physical action of the play and to learn what choices are working and what choices need further attention. Solve problems.

Notice Your Own Process

At every stage of review, do your very best to support the choices made, but also take personal notes on what your least favorite moments are. "If it ain't broke, don't fix it" is an old adage in the theatre and elsewhere. Don't examine to death all the moments and beats that are working. In truth, they may not always work, and you may have to work on them later if a moment has gotten stale, but don't fuss with it if it is working now. What you *do* want to focus on now are the moments that pull you out of the action of the play. The moments you dread are the first ones to examine. Try not to judge yourself, the playwright, or the director. Just notice the moment and wonder what might be missing. More often than not you don't have to *change* but, instead, *adjust* something in the way you are approaching a moment, usually by more completely specifying or intensifying an objective or tactic. You might simply be failing to notice what you are being given.

Add to the Work, don't Change It

Always approach adjustments in terms of adding variety and nuance to your choices, not changing or eliminating them. Perhaps it is the blocking. If you have worked hard to justify the blocking, and you have an idea of how the story might be told more honestly and evocatively, now is the time to talk with the director. Remember that an actor who is respectful, is collaborative, and works hard to develop the production is more likely to find an open ear than one who implies the director doesn't know what he or she is doing by repeatedly challenging their choices. You will have to make this call, but, whatever you do, speak with the director privately and not often. Don't waste your challenges. In a small role, perhaps one. In a large role, perhaps five.

Getting Off Book

This is really important! The idea is to get off book right after the scene is blocked. Don't wait to be asked. At the latest you *must* be off book by the date given by stage management. If the stage manager (via the director) will allow for line calling before lines are due and time permits, get off book as soon as you can. The stage manager will report to the producers and artistic directors that you are a go-getter, off book early, and word perfect. A reputation for reliability and promptness can go a long way toward keeping you employed.

Yes, this is an excruciating and tedious task. So get on with it, and free yourself to pay attention to responding to relationship and what you are being given at every moment by your fellow actors. Get on with it!

As you learn lines, try to involve as many senses as you can. Write the lines out in your own hand. Say them out loud. Record them. After you know them pretty well, record the cues and then leave enough time for you to say your line. Don't kind-of memorize them—get them word perfect right off. The sooner you do this, the sooner you can stop wondering if you have the line right. Place your attention where it needs to be: playing a tactic in response to an obstacle the other person in the scene has thrown in your way.

At all costs, don't attach a line reading or a set way of delivering the line as you memorize. If you do, you will never *truly* be open to react to those onstage with you or to your own self-reaction as you develop in the role. Good playwrights compose lines and speeches with a very clear dramatic structure that will come through if you are sensitive to it. Stay as neutral as possible as you memorize. Don't speak the lines out loud or even whisper them. Instead, soundlessly but energetically mouth the words to feel the muscularity of the language and to allow the sense and structure of the lines to imprint themselves in you.

Note-Taking Sessions

After run-throughs directors will usually give you notes. Say thank-you for every note. Quietly. Mean it. Thank goodness someone was paying attention and concerned with the whole of the play and production and your part in it! *Write your notes down.* Think through them at home as you reread the play. Incorporate them at the next rehearsal. And the next. If a note still doesn't work and you have another idea, go to the director and share your thought in a moment when the director does not seem too consumed with another aspect of the production. Try not to look worried!

Reworking Scenes and Blocking

Following blocking and a first run-through, the director will rework scenes to get them closer to the core of the action. For each scene, you need to be off book and have reviewed your scoring and the director's blocking. The director and other actors are looking to you to bring deeper personalizations to the work and to make the action of each moment less arbitrary and more necessary. This is your job. Your goal is to know the work so well and be so prepared that the scene feels improvised and alive in the moment. You no longer need to think of the line or when you put the coffee cup down—you are only thinking of the others in the scene and getting what you want from them in moment-to-moment action/reaction/action.

The pace of development and the expectations increase during this phase of rehearsal. You must work hard and bring new ideas and discoveries to each rehearsal. Do not be passive in this aspect of your work. Every rehearsal matters.

Technical Rehearsals

Technical rehearsals, as the term implies, pull together and coordinate all the elements that will eventually compose the compete production: actors, lights, sound, props, sets, and costumes. A favorite time for actors! Seriously. If it is not already a favorite time, learn to make it a favorite time! It is such a pleasure to be onstage and know it is someone else's turn to do the work! Tech rehearsals are an opportunity to settle into the play, work exits and entrances, get a sense of how the light and perhaps sound are enhancing the scene, and allowing the light and sound affect you. This is your time to find your light. Check where the lighting instruments are focused for each area of the stage in which you are blocked, and experiment with your stance to sense when the light feels strongest and warmest on your face. While the designers and director are busy adjusting light and sound cues, take advantage of the opportunity to work with the final show props (as opposed to the rehearsal stand-ins) or a bit of business with a door or chair. Tech is a wonderful opportunity as an actor to soak up the atmosphere and just *be* in the world-of-play, to deepen your sense of belief in the imaginary circumstances of the play and feel authentically at home there.

Obviously you need to be alert to the needs of stage management and other collaborators. The moment the stage manager asks for your attention, you must give it completely, but you may talk and do your personal work quietly if you are ready to give focus to the needs of your other collaborators as soon as they need your attention.

If a prop is not working or a window is stuck or a door jams or the coffeepot doesn't heat up or the water isn't coming out of the tap or the refrigerator door won't stay shut, this would be the time to bring it up. Nothing has gone wrong. It's the reason we have tech rehearsals, to get that kind of work done. A note needs to be taken, and it will be fixed. Let an assistant stage manager know that the water isn't running, or the light won't turn on. Please use a pleasant professional tone.

Try not to fix anything yourself unless asked, like pushing a window up only to realize the director and designer decided not to have a working window and didn't tell you, and now you have broken the window. Be aware, too, that this is a potentially dangerous time. Set pieces may be flying in and out from above and wagons can be rolling across the stage in the dark. If at any time you feel that you or any other person on the stage is in any danger, you must call "hold" to alert an assistant stage manager that the action needs to stop to sort out a problem. You must stand still when told and remain silent so others can communicate. Always say thank-you in response to instructions from the stage managers to let them know that you heard the communication, whether or not it was directed toward you or generally to the cast.

Dress/Tech Rehearsals

Much the same as the tech rehearsals for lights and sound, dress techs add costumes, hairstyling, wigs, and makeup to complete all the technical production elements of the show. This is a very rich time in your work as an actor. You will have had fittings and so will know what the

costume is, how it moves and how it helps or impedes your movement. Now you have an opportunity to walk the blocking and work your business in costume. You have your task cut out for you! You may have a six-foot veil you have never worked with before. Take your time and try to get onstage as much as you can to work particularly difficult moments.

The role may call for *quick changes*—these are changes that happen offstage in a very brief amount of time, hence the "quick" in *quick changes*. A good designer will have planned for these changes and designed the costumes to go on and off with as little fuss as possible. Be patient as the dressers work on these changes during dress rehearsals. The director or designer may ask for a *quick change* rehearsal before the dress rehearsal so as not to hold up the entire company and crew while the change is sorted out. Listen to the dressers, and do as they ask you. You might ask if there is anything you can do. They will tell you if there is. Quick changes can be quite stressful at first but they almost always get less so as time goes on.

Take care of your costumes. Do not ever leave them on the floor. Hang them up immediately. No wardrobe mistress/master or costume crewperson is your personal maid service. Don't smoke in costume. Some fabrics are not fireproof and will catch fire fast. You also don't want to risk an ash burning the costume. Don't drink anything but water in costume—you don't want to risk stains. Some costumes don't take well to water either. Be careful! Try not to eat in costume if you don't need to, but if you do need the energy during the performance go ahead and eat nuts, orange slices, or hard candy, but *not* food that is gooey, sticky, greasy, or juicy—you get the picture. Wash hands after applying your makeup to avoid unnecessary stains on the costume.

Dress Rehearsals

Okay, this is when it all comes together. If you didn't have makeup and wigs at the dress tech rehearsals, you will now. If you are applying your own makeup make sure that you have planned it carefully so that you can repeat or adjust what you did in response to notes from the director or costume designer. Work on it beforehand, if possible, and take photos to remain consistent. If you are wearing a wig that is giving you problems with balance because of its position and weight, give yourself time to accustom yourself to that. Same with shoes or perhaps a mask that partially obstructs vision. Don't wait until the middle of a scene to find out that you lose your balance because of the fifty-pound wig or discover that you cannot see out of your mask.

If there have been problems with props, lights, costumes, or costume changes, they should have been worked out by this point. There is almost never a reason to stop a dress rehearsal unless a safety issue is involved.

Previews

The very last element that completes a production is the addition of an audience. Their responses help determine the final shape, tempo, and rhythm of the play. Professional theatres bring in an audience at several preview performances before opening. Tickets are generally discounted, and the director and actors continue to rehearse daily to incorporate what they are learning from the audiences during performances. These performances are where you find out where the laughs are and where they are not. Some laughs are a surprise. Sometimes the lack of a laugh is

the surprise. Keep on working. You find out when the audience needs time to process what has happened and when you need to move more briskly to stay ahead of them. Keep on working.

If you are in a nonprofessional company, you may have previews, but that is the exception.

Opening/Press Night

Opening night is exhilarating no matter what kind of venue or company you are in. In professional theatre, money and reputations are at stake. Whether or not you care personally what a certain critic or reviewer thinks, it matters to the theatre that ticket sales go well. It is not necessary that a reviewer or critic like the play for sales to go well and for the public to attend the play, but it does help to have good press, especially until word of mouth gets around and patrons tell friends about the production. It matters, but it isn't the be all and end all. Do your best to deal with the nerves. Focus on what you want. Rituals, a routine and careful rehearsal help. The director might even have the actors in for a short rehearsal to keep them focused on process. Even if there is no official rehearsal, go over the play in your mind again and give yourself a couple of notes.

If you can help it, don't read the reviews, positive or not, for a couple of days. Even if they say good things, you might find yourself onstage thinking of those moments the reviews praised rather than the action that elicited the praise in the first place.

The Run

The biggest challenge of running a play over a period of time is maintaining it consistently as rehearsed without letting the performance become mechanical and stale. It is good to be consistent, but no one needs to set a watch by your performance. In other words, from night to night, you must reliably repeat the events and shifts that comprise the dramatic arc and adhere to the basic tempo/rhythms and dynamic builds established in rehearsals. At the same time, within the fixed structure of the rehearsed production, you want to respond every night to the subtle variances in energy, tempo, rhythm, and subtext created by the interplay of actors and audience experiencing the play *this time*. Your goal is to do the same performance every time as if for the first time: an improvisation of the rehearsed play. The liberating, though slightly counterintuitive, lesson here is that the more you rehearse and set specific choices, the freer you become to give yourself over to spontaneous interaction with the other actors.

A good stage manager will be very sensitive to changes that take the production away from the director's intent and the play as rehearsed. In a professional production the stage manager is expected to give notes to the actors should they move away from the play as rehearsed. Take the note respectfully as if it came from the director herself. Of course some moments will become stale or dull, and you will be tempted to reignite the fire by trying something daring, different, wildly new. It's not a mistake that you want to reignite the fire, but that you might move away from the play as rehearsed or from the director's intent. Go back to your intention, subtext, and the established circumstances and action. A moment or relationship becoming stale during the run of a production happens to all actors and is just a part of the

business of acting. Nothing is wrong. You just need to keep working. Enjoy this! Keep learning about the play.

If you find that overall you feel uninspired and you want to find a bit of that inspiration again, keep a few volumes of acting books on your dressing table, perhaps Jon Jory's *Tips*, or whatever acting texts delight you, and read a bit of that before making up. Maybe you want to really give your entrances some attention with this performance. Not change them but deepen them. Add something to them internally that renews the urgency of the moment. For example, perhaps you tripped before entering and someone you respect saw you, or you wondered what the neighbor was doing looking in his windows, or you feel hurt by everyone's inattention. Reconnect to yourself, to your imagination, and to an internal reality that you bring onstage with you: a life already being lived that compels you to come to *this* place for an urgent purpose. Just keep bringing yourself to the work.

Closing

The last performance is just another performance. Don't do anything special or different. Don't get maudlin and try to wring every moment out of this, the last time you will get to do this play with these people! No crying or carrying on backstage after your last exit while others are still onstage trying to work. On the other hand, if you had artistic or personal differences with the cast or you didn't like the direction, don't be flip, glib, or condescending about the performance. Don't ever do that. You are a professional only if you behave like one, regardless of whether or not you are being paid. Get on with it. Theatre is like life. You can't take it with you. Pack up your things, and clean your dressing table.

Exchange phone numbers with those you'd like to keep in touch with or keep in your professional networking group. A lot of the work in theatre, as in any business, is who you know and the relationships you create and nurture, so keep track of the artists you liked working with and stay in touch.

Summary

Once you have worked on or performed in a play or two, much of what we've discussed in this chapter becomes common sense. Even so, it is useful to remind yourself of the order of the work, what to expect, and what is expected of you as you progress through rehearsals to the opening night and the run. Each theatre, director, company, and university has its own way of doing things, but generally the progression remains the same. Stay flexible. Write down your blocking. Respect the process.

Working with Directors and Other Collaborators

Theatre works best when those working together collaborate well and the whole is greater than the sum of its parts. The combined creativity of the designers, director, actors, and other collaborators is always enhanced exponentially if there is respect all around for the expertise of all the collaborators on the job. In Chapter 6 we presented an overview of the production process from the actor's point of view. In this chapter we'll look much more closely at the jobs of the other key people in a production and what actors need to know, at the very least, to combine our work with theirs for the good of the play and the delight of the audience.

Directors

What Do They Do?

It is the director's job to ensure that all the artists are working toward the same goal: a unified, cohesive, confident performance of the play. The job of a director in the theatre is very similar to that of a conductor of a symphony orchestra. The conductor must know the entire symphony and exactly what each instrument contributes to the whole, every note played, tempos and tempo shifts, and how that manifestation is to move an audience. The conductor must take the music on a page and bring it to life. He must inspire the individual members of the orchestra to play their best and with each other as a seamless whole. In the same fashion, a director must study the playscript and develop an understanding of what effect she believes the play will have on an audience. She must know how each character contributes to the whole and how the combination of individual actions combines to create the entire action and purpose of the production. She must develop a clear vision of the production's purpose and be able to communicate that vision and purpose to all the collaborators. Good directors will unite the company by inspiring them to serve a common purpose with the production. They will do their best to ensure that all feel that they have a job to do in this production and that it is an important job.

Where Do You Fit In?

In most productions, the director and designers will have already determined a great deal about their approach to the script long before the first table reading, certainly, and almost always before casting begins. Because the director already had a vision for the production when you were cast, you, in a sense, have been a part of the collaboration before getting to the table. Now, at this point, your offering to the community becomes active. A director who is knowledgeable about acting will help to elicit strong action choices from you as well as encourage you to find deeper personal connections to the circumstances and relationships in the play, raise the stakes, and generally to step up your work to meet the challenges of the role. If you are not working with a director who is able to connect to and understand the actor's process, you will need to accept that quickly and move on with *your* work. He cast you; he wants to work with you; you are part of the vision, so get to work.

Working With the Director

First Read

Pay close attention to the opening remarks—jot down a few of the most inspirational or purposeful statements the director makes at the first reading. These are the kinds of suggestions and thinking that might illuminate a scene or moment for you later. Directors generally work hard on text analysis, so these opening remarks are usually well thought out and are the most significant ideas directors want the cast to be aware of in understanding and bringing this playscript to life.

The Director's Questions To You

Many directors ask the actors a lot of questions very early on, beginning at the first table reading, and will continue asking them throughout the process. This isn't anything to be nervous about. The director is putting you on notice that you will be expected to have your homework done and to have thought carefully about the play. That is a good director! He's hoping these questions lead you in a direction of discovery as you explore the playscript and bring yourself to the work. He might ask, if you were working on *A Doll's House*, "Do you think Nora changes during the course of the action?" He's asking you to think about whether Nora *change*s in her basic nature or whether she *realizes*, at long last, who she really is (and isn't). This is a significant question and one that will color your choices in the development of your action in rehearsal. You don't need to have an answer right there and then, but you do need to recognize and acknowledge the importance of the question, which is meant to guide you as you explore the script. This kind of question is not meant to embarrass you or to ensure you "pass the test." It is your good fortune to work with someone who expects you to think and expects you to bring your thoughts and analysis to rehearsal. Just say "Good question. Thank you. Can I think about that?"

Your Questions To The Director

It is good to have your own questions for the director. You ought to have a journal full of them by the first reading! Make sure the questions are to the point, affect the action, or are significant character choice questions. You don't want to take up the company's time with anything superfluous, but you do want to own your voice. Be sensitive to the timetable—if there are twenty-five people in the company, and you are working on a three-hour-long play with only two weeks to rehearse, of course you won't want to take up a lot of time with discussions. Just be aware of the others in the room, the particular purpose for a given rehearsal, how others are behaving, and the clock.

Blocking

We defined blocking in Chapter 6 as the way directors move actors within the ground plan of the set to physicalize the psychological action of the play. Some directors have the actors get on their feet after the first reading; other directors wait a longer amount of time. As discussed in Chapter 6, rehearsal scheduling is a decision based on the density of the script, the length of the script, the amount of rehearsal time to mount the production, and a host of other variables, not the least of which is the director's optimum method of working.

In most blocking rehearsals, the director works from a ground plan given to him by the set designer. The ground plan is the outline of the stage floor as it will be used, including playing areas, levels, placement of furniture, doors, windows, and exits. The stage manager tapes this ground plan to scale on the floor of the rehearsal space. Having worked with an accurate understanding of the space in the rehearsal room, the company can adjust efficiently to the set when they move into the theatre prior to technical rehearsals.

Directors differ a great deal in the way they block and it is the actor's job to adapt to them, not the other way around. If in the past you have always had your blocking given to you, and this director wants you to find the blocking organically, throw yourself enthusiastically into making it up as you go along, trusting your instincts and your understanding of action, reaction, and relationship to guide you. On the other hand, if you are used to exploring endless possibilities as you make up your own blocking, open yourself to the character and action insights that can be the result of having to justify very specific moves given to you by the director. Both approaches are valid and have merit. I would trust an experienced director to know which method suited him best given all the contributing factors of style, time to rehearse, and experience of the actors, among other variables. Truth to tell, most directors work in some combination of the two methods.

When you first begin to block, the director will, at the very least, give you an entrance point and have ideas about when you must be in a certain area of the stage. For example, the director might need to clear the doorway for an entrance by another character and say to you, "Enter up stage right carrying the groceries, put the groceries down on the table, and make sure you are stage left of the table by the time John enters." Here the director has given you the freedom to justify the blocking within the context of your lines and action, only making sure to clear the entrance for John. Another director might be much more specific and tell you exactly on which line to put the groceries down and precisely when to cross left of the table to clear for John's entrance. Some directors just want to rough it in and get down to details later; some directors want to fill in detail as much as possible right away. You are collaborators. If you have never worked with a given director before, watch how she works with other actors and figure out your best way of working successfully and productively with her. Adjust as best you can, write down the blocking, and go over it in your mind after rehearsal, even if you cannot work in the space, until you understand how it connects to your psychological/physical action. Connect the dots so that when you come back to the scene the next day or in three days or a week that the blocking is grounded in the action. The initial blocking can almost always be refined to ground the scene more deeply in the action. At these early rehearsals, though, the most important thing is to see quickly if the initial blocking works adequately enough to move on, or if major adjustments need to be made immediately. Your job is to help make the decision clear by committing fully to the intitial choices.

Business

Business consists of smaller bits or sets of movement, often involving props, such as making a pot of tea or trying on hats or setting the table. You get the idea. Sometimes business is gone over with a fine-toothed comb in a rehearsal; sometimes the actor is expected to rehearse this on her own and clean it up to make it look easy and purposeful. Be prepared to do this kind of work on your own if insufficient time is given in the rehearsal schedule. It's a little bit like learning dance steps; if you can't learn them in the rehearsal in which they are

choreographed, you have to do extra work and put in time on your own to keep up with the rest of the dance company. Some of us need more time for these bits, but we shouldn't slow the company down because we have two left thumbs. Put in the work. Then you won't dread those parts of the production. Neither will the director. Don't expect her to take up rehearsal time to teach you how to chop celery, peel an egg, pour drinks for four, toss a salad, serve tea, or make coffee. That's *your* job.

Getting Off Book Early

See Chapter 6. Directors will love you for this. But only if you've learned them correctly and confidently. They will see you are committed to the work and are now able to receive from others and engage with others: the essence of acting. They are better able to see if the story is being told well and better able to ascertain what they might be able to do to help you tell the story more effectively. The sooner the better. But please don't frustrate everyone in the room *trying* to get off book early. Calling for a line occasionally is perfectly acceptable and expected. Calling for a line every other sentence or stumbling through an inept paraphrase of a speech is not. Conversely, don't ever hold everyone else up doing the same thing because you are *late* having your lines learned.

Taking Notes

Again, see Chaper 6. Be grateful for any note you are given by the director. Someone was watching and cared to make a suggestion. Take the note, write it down, say thank-you. A director bothered to write the note and give it to you; have the courtesy to write it down and acknowledge you received it. If you are unclear about what the note means, ask for clarity. Watch your tone. Ask simply and with an eye to solving the problem, rather than in any way taking the note as a criticism. Solve the problem. Collaborate.

Sometimes members of the company other than the director are tempted to give the actors acting notes. Smile sweetly, say thanks, and move along. If the note has possible merit, run it by the director.

Personal Styles of Directors: Perspective

It is true that a director's personal style has a great effect on all work done on a production. It is also true that actors rarely, if ever, have much influence over the working style and preferences of a director. He or she sets the tone of the working atmosphere for the entire company, but most particularly and significantly for the actors, who must learn to adapt their own personal styles and preferences to those of each director with whom they work. The imbalance in this relationship inevitably furnishes directors with a lot of power and influence. They can end up being placed—or placing themselves—on pedestals. But directors are fellow artists who have strengths and weaknesses and areas for growth, just as we do as actors. It's important that actors not allow directors' individual working methods to undermine their own or to take a director's style personally. Their issues are not about you, personally. There's no need to judge or condemn a director to knock them off a pedestal. But a healthy, clear-eyed perspective can keep you from putting one up there in the first place. In that spirit, I'm sharing the following descriptions of director styles that was shared with me some twenty-five years ago by my father, a director. I've updated it a bit. I was primarily an actor at the time, and this list helped me to let go of the notion that the way a director worked with me had much of anything to do with me—they come ready made!

The Collaborator

This director regards himself as merely one of an ensemble of creative artists at work; he solicits views and attempts to stimulate people to use fresh ideas of their own. He may be more interested in the creative process than finishing and polishing a performance. To avoid a sense of weak leadership, he periodically sets forth clear aims for the creative team.

The Orchestrator

He makes maximum use of what actors and designers bring to the work and exploits and deploys these qualities and potential more than develops them. He usually has a strong instinct for showmanship values. He may not be very helpful to actors with their homework. He holds long note sessions that serve to puzzle rather than enlighten performers. He prides himself that his shows sell.

The Connoisseur

This director has a quiet and removed manner and is almost impossible to satisfy, let alone please. Though he seems depressed by frequent disappointments, he nevertheless has favorites in the cast who are looked to as ones who can do the work at hand, the only ones who are capable, and he gives them much attention. He sees himself as an expert. He enjoys demonstrating how to do bits. He is resigned to the possession of a singular refinement shared by almost no one. He must endure this loneliness of genius.

The Intimate Friend

The personal style of this director is all about working for close relationships, especially with actors. He makes suggestions confidentially and holds lengthy, very quiet conferences in the middle of rehearsal. He stays in the scene, interrupting frequently for whispered consultations. He is an assiduous "stroker" of the company, meaning he gives constant praise and personal support. The trouble is that the process takes so long and bores those who don't receive attention.

The Joyful Companion

This director enjoys a playful manner of fun and games, intended to produce highly enjoyable rehearsals that are "productive" because of the ensemble's delight in the work. His style is marked by enthusiasm for new inventions by the actors and an implicit invitation to come up with novelty for novelty's sake. Working this way causes difficulty when the company doesn't know when to stop having fun and get to work solving problems in the production that cannot be solved with theater games.

The Guru

This director loves to talk about the show, what it means, and how its significance should be taken. He hopes to prompt discussion and expects the discussions and sessions of idea mongering will benefit the whole production. Occasional fits of recrimination such as, "We haven't been making enough progress!" may lead to stimulating approaches that, of course, must be discussed. To get the show up, he eventually has to sit back and let people work, offering only a token aphorism or two. He gives an excellent interview with the press. He might be a dramaturge at heart. Definitely a teacher.

The Inspired Actor

She thinks about the play from the performers' standpoint and displays concern with the comfort of the actors. She may have a weak visual sense. Believes it is essential to "talk through" the show, envisioning how it will play. She performs all the parts, of course, and can often be caught rehearsing before giving a suggestion to an actor. She exhibits particular delight with persons who see things her way. She has great confidence in her ability to sway the audience. Pity she cannot play all the roles.

The Rationalist

She is impersonal and very cool, gives directions with care, and explains the reasons with concern for clarity. She expects others to remember and note down all significant remarks and to avoid repetition of mistakes. She likes to be seen as keeping abreast of the latest trends—perhaps artistic, perhaps intellectual, but seldom both. She looks for rational responses, in short, which can make for dry and uneventful work. She is excellent with the mechanics, as in traffic managing and staging large themes; however, her productions sometimes lack heart or depth of purpose.

The Psychologist

This director stresses the personality development of members of the company over the character development in the roles. She wishes to relate actors' personalities to the role and uses much one-on-one work to get at the actor's psyche. She might even try to get into the designers' or the stage managers' heads! Because her measure of success can be clinical instead of artistic, shaping a finished production may not be her strong suit. This type is usually up on the latest, most fashionable trends in psychology and sociology, and sees herself as a liberator of people from their baggage.

The Genius

Animated by profoundly exciting ideas and a thrilling "concept," he demands that actors place their faith in him and his concept so that miracles can be made. Probably thinks the script is not as strong as he is as a director. Has a tendency to overvalue spectacular effects and an inclination to overproduce to make a powerful, though questionable, impact.

The Revolutionary

She is a dedicated avant-garde-ist to whom orthodox and traditional methods are forbidden. She posits radical viewpoints. She preaches freedom and perhaps dresses the part. She is willing to try anything new, sometimes for the sake of novelty. Her openness can turn from virtue to fault should the "freedom" ethic translate into anarchy. This director's background and training might be more in design or acting than in directing. She can get excited about expressiveness but be careless about dramatic structure and action.

The Wrangler

This director stays on top of everything that happens. It is her show more than anyone else's. Perhaps this director might use terror tactics. The pride of ownership! She is hypercritical in an attempt to be perceived as demanding. She places great emphasis on discipline, which in this case translates to conformity and submissiveness. It is her show, not yours. She aggressively pursues the "vision."

Directors: A Summary

The director isn't there to be your acting coach or your best friend. She has been hired by the producing organization to bring this show, with this vision, to an audience by a particular date. Unless you are working in educational theatre, she was not hired to further develop you as an actor/artist. She was not hired to make you look good. Obviously, it would be nice if someone helped you develop as an artist. It would be nice if the director made you look good. Try not to let it bother you if that doesn't happen. Yes, the really good director usually does make a lasting impression and assists you in meeting challenges in your craft and artistry that you have not had the opportunity or courage to address. Yes, the really good director works well with actors, stages beautifully, collaborates with designers, and brings it all together. The really good director works with each actor differently and works with each actor to create the most truthful and exciting performance that actor is capable of. She can analyze and illuminate a playscript. She can anticipate audience reactions and engage the audience with the playscript's potential and purpose. She can communicate her vision and awaken the creative genius of everyone in the room. Yes, it is a privilege to work with a really good director. A great privilege. And a rare one. Become the actor such directors love to work with. Take responsibility for your own work.

Designers

Your Relationship and Responsibilities to These Artist Collaborators

Just as with directors, designers have many different styles of working. These styles don't affect you as much as does the director's style, and certainly the designers are not casting you and working with you every day. However, when they do work with you, you need to pay attention.

Set Designer

This designer is usually considered the first (designer) among equals and has perhaps the greatest impact on the visual production values and physical movement of the play. He works very closely with the director to create the ground plan, including playing areas, levels, placement of furniture, doors, windows, and exits. These decisions early on between the director and the set designer determine how the play will move and where the actors will play given scenes. The set designer also establishes the basic tone and style of the play, which all the rest of the design elements draw from and contribute to. Is the set realistic and representative of a house, with functional doors, and windows that open and close through which you can see a garden? Or is it a unit set designed for theatricality, which can, by moving set pieces on and off, become a room, a heath, a cave, or whatever the play calls for? The set designer must understand the script on a story and style level as well as a detailed technical and logistical level that takes note of any visual element mentioned in the dialogue or stage directions.

Your relationship with the set designer is often minimal. Should the designer show up for a rehearsal and explain how something works, please pay attention. You don't want to be the one who breaks the swinging kitchen door and causes the show to go over budget, delayed getting into techs, or delayed progressing through techs. Listen. Make sure during technical

rehearsals that you use every aspect of the set you are called to use and make sure it is working and safe. Be careful with set pieces and respect the hours it took to put in a window. Learn how to open it carefully! If you have trouble working a given set piece or prop call the assistant stage manager over and ask them to make a note of the problem.

Costume Designer

This is the designer you will likely spend the most time with and with whom you will have the closest interaction. One of the first things that happens after casting is getting measured for costumes. Once you are measured, the designer and/or staff will set you up for fittings. Make sure you are clear about the times the costume shop has available for fittings and that there are reliable ways of getting in touch with you so that when a fitting time is set up, you are easily contacted. Very often the stage manager will inform you of your fitting times, but always follow up on your own. You are not the only actor being fitted, and the shop usually runs a tight ship on fitting times. If stage management is not handling communication with the shop and you are unable to make the fitting, you must call as far in advance as possible so that a new fitting can be set up and the shop can keep to its build schedule.

If you know that you will be asked to do certain physical moves in the production that will affect costuming, you must let the designer know during the fitting. For example, at the fitting you realize that the suit jacket is very snug and that you cannot lift your arms over your head. The director has staged a given scene and blocked you to pick up a suitcase and place it on a closet shelf over your head. You must check to see if you can execute the move during the fitting. Perhaps the director has you sitting cross-legged in a chair, but the pants are too tight to accommodate that move. You must try the move in the fitting and be clear with the designer and director that there might need to be an adjustment on one or both their parts. They need to solve this problem, not you. You don't have to advocate for the director or designer, you simply have to make sure that you can accomplish all the moves in a given costume and not wait until the dress rehearsal to discover the blocking has to change to accommodate the costume. If all the parties get on the same page in a timely fashion, the problems can get sorted out before there is a time crunch issue.

Allow the costume to affect you. How does it feel? How does it make you feel? How can you justify why you are wearing these clothes in a given scene in the production? Does your jacket have pockets? Do you have a hat? Handkerchief? Fan? Pocket watch? Look at the rendering carefully to see if the designer has any special costume pieces that you want to become familiar with. Ask the costume shop foreperson or costume designer if you may have a hat to work with or a fan to work with in rehearsal if you are to have one in the production. It need not be a nice fan or hat, just something to work with in rehearsal. Working out the small details of a costume can add greatly to your comfort levels and creativity as you move through rehearsal. If you are to have a long skirt and corset, they should be provided at every rehearsal so that you can accustom yourself to the way in which you carry yourself, sit, stand, and so forth.

How do the shoes fit? Be clear about the shoes—if they hurt you now at a fitting, they will certainly hurt later when you are wearing them for two to three hours at a time. It is difficult to think about your action when your feet are killing you. If you are unsure, ask the designer or foreperson if you may wear the shoes at one or two rehearsals to see if they will be a problem.

Try to stay the same weight. In a short educational theatre run this is not usually a problem, unless at the first fitting you were one size and a month later you are another. If you are union

and you change sizes during a longer run of a show, you will be financially responsible for alterations, not the designer or shop staff.

Makeup Designer

Most productions, even on Broadway, will not have a designated makeup designer. Usually the makeup designer and the costume designer are one and the same. In most productions, both amateur and professional, the actors are trusted, in consultation with the costume/makeup designer, to apply their own makeup. Most actors find this process a significant component of their nightly ritual of getting into character and bringing their attention and focus to the upcoming performance. If there are special effects, bruising, scars, or prosthetics that need to be adhered to the actor's face or body, a makeup artist might be hired by the producers to handle this more specialized aspect of the makeup. If you have not had the opportunity to study makeup application and design in a class setting, try purchasing a textbook and makeup kit and learn to design and apply makeup for yourself. You can see how professionals demonstrate some of the more complicated techniques and learn to master those techniques yourself.

Lighting Designer

You probably won't have much direct contact with this designer. Make sure you stick to your blocking because that is what the lighting designer will be looking for to focus the lights. Make sure you get into your light. Allow the light to affect you and inform your work. Is it sunset? Early morning? Hot midday? Use it.

Sound Designer

As with the lighting designer, you probably won't have much direct contact with this designer. The sound designer can do two types of sound design, conceptual and technical. Conceptual design includes underscoring scenes with sound, much as films do, as well as ambient sounds called for by the script, such as crickets chirping, a car pulling in a driveway, or dishes breaking—anything that is called for in the script or that the director thinks might be useful in enhancing or clarifying the audience's experience of the play. Technical design is responsible for the sound system itself and for maintaining the system in the theater as well as working with mics and sound reinforcement.

As with the lights, allow the sound to affect you. Let the crickets chirping be something you take in and let become a part of your imaginative experience on the stage. If the sound volume is *significantly* louder than you have been speaking during a portion of the play where there is now sound underscoring and you have *not* been told by the director to change your readings, stay at the level you were vocally before the sound was added. Don't try to outshout the system. Let the director make that choice and tell you to get your volume up if that is her choice. Don't lose your voice and push if you are not asked to do that. Ask the director what she wants if you are unclear.

Stage Managers

Treat the stage management team well. Before opening night you will have more contact with the stage manager and assistant stage managers than any other collaborator other than the director. After opening night, if you are in the professional theatre, the stage manager is the

only one of the original team of collaborators that you will have contact with. After opening night the stage manager is the protector of the director's original intent and can call brush-up rehearsals, replace actors that are leaving the run, and call rehearsals to integrate those actors into the production. During the course of a run, stage managers may give notes to actors should their performances deviate too much from the original direction. Actors can grow and develop in roles, but they cannot distort the original intent of the playwright as perceived and communicated by the director. Stage managers make daily performance reports to the producers and other contributors/collaborators.

Earlier on in the rehearsal process, stage managers help set up the rehearsal schedule and keep rehearsals running on time. Stage managers write down the blocking and make sure the actors are saying lines correctly when they get off book. Stage managers also write up rehearsal reports every day. If you are late, they will note it. If you were to have been off book and you are not, they might note that as well. Protect your reputation by being impeccable in your work ethic. These reports go to the producers and other collaborators and are a record of the work being done on the production. Stage management is also responsible for rehearsal props; if a rehearsal prop is not working, you need to let the stage manager know. It isn't their fault, so keep any annoyance or frustration out of your voice. Give them time to do their job. Stage managers are expected to do a whole host of other important and essential tasks over the course of the production, but the tasks just listed are the ones that affect you, the actor, most.

In the United States professional stage managers and actors belong to the same union, Actors' Equity Association. Professional stage managers are responsible for making sure that the actors only work the amount of hours the union allows each week and that breaks are taken on time. Stage managers protect the rights of the rest of the stage management crew as well as the actors during the course of a production.

The Dramaturge

In plays that are particularly dense in terms of language, history, or style you might be so lucky as to have a dramaturge. The dramaturge's job is to research a particular period, a playwright's work, and other works related to the play you are rehearsing and hopefully providing a context for understanding the play or the manner in which this play will be produced. One should take advantage of this researcher! If you do have one, it is a blessing, and you may ask this person as many questions as you like. Hopefully this collaborator won't get in the director's way, and you won't be subject to dueling sides of the story as it were. When in doubt, use the director's notes and not the dramaturge's. The dramaturge didn't hire you. Stay open. Keep deepening.

Summary

Theatre is the most collaborative of the arts, so it's a good idea to remain collaborative. Respect the work others are doing on the production, do your job, and you are likely to receive their respect as well. Actors often have the reputation of being highly, shall we say, dramatic. Try to reserve that energy for getting the stakes higher during rehearsals and performances. Try to keep those heightened stakes out of your communications and relationships with others during the course of the production. Save it for the work. Be a team player. Be good to work with. Keep a sense of humor. It will be appreciated.

Auditions

First of all, get used to them. This is the way an actor finds work. As Zan Sawyer-Dailey, casting director of Actors Theatre of Louisville says, "If you like to perform you should learn to enjoy auditions!" It is an opportunity to perform. Yes, the audience is small; yes, the show is short, but you are the star.

There are many different kinds of auditions. We will note and explore strategies for each of them in the following pages. We will explore monologues, prepared readings, cold readings, improvisations, go see's, commercials/camera, film/camera, TV/camera, and voice-overs. Each type of audition has its own purpose and its own manner of exploring your ability.

Your audition begins the moment you walk into the room

It is your show, and you are on. Everything you do is a part of your audition beginning the moment you walk into the room. Perhaps even before you walk into the room. The auditors may later ask the monitor who signs-in the actors how you behaved—if you were professional or unprofessional. In an audition, the people on the other side of the table are people who want a successful production in every sense of the word. Onstage and offstage. Unless it is a one-person show, in which case it is probably already cast, they are looking for a company of actors who can work well together for a long period of time, whether that be three months or three years. They are looking for a nice person. A person who gets along well with, and plays nicely with, other human beings.

Yes, of course they want talent and craft, and they want you to be right for the role, but it is a buyer's market, and they can get someone who has talent, technique, is right for the role, *and* plays well with others. Make sure you present that. You don't have to suck up and be overly nice, but you do have to have a healthy sense of yourself, a professional demeanor, and an eagerness to do the work. No one is doing you any favors, and you are not doing them any favors. All of you are there to work. And work with a great attitude and a sense of humor.

They want to see someone confident, professional, prepared.

They don't want to see insecure, needy, arrogant, unprepared, or angry.

It's so simple. Be prepared. Do the work. Smile. Take notes if given. Enjoy the moment, even if you are terrified. They also want to see that you can work under pressure. Even if you are terrified of failing. Who isn't? They need to know you can face down fear every rehearsal as well as on opening night. Prove it. You don't have to be perfect. You have to have the right attitude. That's all.

Leaving the room

When you leave the room be sure to say, "Thank-you." If you like, ask if there is anything else they would like to see. They won't have anything else they would like to see because if they did, they would have asked to see it, but it's a pleasant formality. Make sure that you leave the room on a friendly, positive note and not peeved that they didn't want to read you any longer than they did. Say thank-you, mean it if you can, and go. This matters so much. Maybe the role is

already cast, maybe they couldn't stand your take on the role—whatever! Leave the room as a professional, and you make a lasting impression *as* a professional. Just do it. The actor they had in mind for the role may say no—hmmm—you were so nice, prepared, and professional! How about you?

What to wear

Some directors and casting directors will care a great deal about what you are wearing, others will not. It is good to be well groomed, be clean, and look put together. You want to look as if you gave some thought to how you dressed for the audition. It shows self-respect and respect for the business at hand. Your clothes need not be upscale. You need to feel comfortable and able to work.

No flip-flops. No one looks graceful or professional wearing them.

No high heels unless the role calls for it. It is difficult to move gracefully in them. Do you want them looking at your shoes or your face? A low character heel is a good thing.

Make sure your hair is out of your eyes. They need to see your face. Really.

Okay, so don't insult the auditors by wearing a full-out long skirt, gloves, hat, and corset to audition for Cecily in the *Importance of Being Earnest*, but you may wear a blouse and skirt that help you experience the role physically, as well as making it easier for them to see you a bit more clearly in the role. A little goes a long way.

Monologues

When you first begin your career, you will more than likely find yourself being asked to perform prepared monologues more often than any other kind of audition. It's best to make friends with the monologue and see it as a useful tool for advancing your career in the business. A monologue is a one-person show. It consists of a piece that is anywhere from 1 to 2 minutes long; has a beginning, a middle, and an end; and allows you, the actor, to showcase the fact that you know how to use your voice, know how to use your body, and know what the arc of an action consists of. You are proving you know how to analyze the script. You are giving the auditor a chance to see you in action by pulling all this together and making it look easy.

How to choose a monologue

Perhaps the most difficult aspect of monologue work is simply finding the right material. Casting directors advise actors to select a monologue that they feel compelled to share. This means reading play after play after play after play until you find the monologue that you simply *must* say. This takes time. It takes commitment. Ask others for help. Find, say, ten to fifteen monologues and share them with people who know your work. Ask them which two or three monologues best suit you. This might give you some idea of how others see you and, in addition, how you might begin thinking about marketing yourself.

When you search for monologues, you may start with monologue books. There are many good ones on the market, but I should emphasize that you must still read the play that the monologue comes from to know the style of the piece, the tone of the piece, and whether it is a comedy or

a drama or some combination of the two. You need to find some reliable clues on how to work with this style and piece. You also want to be very, very clear about the relationship between the character you are playing and the character or characters to whom you are speaking.

If you haven't done that research of the whole play, you could very well find yourself auditioning for someone who does know the play and can see that you are not a person who prepares thoroughly. They can see you are not a person who reads plays. This is clearly *not* the best impression to make. In fact, a casting director I spoke to recently said that in an open call he became interested in an actor's work and asked what play the actor's piece had come from. The actor didn't know. The casting director told me he would never audition that actor again. What an opportunity wasted. You finally get someone in casting interested in you! They thought you did a good job. A good enough job that they are asking a follow-up question to try to get to know you better! Don't blow it for lack of preparation! Casting directors and others in the business aren't just looking for talent; they are looking for preparation, discipline, and an understanding of the demands the business makes of actors. It is a very competitive business. If you consider yourself a collaborative artist, you ought to be ready and eager to discuss material you are working on with any professional who wants to talk to you about the work.

You found the piece—now what?

So, you found a piece in a book of monologues, and you sent away for the play to read. You read the play. You break the monologue down. You contextualize the action. You work on the action of the monologue—what you want the other person to do or how you want them to change. Then you begin to shape the monologue.

You might need to do some judicious cutting of the piece so that it fits into the prescribed time frame but still maintains an overall arc with a beginning, middle, and end. You want to make sure that you convey to the casting director or director that you understand how to shape action and text. You want to prove to the casting director that you know how to play an action.

One approach to shaping a monologue is to split it into thirds: a beginning, a middle, and an end. Perhaps the first third of the piece consists of the character making a strong reach to the person they're speaking to: a strong want or strong action. Shift in the middle third to making a discovery, perhaps about the relationship with this person, that bends the action in a new direction, as you try to change or get something from this character. In the final third, come to some sort of resolution about whether or not you are closer to what you want from the other character or further away. Choose something. Finding an arc in the piece proves you understand the actor's job and are working at a level high enough to generate interest.

It's always dangerous to choose monologues with narrative, or storytelling, aspects that consist mostly of a detailed accounting of a sequence of events. For example, stay away from speeches that read like this: "First I went down to the beach and then I walked on the beach and then my feet got wet in the sand and then I looked over and saw the sunset and this guy started talking to me and he really scared me and then I decided I'd walk away from him." These kinds of monologues are not conducive to playing a strong action, so choose one at your own risk. They rarely serve to showcase your work. These pieces often simply involve "telling," which is always a weak choice for an actor. No casting director or director is interested in an actor who is afraid to make choices. No casting director or director is interested in an actor who is unaware that he or she needed to make action choices.

So, find the monologue you *must* perform; make sure it has a beginning, middle, and end; and make sure that you are working with action and transformation within the piece. Make sure it is not all one note. I would suggest you pick at least six strong, action verbs to play as you're working through it. There is nothing wrong with you if you find this process difficult. So is law school—so is med school. Why do you think your career path ought to be easy? Go for it!

Find the Action!

Here's an example.

Say you were working on Rosalind in Shakespeare's *As You Like It*, Act III, scene v, line 53:

Action: Make a man out of Silvius (very much fun considering you are a woman . . .)

(chastise, attack)	You foolish shepherd, wherefore do you follow her
(mock)	Like foggy south, puffing with wind and rain?
(build him up)	You are a thousand times a properer man
(put her down)	Than she a woman.
(berate)	'Tis such fools as you
	That makes the world full of ill-favour'd children:
(confide)	'Tis not her glass, but you that flatters her;
(enlighten)	And out of you she sees herself more proper
	Than any of her lineaments can show her,
(prove to Silvius)	But, mistress, know yourself;
(command)	down on your knees,
	And thank heaven, fasting, for a good man's love:
(confess)	For I must tell you friendly in your ear,
(advise)	Sell when you can, you are not for all markets:
(demand)	Cry the man mercy; love him, take his offer;
(shame)	Foul is most foul, being foul to be a scoffer.
(entrust)	So take her to thee shepherd; fare you well.

Let's develop and go after Rosalind's speech line by line. There are many, many ways to play this; find your own. I am merely showing you a way of going about working an action, not laying down any definitive way to play this moment, as if anyone could!

You foolish shepherd, wherefore do you follow her,

Always start strong with a monologue, to grab their attention and kick-in your own investment as well. Make a strong start here, and chastise him with energy. Attack him. It is his fault he is unhappy because he won't act like a man. How many times have you had to convince friends that they are worth more than they think they are? Is this the first time or the tenth or the hundredth? Make sure we know where (in your mind) Phoebe is standing. Don't "indicate" this but make sure you at least look in "her" direction somewhere around "her" so we get the sense that they are both right there.

Like foggy south, puffing with wind and rain?

What a picture! All tears, rain, running after, feeling sorry for himself! Mock this behavior; embody his behavior in your mocking. Don't go over the top but Shakespeare is giving you a great license here and a great image filled with movement and sound. Use it!

You are a thousand times a properer man
> Change the tactic here and instead of mocking, build him up! Slap him on the shoulder! (in essence)

Than she a woman.
> Put her down! Rip the blinders from his eyes! (refer to or look at the area where you established Phoebe's presence)

'Tis such fools as you
> Take this line to Phoebe—really insult her!

That makes the world full of ill-favour'd children:
> We can think about "ill-favored" as being "ugly" and essentially you are accusing Phoebe of being ugly and of propagating ugliness.

'Tis not her glass, but you, that flatters her;
> Back to Silvius here, confiding in him, gaining his trust. Make sure you point the antitheses (the opposites!) of *glass* and *you,* and make sure as ever that you hit the verb here: flatters.

And out of you she sees herself more proper
Than any of her lineaments can show her;
> Enlighten him! Expose her! Convince him it is only his *reflection* of Phoebe that gives her any power! She is ugly, and she only thinks she's pretty because *Silvius* does.

But, mistress, know yourself; down on your knees,
> Focus back to Phoebe—prove to Silvius this is true by forcing Phoebe to admit that she is ugly!

And thank heaven, fasting, for a good man's love:
> Make Phoebe grovel in gratitude for Silvius's love.

For I must tell you friendly in your ear,
> Confess, pretend to be a friend; I'm on your side. This is confidential, between you and me.

Sell when you can; you are not for all markets:
> Advise her. Take what you can get, Phoebe. You're ugly; no one wants you.

Cry the man mercy; love him; take his offer;
> Demand gratitude! Great verbs here! Cry, love, take!

Foul is most foul, being foul to be a scoffer.
> Shame Phoebe here. Ugly is even more ugly, being ugly, to be ungrateful for love.

So take her to thee, shepherd; fare you well.
> Conquer! You have achieved the objective! He is a man! Overcome his doubts! Entrust her to him! Bow! Hand her back to Silvius. Marry them.

Go through any piece this way, placing verbs, subtext, and ideas next to lines or passages. This helps you get more specific with what actions you are taking, and what attitudes you have about your actions and those of the other character. You should never *play* an attitude, but you must *have* them! I can have the *attitude* that Phoebe is cruel, but I need to *play the action* of shaming her.

In performance, you don't have to rigidly adhere to playing the verb you chose when analyzing the text for action and tactics. If all you are doing is remembering to play a verb you wrote down three days ago, the analysis you have worked on becomes a purely intellectual process. This process of text analysis and exploration should make the work more fun and more specific. This work forces you to make choices, specific choices that come out of the text and are supported by the text. It should be a springboard to a lively, brave, and useful rehearsal process.

Once you know what verbs you are using, what action you might be taking, you then begin to Explore how to *receive*, how to perceive what you're seeing or hearing from the other or the imaginary (in the case of the monologue) character in relationship to your objective. For instance, you know you must shift focus from Silvius to Phoebe on, "But, Mistress, know yourself." How are you going to get there? If you imagine you have been working very hard on *enlightening* him and *tearing the blinds from his eyes* and he doesn't give you an emphatic, powerful nod or cross to Phoebe to take her on, you need to *do something else* at this point to "Make a man of Silvius." In this case, you choose to take her on yourself because you did not *get what you needed* from Silvius. Alternately, you could imagine that Silvius nodded his head with encouragement or shook his head as if he didn't understand. This would also give you the pinch or prompt to change your tactic and go after Phoebe and prove to Silvius she can be taken down. You can give him the courage to do the same if you prove it can be done! You realize you now have to attack Phoebe because Silvius won't have the gumption to listen to you and take action on what you're exposing. So, finally, you either turn to her because you *did* get what you wanted from Silvius or because you *didn't* get what you wanted from Silvius. It's got to be one or the other. If not, the casting director or director will know you haven't done your homework. And, again, homework is only a springboard to waking the genius inside you in service to the work. You will wake up your intuitive responses by getting to specifics.

Physicality

The way you stand and where you face matters a good deal in the monologue. Certainly as you introduce yourself and your pieces, you want to face forward and look at the auditors. Moving into the monologue, you might shift your focus inward and turn away from the auditors. Perhaps turn toward the spot you have chosen to place your imaginary scene partner and start at the bottom of the imaginary partner's feet and let your eyes travel up his (imaginary!) body till you find his face. Another approach might be to start the piece turning to look directly at the imaginary scene partner. The most important thing here is to make sure that this first contact with your imaginary partner is clear, clean, and precise. You need to know to whom you are speaking and play an action. The confidence you express here will grab and hopefully keep the auditors' attention.

When young actors are nervous, they are often afraid to let the auditors see their faces and sometimes play to the sides of the room or theatre. This isn't a great strategy, as you came to be seen, heard and hired. You must primarily play out, perhaps 15 degrees or so to the right or left of center, so that the auditors can see your face, your choices, and your expressions. It also helps them hear you because they can see your mouth moving and forming the words. Try, too, to keep your eyes up; not too high, or it will look as if you are praying! But you must get them up off the floor and out. It is the mark of a real amateur if your eyes are cast down. The auditors need to see your eyes. If the eyes are the windows to the soul, you want them to see what is going on in there!

Now, with each piece you want to make sure that you're incorporating physical action. If you just stand there the whole time, the casting director or director has no clue that you know how to move with the action and in relationship. You should have a good sense, hopefully from your training, of moving on the beat change. If you have broken the piece into three sections, you might take the bigger moves between the sections or on the first line of each section. These moves do not have to be huge, but you need to make them as they will help you stay in the

moment and connect to the physical action. This can help you "stay out of your head" while you are auditioning or, for that matter, acting in any situation. Going back to Rosalind, when you shift your focus back and forth between speaking to Silvius and speaking to Phoebe, not only should we hear a change in *tone* (because your relationship to each of them is different as is the action/tactic different), but so too should the *physicality* be different. If you play the entire piece with hands at your sides or with hands on your hips, you are not making useful choices. If you only take one step each way and stay locked in the middle, that is not a useful choice; it is repetitive and lacks meaning.

Two common problems regarding movement for the amateur actor

Amateur actors often make two mistakes with regard to physicality both in auditions and in stage work generally. One mistake is making parallel gestures in which both arms are doing the same thing, making the same gesture. One of the most painful examples of this gesture is when an actor's arms are bent at the elbows and the actor just keeps moving the lower arms and hands up and down either to the side or in front. Flapping away. It is not a strong choice. This also often leads to the second mistake, leaning or bending forward at the waist, which proves to the auditors that you cannot move and that you are so unfamiliar with your body that you will be unable to use it effectively and unable to respond to physical cues in any immediate or genuine fashion. It proves to them you are too frightened to make a choice and even were you capable of experiencing a moment onstage, you are probably too blocked to respond truthfully or evocatively.

Advice from Geoff Nelson and Jonathan Putnam

Geoffrey Nelson, founding artistic director of the Contemporary American Theater Company, and Jonathan Putnam, longtime associate artistic director of CATCO, shared some observations made over the course of twenty-five years of acting, directing, and casting at this and other professional theatres. They thought a telltale sign of younger actors is that the younger actors are more nervous and go too fast during their monologues and readings. Geoff said that a wise actor places a pause early in the piece to set up a place to reset the pace should the work have gotten off to a rather rapid start. They also noted, as have others, that the audition begins the moment you enter the room. They suggested that the actor be open and confident without being too "cocky." Even if you are faking it, they like to see a professional demeanor that says, "I've been here many times before." They thought young actors might sometimes be too chatty and not get on with the work.

In particular, they thought that a monologue devoid of action changes, arcs, tempo changes, vocal changes, discoveries, or shifts was the mark of an actor with few skills and little technique. They agreed a good monologue contains these aforementioned qualities, and they were clear that an experienced actor would be capable of choosing and distinguishing between pieces that created the opportunity to reveal craft and what pieces did not.

I asked Geoff how he would define talent. This was his response:

Geoff: "I don't believe in talent so I won't define it. Someone may have skills, might have aptitude. I've seen too many people who I thought had no talent and then have worked hard and suddenly seemed like they were really talented. For me it is about skill and work ethic."

I asked Jonathan what one piece of advice he would offer an actor regarding auditions. Here is his advice:

Jonathan: "My biggest thing with actors is *make a choice*, an *interesting* choice, Just one! Show that you know what an audience likes to watch. They don't like to watch little, tiny acting with no strong choices."

Prepared readings

This kind of audition is an audition in which you have been told the play you are working on. You will be given the scenes or *cuts* of scenes: these are the pages that you will be reading for the audition. You will be expected to have studied the play. The readings ought to be prepared with a strong objective in place. If you are auditioning professionally, you will often be asked to read with a *reader*. The reader must be treated with respect. Don't touch the reader without asking if that's okay before you begin. The reader may be another actor who's been hired by the casting director, or a stage manager or an assistant director. The reader might be the casting director herself. You want to make contact with the reader and make the scene happen between you, but you don't want to cross the boundaries and physically assault the reader! For instance, if you were reading that scene between Rosalind and Silvius, you would really play your action with the reader; you might even be able to touch the reader on the shoulder, but only if you asked the reader before the scene began if that were all right with him or her.

Be prepared. Have your own ideas about the play and what the character wants within the circumstances of the play. Know about the playwright, and if you have the time, read other plays by this playwright to gain a better sense of the style of his or her works. You would give a very different reading if you were doing a play by George Bernard Shaw versus a play by Shakespeare versus a play by Harold Pinter versus a play by Sam Shepard. That is not to say that any of these playwrights require an entirely different sort of acting, but they create specific worlds in which characters driven by specific actions are fashioned. You must understand these actions and worlds. If this is the playwright's first play, then keep reading it until you sense you understand his point of view, the world that has been created, what the characters in this world want, and how they get it. This is, of course, much the same work you would do for a scene study class. The work is the work.

Some Thoughts on Prepared Auditions from Zan Sawyer-Dailey, Casting Director and Associate Producer, Actors Theatre of Louisville

Zan Sawyer-Dailey of the Actors Theatre of Louisville has been both the associate producer and casting director for many years in this organization. For the past twenty years Zan has cast or has had the major hand in casting most of the productions at ATL. Zan has cast out of New York City, Chicago, and Los Angeles. She has a very clear sense of the business and is current in her understanding of how the business works and what actors can do to help their chances of succeeding in this business. Zan thinks that when actors get the audition, they should have read the play, determined the style, thought about the playwright, and explored some of the playwright's work. She thinks actors might want to ask themselves why the director selected this particular scene or scenes for them to read. They might ask, what is so significant about these scenes? Why

would the director need to see these scenes to cast the role confidently? Obviously, the director chose this material for the audition in an attempt to clearly gauge an actor's rightness for the role.

Zan Sawyer-Dailey suggests that when you come in to do the reading, just begin. She said that most often the director or the casting director is very interested in what you thought of the material, why you think this scene is exciting, and if your instincts about this action and character will work. It is a collaborative art form, and to be taken seriously as a collaborator you have to show up with ideas about the work. Most directors don't want to work with actors who have no ideas about the work or interest in developing the work. You are an artist, so show up as an artist with ideas for fulfilling the potential of this production. If you say things like, "Is there anything you'd like to tell me before we start?" you are losing the opportunity to show them what you brought. What if, after all of your careful analysis, you grasped some pretty substantial ideas about the play? If the director simply hands you those ideas you now can take no credit for that work and have lost the opportunity to prove your skills in understanding and bringing the play to life! After the initial reading, they can suggest adjustments or you can ask if there are any adjustments that they would like to see.

Some red flags

Here are a few red flags that Zan and others have mentioned of behaviors to avoid:

- Asking too many questions—this is often interpreted as (a) you did not do your homework, (b) you are trying to make the audition last longer, thinking the longer the audition the better chance I have, (c) that you are needy and this is a bid for attention, and (d) unprofessional in that you don't understand how the professional audition works.

- If you do ask a question and the question is general and not thoughtful as regards the work, it sends a red flag. If the actor asks the wrong kinds of questions, it is a signal that they are unprepared or have little technique.

- Any sort of come-on or suggestiveness to any person in the room, unless of course it is to the reader and it is contained in the material!

- Seeing any of the reactions on the parts of those auditioning you as a signal that they do or don't like you. Get it into your mind that they either see you in the role or they don't and let it go, period. This is a professional attitude. They value that. So should you!

How do you put Zan's advice to work?

So, say you were auditioning for the part of Catherine in David Auburn's *Proof,* and the director chose the scene between the sisters during which Claire tells Catherine she, Claire, is selling the house. You might ask yourself, "Why this scene? What do we see in this scene that we don't see in any other scene?" You might decide that this scene would be important to a director because it forces Catherine to go from her most peaceful and whole moments thus far in the action of the play to reacting violently and acting out of deep fear and instability. The scene asks that Catherine try to solve the problem by struggling with her own fear as she tries to force her sister to tell her the truth. A director might have picked this scene to explore the chemistry between the sisters when they were getting along then moving away from that toward Catherine distrusting her sister again. In preparation for the audition, you would want to map that journey between

the sisters and sensitize yourself to that journey. You would want to decide when you do trust her and when you don't trust her; this would need to be borne out by responding specifically to what Claire says or how Claire says what she says or how she looks at you. Nothing generalized is useful. It must be a specific reaction to a specific prompt. It must be *causal*.

Perhaps the director chose the scene between Hal and Catherine the night of the funeral. The director would be looking to see if there were a believable connection between Catherine and Hal. Looking for that magical combination of Catherine the incredible genius, willing to take risks emotionally and sexually. A woman testing Hal and herself to make sure she recognizes and is ready for the risks.

Think about why these scenes were selected and what in particular the director or casting director might be looking for in choosing them. Solve their problem. Give them what they are looking for. You want to know what you want out of the other character, what your objective or objectives are; I want to force Claire to tell me the truth. I want Claire to admit that she's a scheming bitch. I want to challenge Hal's assumptions. I want to make Hal curious about me. I want to fascinate Hal enough so he'll take me to bed. Achieve these various objectives using specific verbs (tactics). You could either have a list of verbs that this character might use in this particular situation with the other and use them intuitively as it feels right during the audition, or you could be more specific and choose line by line which verb to use. It doesn't matter to anyone but you, and you must choose whichever way ends up working best for you in any given situation. This may change role to role and audition to audition. You could prepare it specifically then throw it out the window and just hold to your objective and play it as it comes. You need to define your technique and how it works best for you; what works best in opening yourself and your imagination to the material: its context, action, and possibilities. This is no one's job but your own. Period.

Some thoughts on taking direction during an audition from Marc Masterson, Artistic Director of South Coast Rep

If the audition is going well and the director has the time, he or she may give you some direction. Marc Masterson says that it's the "kiss of death" if an actor does not take a direction given by the director during an audition. Marc says that the direction given may never be used again in the course of the production; the director is often only looking to see if this actor and the director can communicate and work together. The direction may simply be given to make sure the actor is capable of taking direction, communicating and being communicated with. The director is thinking about future rehearsals should that actor be chosen to play this role. He or she is looking for an actor to take the note and do their best in moving in the direction of the note. The director is also looking for a good attitude in response to the direction given; is the actor able and willing to work collaboratively? Or does the actor insist that the director's questions or suggestions are just too confusing, insupportable, and therefore not worth doing? Masterson also remarked that if it came to a choice between a brilliant actor who was difficult to work with and someone slightly less talented but easier to work with, he might very well choose the person who was more collaborative.

What does that mean? Can I not have an impact on the choices in the production?

Working well with others is a lesson we learned in kindergarten, and it still holds true. We are all individual artists in the theater, but we must work together collaboratively in this, the most collaborative of art forms. If you chose this business, then you chose to work collaboratively. Give

the director the benefit of the doubt and do the best you can. Make sure that you understand the director's suggestion, but don't "comment" on it. "Comment" means making a judgment call about it, that either you think is a bad idea or a brilliant one. It is an idea, and if you want to work with this director you should be eager for collaboration, not resent it. Ask a question about the suggestion if you're not clear, and then give it your best shot. The director is looking to see if he or she can work with you and making sure you enjoy the collaborative process.

Bill Tatem, an actor of long standing who has worked in New York, in Los Angeles, on soap operas, and in regional theatre, thinks that during an audition, the actor should, in a sense, audition the director. Do you want to work with this director? You need to be observant and note the way you are being spoken to and whether or not you like the energy in the room. Is this a relationship you think you can work within and develop communication? Do you feel like an equal? Do you feel as if what you offer the production will be valued? It is a small business, and you don't want to burn any bridges so if you do have a negative response to this audition experience, for heaven's sake don't let that show in the room. The last thing directors, casting directors, and agents want is a bitter, angry actor. They asked to see you. They think you might be right for a role, or you wouldn't be in the room! Yes, it is can be an ego-busting business, and many, many actors become hurt and damaged in the process of trying to build a career, but don't take your frustration out on anyone else in the profession. It is easy to feel slighted in an audition. Clear your head, and give all the collaborators the benefit of the doubt, including yourself. If you really don't like the director, make sure you don't audition for her again, but don't let her know that— she might just tell someone you would like to work with that you are difficult. This holds true in any theatre community, not just the professional theatre community. Theater practitioners in university theatre and community theatre also chat with one another and warn companies and directors to steer clear of actors who have an attitude, are late for rehearsals, don't learn their lines on time, don't get along with other cast members, or demand special treatment. Make it clear you can play well with others. If you are prepared, everyone in the room will know you are intelligent, committed, and capable of making a contribution. Bill Tatum thinks you have a right to experience respect for what you offer. Audition them a bit, too, but without an attitude; it helps to get your focus off "Do they like me?" and shifts it a bit to "Do I like them?"

Some Further Thoughts on the Prepared Reading

These are the most typical auditions you will experience to obtain work in the legitimate theater and can be a lot of fun. They might know by looking at you when you come into the room that you are not the right "type" for this role; it could be over that fast. You might change their mind with your reading, or not. You could fit in with the company members already cast, or not. There is so much that is out of your control at this point. Do your best. They are evaluating you from the moment you walk into the room until the door closes behind you when you exit. You may not get this job with them, but if you do good work, have a great attitude, and are professional, you might get the next.

Michael Legg, intern and apprentice company director at Actors Theatre of Louisville has a few thoughts on the audition process

Michael Legg has been a working actor, agent, and educator and knows the business inside and out from a variety of perspectives. Michael said he learned a term used for the actor's "presence" in the business from an actress he worked with at ATL. He said she had remarked that

actors needs to find their "professional persona." You playing "You," in a sense. Many of you have had jobs, and in each of those jobs more than likely you had a "persona" that you put on like a uniform most days, and you worked with others out of that *persona*. Yes, it was you, but it was the part of you most suited to doing this work. You need to do the same with your *persona* for the industry. Then no matter what kind of a day you are having, you have this self that you present as your professional persona. It is no substitute for the work, but it can relax you and the others around you enough to see what you offer the business, the role, the company, the agent, or the casting director without a lot of other messages getting in the way. Tell them what you want them to see.

I know that as a teacher I have a very consistent persona in the classroom. That isn't all of me, hopefully, but it is what is appropriate for the classroom experience. I "put it on" every day when I am teaching. You must do the same for your work in this business. Michael Legg said find your persona and then do your work!

The second tip Michael offered was to look beyond your first choice in playing a scene. He thought that it was extremely valuable to have something besides your initial instinct in exploring any role you were working on. He thought that yes, the first choice is generally a good one and can bring a lot to the work itself, but often an actor finishes making their choices there. Michael explained, "These initial choices can be shaped, morphed and transformed by what others are giving you and you must be open to that kind of work at all times. You have to be open. You have to show up and be present." Michael was pretty emphatic that a continual and, more dangerously, singular reliance on the first instinct had benefits but was also limiting to expanding and sustaining a role. Instincts are not technique. They are useful, but they are not technique.

Cold Readings

Cold readings are cuttings from plays that you have never seen before; perhaps no one other than the playwright, director, or casting director has seen these scenes from these as yet unproduced and/or unpublished works. This does not happen nearly as much as it used to with the advent of the digital age. Now new scripts can be sent out to casting directors, and they can, in turn, send actors to Web sites to read the scripts in advance. However, it still does happen, and here are some thoughts on this process. It can be very exciting, as people may have fewer preconceived notions or ideas about the exact way this new play should be cast. The field is definitely more open, but really strong choices need to be made with this material. You need to find an action very quickly, commit to it, and play it.

More often than not when you show up at the audition, you will be permitted to look over the scene or the play briefly before you are asked to read. Naturally you want to get there early and see if you can read through the material as completely as you can before auditioning.

If the material is not available, then it's not available, and you can't prepare ahead of time. Read it quickly, get a sense of the relationships, pick an action, and commit. Fully engage the other person. Read the line silently and then raise your eyes to the person's face and say it out loud. You want to make sure that you're really connecting with this material, connecting with the reader, and giving yourself the time to make this connection. If you find that all of a sudden there's a lot of momentum in the scene, feel free to play and make choices regarding tempo, timing, movement, and variety. That's good! Even as you begin working the scene, make sure

that you are still pretty much saying the words as they're written and making contact with your partner. If the directors are interested, they'll start to guide you through the material. Have fun.

A method of preparing for this particular experience, or any experience with reading from a text, is to practice reading out loud at least five minutes a day. Practice with novels, newspapers, textbooks, poetry, any kind of reading material. The more you practice this, the more easily you will free yourself into a natural expression of voice, body, and spirit, as well as being able to respond intuitively in the moment to what is actually happening. Which of course is the aim of all good technique! You may not be the better actor, but if you are capable of reading easily and expressively from text you may get the job.

Musical Theatre

First things first. You need to be able to sing on key in the vocal range of the song with which you are auditioning. Next, you need to be able to excel in the vocal style of the piece for which you are auditioning. Is the style blues, gospel, pop, legit, rock, folk, country, or operetta? Make sure you know and can work within the given style. Third, you must be able to treat the song selection as if it were a monologue with all the actions and specificity we have previously discussed. It will be an integral part of your work on the piece.

Shakespeare shifts from prose into poetry within his plays. In Shakespeare's plays we leave the prose and shift to poetry because the subject matter requires a lift to a new, heightened level of communication, discernment and emotion. The same principle underlies the shifts from dialogue into song within musicals, In musicals we leave the dialogue and shift to the poetry and music of song because the subject matter requires this lift and heightened level of communicating and discernment.

Say lyrics of the song *as if* the lyrics were a monologue. This anchors your performance in the *action* of a song. The beauty of your voice and your ability to master the music is significant, but what you must *also* master is significant: an ability to connect with the material and the intent and action contained in the lyrics. You aren't just hitting the high notes, you are communicating the lyric.

General Auditions In general auditions you can pair a song with a monologue. Choose the material you do best and make sure the song and monologue are contrasting. If Cole Porter is what you do best, do it. Rogers and Hammerstein? Do it. If you don't yet know what you do best, ask around, find the best accompanist in town and set up an appointment. Ask the accompanist to determine your range, give you a vocal warm-up you can tape during your session, sheet music, and taped accompaniment for three or four songs that are within your range, appropriate for your style, and usable with some work, study, and practice on your part. Make sure you've checked to see how many bars of a song you are permitted in a given audition and prepare accordingly.

Specific Show Where you are auditioning for a specific show and perhaps a specific role in the production your strategy will be different. Find material of the same style, perhaps the same composer, to prove you understand and can sell that style. If you are not familiar with the music go online. There are so many databases and offers of free sheet music online. Some will actually play the music so you can check it against your range. You can go on YouTube as well, plug in the name of the composer or song, and watch others sing the song to see if you have an aptitude for that style or, at the very least, get a sense of the style by watching twenty different performers struggle with or master it.

A Warning Don't go beyond your reach if you do not have the time to prepare. If a style is new to you and difficult, better to cancel than to go poorly prepared. We've mentioned it before. A bad impression is hard to unmake. If you only have a day to prepare Sondheim and you don't know the song, the style for this show, the purpose of the song, and the ability to move the song and action forward, don't go. If you've known about the audition for three weeks, shame on you. Tell the auditors right away so they can see someone else they might actually cast. If you are auditioning for educational theatre and you have been asked for a Sondheim piece, pick the one you can do best and go with it.

Bring your sheet music You must always bring your music to the accompanist in auditions unless otherwise noted. You must mark your music clearly: tempo, where you wish to begin, where you want the music to shift to another stanza, and where you will end the piece. Be especially clear about crescendos, pauses, caesuras, and liberties with the timing or phrasing. If you expect a specialty moment where you hit the money notes, tell them. Go over all this with the accompanist before you begin your song. And be nice to the accompanist. They are your advocate. Help them help you. It bears repeating. Be nice to the accompanist.

Choosing material In choosing material it is not so important to surprise the auditors with new material as you are there to prove to them that you can sing the kind of material that will be used in the production. Don't be afraid of singing from the Jerry Herman repertoire if the musical being produced is a Jerry Herman masterpiece. Don't worry about singing a song that the auditors will know. If they have asked for a specific song, then you will need to prepare that song. As always, the audition begins as you walk into the room and continues until you exit. Bring your book of material with you if you are a musical theater performer. You will want some legit music, country, folk, pop, jazz, and include anything that you think you excel at. They may ask you to sing everything in your book or nothing from your book. Just make sure that you're prepared to excel.

Movement You don't have to have major dance moves in your song but you do need to prove you are physically sensitive to musical cues. Move on key changes, interludes, tempo shifts, new stanzas, refrains, and so on. Not on each and every one of them, but you should move a few steps on at least two of them if you get sixteen bars. You need not go far, it need not be more than a few steps but it should be very connected to your intent and to the music itself.

Another warning Be careful of singing just for the sake of singing, no matter how glorious your voice. No one likes to be belted at just for the sake of the belt. It can feel like an assault, especially in a small room. Always be working on an action, solving a problem, changing the other, making a decision, figuring out a solution, pinpointing the problem, making someone see your point of view. Do something other than just overpower the room.

Improvisation

Sometimes directors will ask that you improvise a scene or relationship. Their reasons for this may be various. They may feel that you are hampered by the script and want to see what you are like on your feet playing off the relationship and diving into the action. Or they may want to see how brave you are and if you're simply willing to improvise. Or they realize that the script is in its early stages, they aren't necessarily married to certain aspects of the work, and they would just like to see a different take on the material. Whatever the case, without appearing afraid or neurotic, make sure that you understand what the director wants to see in the improvisation,

and then go for it. Improvisation can never be "perfect," and that shouldn't be the measure of your success. If you have used improvisation before or studied improvisation, this will be easier, but if you haven't, just do the best you can, and don't apologize.

Sometimes in improvisation we get the feeling or the sense that we succeed only if we are funny. This is not the kind of improvisation we are discussing here, unless you are auditioning specifically for a comedy club or improvisation troupe. Here we are discussing improvisation within the context of an actor auditioning for a particular role or roles in a given playscript.

Go sees

This is the term that was often used in the business for simply going to meet casting directors, agents, or artistic directors. These meetings can happen in little towns with small theatres and television stations, or they can happen in the big cities with prestigious corporations. These meetings are primarily about discovering what kind of person you are. Finding out if you can have a conversation and get a feel for what you might be like to work with. They'd like to know how you show up in real life before they start suggesting you for particular roles in the theater, television or film. You show up looking the way that you normally look on a good day. You take care of your appearance and dress to your type a bit. If you tend to play intelligent, corporate women, then dress accordingly. If you play laconic cowboys, perhaps jeans and a flannel shirt. You get the drift. Have something to talk about, whether it be what happened on the way to the meeting, what shows have opened, a controversial film, a current event, something! Be very familiar with this person who is interviewing you. Know their work and work history. It is a part of your preparation. Know what they do and how long they have done it. Not that you ever have to bring it up, but you never know how a conversation will turn and what might become of it. If you were applying to be a clerk for a judge, you would certainly have researched the judge and become familiar with what kinds of decisions she had handed down and the sorts of cases she had heard. Why not do the same in this profession? You might perhaps touch on subjects that you know would interest them without sucking up too much. These are people too, people who are eager to do well at their jobs and eager for you to be an asset to them and an asset to the industry. They wouldn't bother seeing you if they didn't think that that was a possibility. So enjoy it. Get to know them. Be your interesting interested self as best you can. Be on time. Be on time. Be on time. Don't be needy. Do be nice.

Camera/commercial

When auditioning for a commercial on camera, you want to make sure you get there well ahead of time if possible. You want to get a copy of the copy (the words that you're going to say) and to go into the restroom to work or work in a hallway. Find an approach to this piece, figure out who you're talking to, memorize it as much you can, and get into your own creative world. If you are not able to memorize the entire piece, memorize the first and last lines so that you can give them directly to the camera. If it's a commercial about ibuprofen, decide that you're going to be speaking to a best friend and that you're really trying to help them out. Prove you empathize with how difficult it is to be a mom, work a jack hammer, study for a test, or clean the house when you're experiencing such a debilitating headache. At the end of the story (the commercial is a story), the happy ending is when you are cured of that pain! Let that be a tangible cure! There is relief in your voice and renewed energy to go on living. Break it down into these bite-sized

storytelling chunks. Usually there will be a storyboard on the copy; if not, make up your own. Practice all this in the hallway or looking into the mirror in the restroom. Mouth the text, meaning say the text without engaging your voice, if you feel self-conscious about vocalizing.

When you go into the audition itself, you will be shown where to stand or sit. There is generally a line taped on the floor that is usually referred to as your *mark*. You will walk up to the line or sit in the chair, whichever is indicated. The camera is focused on this point and on this particular plane. The lighting, if there is lighting, is focused here as well. It is unlike stage work or a stage audition, where you're free to take a couple of steps this way or that way if you are working within the designated area. However, in any camera work, if you move at all, they will tell you where and when you are to move.

They will then ask you to *slate,* which simply means to say your name, the take number, and perhaps the product. Cindy Toblonsky, take 3, Dove Lotion. Check with them to see if they're ready. And then you begin the work. It's important to know how long the commercial spot is. If it's fifteen seconds and you have quite a bit of copy to get through, you will be wanting to go through it a little more quickly. If it's fifteen seconds and there are only two lines of copy, you can go more slowly. You don't want to rush, unless that's part and parcel of the harried housewife or contractor that you're playing. Get a sense of the material. Make a commitment. Look at the camera. Take your time.

Camera/film

Normally, when doing television or film work, you will receive the scene that you are to prepare ahead of time. You may or may not get the entire script. Certainly you can ask whoever offered you the audition or got you the audition to tell you more about the script if the script is unavailable for you.

If you don't have access to the script, the auditors or your agent may give you a feel for the style of the work; perhaps *George of the Jungle* meets *Godzilla* or Las Vegas meets Disneyland's Splash Mountain. They may say to you that this role is a young Matt Damon or a young Emma Thompson. They don't say this to tell you how to play it, but to give you an idea of the kind of character that has been written. If those images offered don't make any sense, do some research.

So we're assuming you're as prepared as you can be; you've read the scene or script at home, and if you can, you've gotten other people you trust and respect to review how you've explored the beat changes and the progress of the action. You arrive at the audition on time. You sign in. You may or may not work on camera for the first audition. It depends on their timetable, preferences, and finances. They'll let you know, and if they don't, don't worry, you'll catch on fast!

If you are on camera, you won't be allowed to move anywhere else other than your mark, again because the lights and camera are focused on that spot. Should they ask you to move on a given line to another place they will have marked the place with tape on the floor, and again, that is your mark for that portion of the scene. If you are on camera, you will *slate,* meaning you will say your name. As in, "Karen Garcia, Take 5, Little Insights." You then begin the scene. They will tell you where to look, be it at the camera or a tape mark on a chair. They will tell you the setup. If not, ask a question. Do your best to visualize the person to whom you believe you are speaking.

Do the same kind of work you would do on any other scene or monologue, but *take your time*. It isn't a three-minute time slot. If you're in the theater, you have a sense that you don't want to bore the audience or take too many pauses that were unearned. You keep the tempo moving. In

film work that is generally not as necessary; the editors will cut out pauses if they are not useful. What's interesting about camera work is that we enjoy watching thoughts, realizations, and discoveries play on the actor's face, so don't push through the material and miss opportunities to allow those nuances to play. A little goes a long way. Michael Caine's book *Acting for the Camera* is brilliant. Highly suggested reading for an actor going into the film or television audition.

Voice-over

This is a great way to make a substantial amount of money in the industry if you find that you've become good at working with your voice. This means you are specific, articulate, creative, and interesting vocally. You don't have to worry about how you look or what you wear! Many books have been written on the voice-over industry, but one of the best is *There's Money Where Your Mouth Is: An Insider's Guide to a Career in Voice-Overs* by Elaine Clark.

If you're serious about voice-overs, you need to put together a demo, which is your resume in essence on a cassette, CD, or sound file on the Web. It's a resume of sorts containing representative samples of your recorded work. If someone wants to hear your work, they would listen to this demo, in whatever form you've put it, to get a sense of the type and the breadth of the work that you do. Putting together a professional-quality demo is an investment, certainly, but it is well worth it if you are serious. You can look in *Backstage* online and find professionals in differing markets who can help you put a demo together. These might be expensive, but if you want to work in a larger market, you need to present a professional-quality demo to compete. If you are in a smaller market, check Craigslist or the Yellow Pages. You might go to local television and radio stations and see if they can recommend someone locally that they respect.

So, whether you find the audition on your own, or if you are submitted or read about it in the paper or saw an ad in *Backstage*, get there early! The first thing that you'll do is sign in and let them know that you're there. Then go over the material, the copy. You want to try to get this ahead of time, if possible. If not, practice now. Remember, if there are lots of folks around, you can "mouth" the text, which means making all he mouth and tongue placements, and so on, but not making any sound whatsoever with the vocal folds. This way you can play with the copy without disturbing anyone as well as familiarize yourself with how the text feels in your mouth. It would be a good idea to carry a pocket dictionary with you just in case you don't know what a word means or if you aren't sure how to pronounce a word. On the copy you'll notice the length of the spot. It could be anywhere from a five-second spot to a forty-five-second spot; fifteen and thirty are pretty standard spot times. At any rate, using the second timer on your cell phone, make sure that you time yourself and get as close as you can to the allotted spot time.

This is probably not the time to do all your tongue twisters and mouth exercises other than as a light warm-up. If now is the only time you perform articulation drills, you could create a lot of tension in your mouth, tongue, and throat. That isn't going to help you as you try to work on freeing yourself into these voice-overs. Whatever work you are doing, make sure that you are doing your vocal work every day. Don't get your instrument all knotted up trying to do a month's worth of articulation drills in ten minutes when you're at the audition or booking.

When it's your turn, you'll be shown into the control room; this is the room where the director and the engineers listen to your work and adjust the audio equipment. They will introduce themselves to you and give you an idea of what they are looking for. If you are still unsure of any pronunciations, even after having looked in your pocket dictionary, please ask now. At this

point they will take you into the isolation booth or room, where they will have the microphone and headphones set up for your use. You will be asked to slate, give your name, and perhaps say the take number: "Cindy Toblonsky, Take 3." They'll give you feedback; you'll make the adjustments. Maybe they want it faster, slower, louder, or with more "color." Color means they want more nuances of speech that make the word or words more interesting. You will probably go back to your basic vocal work and look for operatives (i.e., the most important words, the words that the meaning hangs on). You'll work with pitch, quality of voice, duration of sound, length of thought, tempo, energy shifts, dynamics, and so forth. The better you get at responding to their feedback, the better. The more you read out loud on your own as a matter of course, the better, freer, and more responsive you will become at these auditions.

Final thoughts on auditions

Karen Ziemba has some advice for young actors regarding auditions. Karen is an actress who has worked on many Broadway productions, including *Steel Pier, Chicago, A Chorus Line, Curtains,* and *42nd Street.* She won the Antoinette Perry Award for her performance in *Contact.* Karen Ziemba is truly what we refer to in the theater as the triple threat—she can sing, dance, and act—all beautifully, as she has proved time and time again. She has worked in many other areas of the business, including voice-over work and regional theatre. She is generous with her talent and her time and performs in benefits and concerts all over the country.

She thought it was important that actors safeguard their creative facilities before and during the audition. She strongly urged actors to create a space for themselves in which they, in a sense, protect their creative impulses and keep their center during an audition. It is easy to get thrown off track by even well-meaning acquaintances who are happy to see you and want to chat. This is hard for us, but Karen has an even more difficult problem to handle in that others want to talk with her because she is so successful, and they want to learn about her work and process. It may be simply eager attention, but it can distract you from your purpose, and you need to stay centered. Whatever the reason, when others want to reach out to us during an audition it is *so very cool* to ask for time alone or agree to meet them after the audition. Karen said, "If necessary, go to the restroom and lock yourself in a stall to make sure you get and keep that inner sense of grounding and power." She ought to know—she has worked more consistently than almost any actress on Broadway!

Bill Tatum, another very successful actor in regional theatre, soap operas, commercials, off-Broadway, and mentioned earlier in the chapter, has another bit of advice besides auditioning the people for whom you are auditioning. In addition to insisting that you aren't a victim and that you don't have to take any job, Bill also says that when the audition is over, get out of the room. Don't drag it out, try to charm them, or try to make friends. Keep that great professional persona you've got going for you, but do *graciously* leave when it's over. He reminded me that that the actor cannot know in that moment whether or not they have won the role. The actor cannot do that. Bill says to stop trying to close the deal. Do the work. Leave the decision to them.

I think the very fact that Karen Ziemba takes auditioning seriously is deeply reassuring. She doesn't resent auditions or think that the casting director and director don't think she is a good actress or anything remotely like that. She realizes she is in a business that uses auditions to find the right person for the job, given all the variables. It isn't a fail-safe system, but it *is* the system we have to work with if we want to work. If anyone could come up with a better way to do it, I'm sure they would. Come to terms with the realities of your business. The sooner the better.

The Business of Theatre

From the moment you decide to make your living as an actor, you need to come to terms with the fact that you are entering a multibillion-dollar global industry. Before you make the decision to become a professional, you must determine whether or not you have any aptitude for the *business* of show business. You can be a consummately talented, dedicated, and skilled artist, but to succeed professionally, you must also find a way to manage yourself as a businessperson. In previous chapters we acquainted ourselves with the theatre professionals and processes involved in doing the actor's job. To get the job in the first place, you must become equally adept at using the business tools of headshots, resumes, cover letters, and Web sites. You must also develop productive business relationships with the professionals who specialize in, for a lack of a better term, the *marketplace* of the entertainment industry. In essence, these people manage the process through which producers of plays, films, television shows, commercials, and industrial promotions shop for the performing artists they need. These professionals are agents and casting directors.

Casting Directors

Casting directors are professionals who select potential actor candidates for a given project in film, TV, commercials, legitimate theater, musical theatre, and the like. Casting directors are hired by producers or producing organizations to do this work—this seeking and sorting out of talent for a particular project. It is the casting director's job to see as many people as might be right for a particular role, given the description of the project, discussions with the director, the role description, and the time frame specified by the producer to accomplish this work.

The casting director or producers are responsible for writing what is called the "breakdown." A breakdown, published by Breakdown Services, includes a written synopsis of the project, complete with character descriptions of each of the roles being cast for the project. Other information about the project is published such as location, time frames for rehearsal and performances, the shooting schedule, the casting director associated with the project, the producers, the writers, and the director. Breakdowns cover a large range of projects, including, but not limited to, episodic television, television pilots, television movies, reality television, films, feature films, student films, videos, legitimate theater, musical theatre, spokespersons, and voice-over. There's a separate division called Commercial Express; they send breakdowns for commercials and industrials to agents who are eligible for the subscription.

Once agents and managers receive the breakdowns, they submit the picture/resumes of actors from their "stable" who they feel fit the descriptions of the characters in the breakdown. They can also chose to post certain jobs from the breakdowns on any number of Web sites and online periodicals. (A listing of those Web sites will be discussed at the end of this chapter.) Actors are free to submit themselves for these auditions or alert their agents that roles are available.

Even if you feel you are right for a role, though, there's still a good chance you won't be seen. Casting directors assume that agents and agencies have already checked out whether or not an actor has discipline, a good work ethic, strong technique, and a strong training background, among various other aptitudes, so they generally prefer to see those actors who have been, in a sense, prescreened.

Even when relying on agent submissions, casting directors must pare down the number of actors they see for a given role. If every agency in New York City submitted one actor for a casting director to look at for one role in one project that might add up to a list of over 200 actors. There isn't enough time to see all of those actors. So the casting director must make cuts to the list of actors submitted by agents. Perhaps the cuts are based on age, perhaps based on height, look, experience, or whether an actor's resume represented more comedic or dramatic roles. Whatever the criteria, the casting director must make a shortlist of perhaps 25 actors to be seen for each role. If casting directors are coming from outside New York City or Los Angeles, they generally cast over a period of just a few days. If they are located in the city in which the project will take place, the process might take longer, and perhaps more actors can be seen; it depends on the timetable of the producer and availability of all the major players. The casting director will see all 25 actors from the initial cut, then call back perhaps ten of those actors for the director to see. This is just a rough idea of how a casting director might proceed. All directors and producers have their own relationships with the casting directors they hire, and each process is unique to those relationships and projects.

For larger projects, a casting director might have several assistants who divide the initial group between them for a _preread_. The assistants pass those actors they like forward for the casting director to read, who then schedules appointments for the most promising actors to be seen by the director. The preread process can be nerve-wracking. Accept it. Only the very famous and well known can get away without having a preread.

Sometimes casting directors hold _open calls_, which actors call cattle calls because of the herd-like number of actors they attract! These open calls can be for either Actors' Equity Union members or nonunion members or both. The call posting, on a Web site or in the trades (industry periodicals), will be clear about who is eligible to attend the call. Normally actors line up at the audition location very early in the morning to ensure they get an audition spot. You must be there in person with your headshot and resume to obtain your time slot. Once all the designated audition time slots are filled the monitors will either start a waitlist for actors who missed the cut or simply turn away those who arrived too late. Once you are given your time slot by the monitor, you are free to go until your designated time to audition. If an actor holding an audition appointment is late or misses the appointment, the next actor on the list is called. The actors on the wait list must hang around the entire audition period hoping enough people miss appointments for their numbers to come up. It's just better to sign up early and make sure you show up in plenty of time for your audition appointment in case they are running ahead of schedule.

Another word about open calls. Only go to calls for roles for which you are honestly appropriate. If the breakdown says "Male, 17–20, short, edgy, athletic," and you are 25, 6' 3", 40 pounds overweight and out of shape, don't go. Don't go! The casting director might remember you, but he'll remember you as a person who hasn't got a clue about himself in the business. He'll remember you as a person who wasted his time and who took up a slot in which he could

have seen someone right for the role. Don't go. Create *professional* relationships with casting directors. You need them.

When you check the breakdowns online or see them in periodicals, you can see clearly who the casting directors are. When you want to be seen by a casting director and there is no open call, you can still ask for the opportunity to audition. Send a picture/resume with a cover letter (discussed in more detail later in this chapter) that says briefly—three or four sentences tops—who you are, what you want, and why you want to meet them. Networking is an important part of this and any industry, and you need to make contact with casting directors whether or not you have found representation. Even should you have an agent, contact casting directors asking for opportunities to meet with them and show them your work. If your agent later submits you to these casting directors who have already met you, they will have a sense of you, be familiar with your work, and be more likely to see you if you are right for the role.

Impressing casting directors *begins* with a businesslike cover letter, excellent headshot and a resume that shows the appropriate experience and training for the kinds of projects the casting director is involved with. When given the opportunity to meet and show your work, draw on the earlier chapters of this book to help you prepare. It may indeed take you ten hours to prepare for a three-minute audition, but that is what you must do if you want to keep impressing the casting directors beyond the first hellos. Casting directors are as concerned with their reputations as actors are with theirs. They need to know that they can trust you to do the work. And word gets back. If you show up at five auditions having done the right kind of preparation, they will begin to feel as if they have a solid working relationship with you. In fact, there may be times when they allow you to read for roles you are not especially right for. In essence, they are sending you to audition for a chance to audition for the same director ten months from now. Whether or not you get *that call* depends on how you have prepared for *this audition*. Excellent work does not go unnoticed. It sets the stage for a casting director to bring you in front of a producer or director with confidence, knowing that the director or producer may not embrace the choices that you make, may not think that you're the best actor for *this* particular role, but that they will be happy to have met you and feel their time was well used in becoming acquainted with your talent and work.

This auditioning work is never-ending, and therefore you have never wasted your time preparing for an audition, even when you don't book the job. You are impressing someone. Many casting directors will help you to get an agent, or if you already have an agent, they will call your agent to tell her how fabulous you were at the audition. This gives your agent the assurance to sell you to other casting directors, directors, and producers because she has gained more confidence in your ability to deliver a professional audition. The work is never wasted. The work is never wasted. The work is never wasted. If you think it is, if you think you wasted your time doing a ten-hour prep for a three-minute audition for a job you didn't get, you should probably rethink entering this business.

Agents

An agent is a licensed professional who represents the actor to casting directors, producers, and other professionals in the theatre industry. Ideally an agent is an advocate for the actor in the business. Agents promote you to get into auditions, convince casting directors to meet

with you, negotiate contracts for you, and advise you on career moves looking at the big pic-
ture for the long and short term. An agent is an actor's ally in the business. The agent isn't
there to do all your footwork or hand you a career, but an agent is there to help kick open
doors for you to walk through and earn the work. For this service, the agent gets 10 percent
of your gross pay for every job you book. If you don't make money, your agent doesn't make
money. Simple as that.

There are many different kinds of agents and agencies. Agencies consist of a group of agents
working together under the same umbrella. Some agencies have numerous opportunities for
promoting actors. Perhaps they have a legitimate theater division, a commercial division, an
episodic television department, a soap opera department, and a voice-over department. They
may have a modeling division. Some agencies only promote one aspect of the business, for
instance, restricting themselves to submissions for legit theatre, or indie films, or feature films
and TV. Some agencies are bicoastal, meaning they have offices in both New York and Los An-
geles. Some agencies may also have offices in Chicago and Vancouver. Licensed, or *franchised*,
agents follow federal state and local laws and belong to the National Association of Talent
Representatives (NATR). If an agent does not have a franchise number, they are not legally
able to do business with the unions.* They are unable to negotiate a contract. So beware. If
they don't have an NATR license number, run. If they ask you to use only *their* photographer,
run. If they ask for a *fee*, run. There are many unscrupulous people out to fleece eager, hopeful
actors in search of an easy way into the business. No one can make you a star, though many
will tell you they can for a price. Don't believe them. It will not be easy. It's that simple.

Agents and agencies fall into roughly three categories as far as size goes. There are variations,
of course, but for our purposes large, medium, and small pretty much sum it up.

The large mega-agencies such as ICM (International Creative Management), CAA (Cre-
ative Artists Agency), or the William Morris Agency represent major stars, playwrights,
screen writers, sports figures, and music industry giants, among others. These large agencies
generate a lot of money, represent most of the major stars, and would expect *you* to make
loads of money. Getting into one of these agencies is difficult to say the least, but once you
get there, they may or may not work hard for you, depending on your ability to make big
money. Remember, the only way a legitimate, franchised agent earns money is by taking 10
percent of whatever *you* make.

There are mid-sized agencies. They have clients that are immediately recognizable. Their clients
may not be superstars, but they are strong competitors and have a strength and longevity in the
industry. At these mid-sized agencies you can get attention from your agent, and they will take
care of you, but will not necessarily befriend you. That's not a bad thing. These agents and agen-
cies generally have quite a bit of respect in the business, have been around for some time, and are
trusted. Sometimes these agencies insist that every agent in every department be enthusiastically
on board in order for an actor under consideration to gain representation. Sometimes these mid-
sized agencies will allow an actor to come and work for just one department of the agency, later
developing additional relationships within the agency or, instead, will allow the actor "freelance"
with other agencies for specific work in commercials, voice-overs, or other areas of work.

The small-sized agencies are sometimes referred to as "boutique" agencies. These are the agen-
cies most likely to acquire new talent. This is the young actor's best chance to find representation.

*See unions pg. 116, 117

These agencies are smaller but are happy to see new actors who engage them and who they believe have potential. They like actors who love the work and are willing to seek out the work. You generally have a lot more hand-holding and a stronger personal relationship with an agent at a boutique agency then you would have at a midsize or large agency.

As mentioned earlier, different agencies have different specialties. As you go through the "Call Sheet Online" published by Backstage.com, note which agencies cover commercials, legit theater, film, voice-overs, and so forth. Make sure that you target an agent specifically for what you have to offer, and make sure that you're not wasting your time and money on an agent who is not even remotely interested in representing your strength. Asking an agent to come see your cabaret act when they work exclusively on commercials and episodic television would be a waste of time and money. In "Call Sheets" you'll find out if agents are receiving submissions and in what forms they accept them. Some agencies still prefer a traditional headshot, resume, and cover letter sent through snail mail or delivered in person. You must know what you're marketing and your marketing audience.

When you think of all the established professionals looking for work and add to that the nonunion, nonrepresented actors who would like an opportunity to be seen, it is easy to see how overwhelming and difficult it is to book a job in the industry. Yet first and second jobs are booked every day by young, untried talent who see themselves as professionals before anyone else does. Don't wait for permission! Actors work who market themselves as professionals by dint of their work, preparation, and research, rather than waiting for someone to recognize how potentially brilliant they are. Go for it! But do it wisely and with full cognizance!

Type

Marketing yourself as a professional begins with "typing" yourself. This means determining and selling yourself for a certain *type* of role. For some actors, this is a relatively easy task. For others it is rather difficult. If you are 21 years old, 5'5", 120 lbs., pretty, and have a lovely voice, you are an ingénue. If you are 21 years old, 5'9", 180 lbs., you are character actor. In truth, acting is acting is acting, and we are all character actors. Still, you must know yourself and your physical and vocal prospects in this business. Those in the position to promote you appreciate and respect actors who know who they are and are realistic about how they are seen by the industry. Most agents look for really great actors of very specific types who can work in a variety of media and know how they come across in each. Pay attention to the phrase "how they come across." Being "typed" can feel very personal and sometimes hurtful. It's important to remember that type is not who you *are* but how you *seem* to match the qualities of certain types characters. Your type is composed of your basic personality and physical appearance as it is *presented* through your movement, voice, energy, and general demeanor in comparison to what we generally expect of certain kinds of characters. It's not you. It's *how you come across.*

The following are a few basic casting types students might fall into. I'm referring to the live theatre when I refer to height. In other media it isn't nearly as important. These are very rough guidelines.

Ingénue: A young woman, often a romantic lead. Usually innocent sexually. Generally shorter to medium height and slender. Pretty. Pleasant speaking voice. Possible roles: Irina

in *Three Sisters*, Babe in *Crimes of the Heart*, Ophelia in *Hamlet*, Christine in *Phantom of the Opera*, Raina in *Arms and the Man*, Hero in *Much Ado About Nothing*, Juliet in *Romeo and Juliet*, Celia in *As You Like It*, Perdita in *Winter's Tale*, Maria in *West Side Story*, Emily in *Our Town*.

Leading Lady: Usually very attractive, more experienced. Perhaps the ingénue all grown up. Age range usually anywhere from twenty-five to forty or so. Generally of medium height or taller and slender to medium build. Shapely figure. Pleasant speaking voice. Possible roles: Masha in *Three Sisters*, Elena in *Uncle Vanya*, Hedda in *Hedda Gabler*, Nora in *A Doll's House*, Rosalind in *As You Like It*, Beatrice in *Much Ado About Nothing*, Eliza Doolittle in *Pygmalion* or the musical version, *My Fair Lady*.

Young Leading Man: Youthful, very good looking, perhaps on the taller side in larger markets. Often a romantic lead. Well built, fit. Pleasant speaking voice. Possible roles: Raoul in *Phantom of the Opera*, Claudio in *Much Ado About Nothing*, Romeo in *Romeo and Juliet*, Algernon in *The Importance of Being Earnest*, Florizel in *Winter's Tale*, Laertes in *Hamlet*, George in *Our Town*, Freddy Eynsford Hill in *Pygmalion*.

Leading Man: Usually very attractive, perhaps on the taller side in larger markets. Often a romantic lead. Age range perhaps 28 to 45 or so. Well built, fit. Pleasant speaking voice. Possible roles: Jack in *The Importance of Being Earnest*, Benedick in *Much Ado About Nothing*, Petruchio in *Taming of the Shrew*.

Young Character: Male or Female. Any body type, depending on needs of role. The voice can be of any timber, accent, or quality that suits. Possible roles: Will in *Oklahoma!*, Ado Annie in *Oklahoma!*, Gertie in *Oklahoma!*, Millie in *Picnic*, Sonya in *Uncle Vanya*, Rizzo in *Grease*, Anybodys in *West Side Story*.

The Young Character is impossible to pin down and falls into many categories when looking at episodic television, commercials, and some film. As a general rule, though, they tend to have at least one physical and/or vocal trait that is excessively one way or the other. They will be extra tall, short, skinny, plump, or buxom with voices that are high, low, nasal, squeaky, raspy, soft, or loud. Again, this is simply the most common method of organizing how actors are submitted for jobs, not the definition of any actor and his or her breadth. Many agents and casting directors reject this kind of typing—others embrace it. Here are a few specific sub-types of the preceding categories for young actors:

Young Character Men

Stupid frat guy	the suck-up	class clown
cocky jock	edgy indie	funny sidekick
stoner	coward	downer sidekick
thug	best friend	yokel
geek	guy next door	self-appointed guru
sexy geek	dreamboat	cowboy
surfer dude	underdog	fresh off the farm
class president	upstart	

Young Character Women

mean girl	bombshell	tomboy
girl next door	class clown	chatterbox
little sister	vamp	caretaker
best friend	free spirit	cheerleader
girl next door with a quirk	femme fatale	backstabber
sorority plastic	nosy neighbor	silly gossip
the innocent	know-it-all	vicious gossip
sexy geek	geek	

We can go even further with typing and add an ethnic grouping to <u>any</u> of the previously listed types, such as Hispanic leading man, or African-American sexy geek.

The danger of typing yourself is then choosing to play only one or two "qualities" in an audition and not play an *action*. Yes, there are types of characters, but you must always play *action*. Get realistic about how you will be seen and cast, but don't let that blind you to the work that still needs to be done. Don't play a stereotype or caricature. We can tell from analyzing the script that some roles are more complex with more depth than others. Obviously we don't need a "Chip" from *Beauty and the Beast* having a tortured existence as a teacup, but the actor playing "Chip" still needs to play an *action*.

Another common way of typing actors is to compare them to already well-known actors such as a young Will Smith, or edgy Matt Damon. These terms are not intended to limit your range or depth but are used simply to understand or grasp how you are seen in the industry. The business works fast, and many professionals don't have the time or interest in figuring out how you might fit a project if you come off vague or ambiguous as a type. They'll move on to an actor who knows exactly how to present him- or herself in the professional marketplace. Time is money.

<u>So, just how do you go about figuring out your type?</u> Ask. Not just anyone. Only people who *understand the business* and *love you*. Bring each of these people a list of twelve prominent characters in your age range from twelve plays you have carefully thought about and ask which of those roles they would cast you in today *in a professional company*. <u>Then</u> give the same folks a list of twelve famous movie or TV roles played by twelve different movie/TV stars (roughly your age range) and ask if they could see you in any of those parts played by those famous actors. <u>Then</u> ask if they could see you as the brother, sister, cousin, or best friend of any of those actors. Over time, if you ask enough knowledgeable people, a pattern of responses will emerge that will help you zero in pretty objectively on your type.

You will often in your early career submit picture/resumes that get "<u>typed out</u>," or even have the same thing happen at an audition. The casting director will have everyone line up and then will walk down the line and select the performers he or she wants to see simply by looking at their physical type. If casting is looking for 5'7", blonde women in their early 20s and you are 5'3", 17, and a redhead, you get "typed out." No hard feelings. They have a day to cast this and know what they want. No time to rethink the script and the characters to accommodate you

and your potential. Really. If this sort of thing would be devastating to you, don't get into the business at all. Why would you want to put yourself in the position of constantly having your feelings hurt when no harm is meant? It's business.

Job Hunting

Picture and Resume

What are a picture and resume?

Calling cards. Your face on the front = headshot. What you do best on the back = resume. In short, you and what you have to offer. Don't rush this initial step; the headshot and resume must represent who you are and what you market. If you give this part of your process the time and attention it deserves, it could go a long way toward helping you get audition doors to open and/or agents and casting directors to see you. Pay attention to your calling cards. If you do this poorly, you won't be seen, and you won't have an opportunity to do what you love best.

The Picture, or what is known in the business as a headshot

There are as many different headshots as there are actors; however, some things tend to be consistent among successful headshots.

1. The headshot *must* look like you look *every day*. Yes, you on a good day, but you must be able to look, other than clothing, exactly like this at every audition you go to or any meeting you attend. There should be no confusion on this point.

2. Allow your eyes to communicate easily and effortlessly who you are. You must let your soul, or spirit or intelligence (or whatever you believe your primary characteristic might be) beam through and make contact with the person holding this picture of you. If you don't make that contact with your eyes, they will toss the photo out or delete the headshot. One or the other. You must allow that contact. You must allow that expression in the eyes to shine through. If not, you will be perceived as having no courage and being too hard to fathom.

3. You want to make sure that the picture is about *you*, not the background. Keep the background energy, if you will, to a minimum. Keep it bland, unfocused. This isn't an "art shot" marketing a clever background or concept; this is a headshot marketing *you*.

4. Most folks looking at headshots believe that color is the only way to go. There are the exceptions, but why take the risk? There are many agents who do not care at all; many do. If you do go with black and white, make sure you write your eye and hair color on the resume.

5. Heavy makeup for women is a no-no. They want to see you. Makeup for men is a definite no-no.

6. Use touch-up work only to hide a pimple, or perhaps a mole you plan to have removed. See number one.

7. The look must match the roles you might play. Your *type*. If you are an ingénue, best not to have a plunging neckline and heavy eye makeup. If you play sophisticated leading ladies, best no pigtails and plaid shirts. You get the idea. Most photographers' Web sites suggest

what to bring to a shoot, and your photographer will guide you as well. Just as with backgrounds *you* want to shine through, so no patterns on the tops. Textures are fine.

8. Even if "Judd" from *Oklahoma!* is your favorite role, best not to pick a menacing, brooding headshot. No one wants to see a psycho. You have to look like a nice, relaxed human being. That's who everyone wants to work with.

OK, how do I get all that in a shot?

First, hire a really good headshot photographer. When you get serious about this, you will have to find a photographer with whom you connect and who, in turn, respects and connects with you. We are talking about an expenditure of money here. These are professionals who know their business, and it is their business to get you in business. Once you get out of school or to a bigger market, your headshot can no longer be the picture a friend took with a digital camera on a nice day in the park. Those headshots might be good enough to help you into a decent graduate school or an internship, but they will not be enough to get you into the door of an agent or casting director in New York, Chicago, or Los Angeles. Just be forewarned.

How do you find a photographer?

Ask any friends in the business who they like or recommend. I suggest online Web sites such as *Backstage*, an online magazine for actors. If you go to the Web site, look for the "yellow pages," and then select photographers. It will offer you Headshot photographers listed by area (e.g., if you live in the San Francisco Bay area, you will find a listing of photographers based there).

Go to the photographers' Web sites to view examples of their work and see if you like their style. If you do and there are certain shots that appeal to you, mark them so that you can communicate effectively when you meet the photographer, stating that this is the style of headshot you are looking for. Most all the photographers list their fees for sittings and additional fees for makeup and hair. Many of the photographers have a list of suggestions for their sessions, and some even have a video of how the shoot is conducted so you can have a very clear idea of their style and working persona before contacting them. Take advantage of all the information you can get, and get the best value for your money. This is no place to cheap it out nor is it a place to spend money unwisely. Do your research! Well worth the investment of time!

Many casting directors swear by the three-quarter shot so they have a chance to see what your body type is like. Other casting directors and agents either don't care or prefer the headshot. Look at the photos you see online with various photographers and see which you like best. Be sure that the headshot or three-quarter shot looks good as a thumbnail. On some of the Web sites for actors, this is all the agent or casting director might see. Make sure that *you* shine through, even in a smaller version of the photo.

To stay current in the business, you will need to update your headshot every two years. You need to stay up to date with the style of headshot being used as well as making sure you still look exactly like the person who will walk into the room to meet the professionals able to cast you and/or promote your work.

The Resume

Finessing the resume is not as important when first starting out in the profession as it is later. If you are just coming out of college and looking for internships or graduate school placements,

no one expects you to have credits that are professional. Later on you might need to hone your resume and remove some roles you have played, keeping just the most significant on your resume. Following are some guidelines that will prove useful.

1. You do not need to list roles chronologically. You want the most impressive first. However, as you go along, you will want to remove roles you have played that are no longer relevant to your current age range.

2. List roles that are representative of what you do best, not necessarily roles that show your breadth. Those looking at your resume want to understand *in a very few seconds* how they would cast you. Are you funny? Do you do classical work? Do you sing? Do you excel at dramatic roles? Are you a leading lady? Are you a young leading man? How tall are you? What is your vocal range?

3. Make your resume as accessible as possible. List first whatever you feel are your strong suits as a performer. Ask trusted professors and fellow actors how they see you and how they would cast you.

4. Compose the resume in three columns. The first column should be the name of the play/film/episode (for television). The second column should be for the name of the role(s) you played, and the third column is for the name of the producing organization and the director.

I realize that for an undergraduate or actor just starting out this is a bit of a stretch, but it's how it works. On several Web sites, including Backstage.com and Actors Access, a sample resume is presented, as well as a resume template you can fill out and use to submit yourself for work online. Great tool. Their sample also uses the three-column format and asks for much of the same information outlined here.

What else should be on a resume?

- Your Height—Yes, folks will need to know this! What if you are auditioning for Hermia (short, already determined by the script!)? You will be happy to have written 4'11". No amount of talent and work will get you to Helena (tall, already determined in the script!). But it might get you an audition for Hermia.

- Your Weight—Oh yes! Even if you feel you are under- or overweight. You are who you are, and that is what will get you the part. Be honest. They'll know anyway; tell them up front. You want to be considered for parts that are right for you right now, not for who you think you *ought* to be.

- Your phone number—this can be your actual number or the number of an answering service. You may have both. If you have an agent then, of course, it would be your agent's number. Whatever number(s) you choose, you must have absolutely reliable, immediate access at all times to messages left there to make sure you don't miss an audition opportunity or a callback.

- Your vocal range—if you sing: soprano, mezzo, alto, tenor, baritone, or bass.

- Your Web site—All actors should have one nowadays—if you don't yet then give an e-mail address that is professional and reserved exclusively for the business. Work on putting together a Web site where agents, casting directors, and directors can get a sense of your work

and your range. This is a great promotional tool, way beyond anything actors had to work with a generation ago. The more professional it is, the more your colleagues and prospective employers will believe you cross your t's and dot your i's in the work itself. It makes a good impression. Most actors now have Web sites. Backstage.com and other Web sites listed later in this chapter have sites to assist you and guide you in doing this! Do it!

- Your training—This matters to anyone seeking to understand what technique you have and how hard and how long you have studied to gain this technique. List any instructors you have had and classes you have taken outside a college/university setting: commercial classes, movement study, singing lessons, dance studio work. List the organization where you took the classes and the teacher(s) with whom you studied.

- Your education—BA, BS, BFA, MFA, and where you got your degree. You need not write the year. Let the casting director or agent or director guess your age. That is their job. Yes, some schools are more prestigious than others. If you went to one with marquis value, flaunt it! Otherwise, be prepared in an interview to name the aspects of your program you considered to be strong and perhaps what you learned. This will prove you have some idea of what technique is, how it is acquired, and that you know how to acquire it.

- Special skills over and above acting—playing any musical instrument(s), stage combat, dialects (list them), languages you speak, horseback riding (English or Western), mime, acrobatic work, magic tricks. With *each* of these, note years of training, any certification you may have received, and any other specifics that might be relevant. Make sure you can do all of them and do all of them well. Don't add anything that isn't a genuine skill. Really.

Hard copy or digital?

Both. The business is very much set up in a digital, electronic mode, but you still need hard copies to carry with you everywhere! Especially to auditions. They may have seen an electronic copy before seeing you, but you want them to have a hard copy to takes notes on and to keep to remember you when you leave.

Carry your headshot with the resume stapled to the back everywhere you go. You honestly never know when someone will stop you in an elevator and ask if you are an actor and ask for a resume. If they offer you their business card and seem legit, then give them your business card—your photo and resume! You also never know when you might walk by an audition in process, find you can crash it and need to offer them your headshot and resume. Easier if you don't have to go all the way back home to get it.

Because the headshot is always an 8 × 10 photo, the size of the resume has to match so that you can staple it neatly and professionally on the back. No glue. Only staple. You can print it on 8.5 × 11.0 inch paper and trim the ends or, more easily, go to a copy shop, and they will run 8 × 10 copies for you. A thought.

Here are the resumes of several young actors who are either just leaving their undergraduate programs, or just leaving their graduate programs and starting out in the business. You can see variations in these resumes, but they are all easy to read and allow an agent or casting director to very quickly get a sense of who they are and what they do. These are good examples of beginning actors' resumes. Everything on these resumes is true, and there was no need to pad them. No one expects anyone coming out of school to have professional credits yet. You are who you are.

PAA
Progressive Artists Agency
1041 N. Formosa Avenue
West Hollywood, CA 90046
000-123-4567

KEVIN MUSTER

Height: 6"4" Weight: 220 lbs.

FILM
InfraRed	Kevin	Mel Shapiro
Broken Wendahl	Detective Yorke	Raul Gonzo

THEATER (selected)
A Midsummer Night's Dream	Nick Bottom	Joel Bishoff
Homer In Cyberspace	"O"(Odysseus)	Mel Shapiro
Gross Indecency: The Three Trials of Oscar Wilde	Oscar Wilde	Joel P. Rogers
Defying Gravity	Claude Monet	William Johnson
The Importance of Being Earnest	Jack Worthing	Cynthia Lammel
Born Yesterday	Harry Brock	Lani Harris
Enter the Guardsman	Actor/Guardsman	Clint Rebik
Cabaret	Ernst Ludwig	Bill McCrary
The Lady in the Van	Rufus	David Wheeler
Measure for Measure	Angelo	Joe Hilsee
The Fantasticks	Mortimer	Bob Hechtman

EDUCATION AND TRAINING
Film	Acting	Gil Cates
Theater	Acting	Mel Shapiro
Second City Workshop	Improvisation	Dave Razowsky
Steppenwolf Workshop	Ensemble Work	Jeff Perry
Alexander Technique	Acting	Jean Louis Rodrigue
Movement/Tumbling	Acting	Tom Orth
Cold Reading Workshop	Acting	Andy Henry
Stage Combat	Acting	Ed Monaghan

UCLA
 MFA Acting
CSU, Chico
 BA Theatre Arts

SPECIAL SKILLS
Orca sounds, eyebrow wave, British dialect, swimming, versatile with singing styles, archery, piano, guitar.

Figure 9.1
Kevin Muster's resume

Paige Patterson

Phone: (000)123-4567

E-mail: email123@yahoo.com

Height: 5″8″ Weight: 116 Hair: Red Eyes: Blue

Mezzo-Soprano

THEATRE

AS YOU LIKE IT	Rosalind	CSU, Chico/Bill Johnson
TOP GIRLS	Marlene	CSU, Chico/Bill Johnson
BORN YESTERDAY	Billie Dawn	Court Theatre/Joel P. Rogers
KING LEAR	Regan	Shakespeare on the Plaza, Chico/ Cynthia Lammel/Bill Johnson
SLY FOX	Mrs. Truckle	CSU, Chico/Sue Hargrave Pate
THE LEARNED LADIES	Armande	CSU, Chico/Cynthia Lammel
KISS ME, KATE	Bianca/ Lois Lane	ACT, Temecula/Beverly Stephenson
ROYAL GAMBIT	Kathryn Howard	Court Theatre/Joel P. Rogers
ANTON IN SHOW BUSINESS	Holly Seabé	CSU, Chico/Gail Holbrook
HOW TO SUCCEED…	Hedy LaRue	Temecula PAC/Jillian Stones
CABARET	Texas	Court Theatre/ Bill McCrary
BAT BOY THE MUSICAL	Mayor Maggie	CSU, Chico/Michael Mazur
THE KING AND I	King's Dancer	CSU, Chico/Sue Hargrave Pate

EDUCATION AND TRAINING

BA Theatre Arts, with minor in Musical Theatre Dance: California State University, Chico
 Acting: William Johnson, Cynthia Lammel
 Voice: Cynthia Lammel
 Movement: Susan Hargrave Pate
 Musical Theatre: Joel P. Rogers, Michael C. Mazur
 Dance: Sheree Henning, Deborah Jorritsma, Susan Hargrave Pate

SPECIAL SKILLS

Singing (Mezzo-Soprano Belt), Voice Impressions, Dialects (Received Pronunciation, Cockney, New Orleans, Minnesota), Dance (Intermediate skills in jazz, hip-hop, and lyrical. Beginning skills in ballet and tap), Cheerleading (3 years), Passport, Baby Cry Noise

Figure 9.2
Paige Patterson's resume

Davis Carlson

Phone: 000-123-4567
e-mail: email123@gmail.com

Height: 5″ 10″ Eyes: Blue
Weight: 250 lb Hair: Sandy Blonde

University Training:

MA Acting (2010) *expected* – Birmingham School of Acting
BA Theatre Arts (2009) – California State University, Chico

Professional Summer Stock:

Royal Gambit	Henry VIII	Court Theatre/Joel P. Rogers
The Weir	Jim	Court Theatre/William Johnson
Cabaret	Herr Schultz	Court Theatre/Bill McCrary
Beauty and The Beast	Maurice	Court Theatre/Joel P. Rogers
King Lear	Duke of Cornwall	Shakespeare in the Park/Bill Johnson

Stage Experience While Training:

As You Like It	Touchstone	Birmingham School of Acting/Philip Breen
Vanya	Vanya	Birmingham School of Acting/Lise Olson
Ghetto	Jacob Gens	Birmingham School of Acting/John Adams
Ensemble	*Water*	Birmingham School of Acting/Dawn Falato
Ubu Roi	Pere Ubu	CSU, Chico/ Katie Whitlock
Bacchae	Pentheus	CSU, Chico/ Katie Whitlock
Once Upon A Mattress	King Sextimus	CSU, Chico/Sue Pate
Twelfth Night	Fabian	CSU, Chico/William Johnson
Natural Selection	Ernie Hardaway	CSU, Chico/Cynthia Lammel
Murdering Marlow	Robert Poley	CSU, Chico/Joel P. Rogers

Additional Training and Workshops:

- Stella Adler Studio of Acting, New York – Shakespeare Intensive (2009)
- Stella Adler Studio of Acting, New York – Chekhov Intensive (2009)
- Acting on Film Workshop with Jason Connery (2009)
- Steppenwolf at Summer Arts – Viewpoints and Improv (2008)
- Improv Troupe *Jar Full of Hammers*

Special Skills:

Dialects: Californian (*Native*), General American, Southern American, New York, Irish, RP, German, and Russian; Sing Tenor; Armed and Un-armed Stage Combat; Eagle Scout; Play Guitar (6 Years); Whistle; Dance Tango, Waltz, Cha- Cha, and West-Coast Swing (2 years)

Figure 9.3
Davis Carlson's resume

Cindy Kay

Phone: 000-123-4567
Email: email123@yahoo.com

Height: 5"9" Hair: Brown
Weight: 157 lbs. Eyes: Blue-Green
Mezzo-soprano

Theatre

Balm in Gilead	Bonnie	Steppenwolf at Summer Arts/Rick Snyder
Carol Channing Benefit Concert With Carol Channing	Ensemble	CSU, Chico/Mike Mazur
Bernarda Alba	Poncia	CSU, Chico/Joel P. Rogers
Why Torture is Wrong and The People Who Love Them	Felicity	Blue Room Theatre/Brad Moniz
Top Girls	Pope Joan/Louise/Nell	CSU, Chico/William J. Johnson
Murdering Marlowe	Anne Hathaway	CSU, Chico/Joel P. Rogers
The Great American Trailer Park the Musical	Lin	CSU, Chico/Joel P. Rogers
Zombie Prom	Ginger	Solano College Theatre/Stuart Rosenthal
Crazy For You	Patricia Fodor	CSU, Chico/Mike Mazur
Chico Improv Fest	Jar Full of Hammers	Blue Room Theatre, Chico

Education/Training

Steppenwolf Theatre: *Viewpoints* with Alexandra Billings
 Acting with Rick Snyder and Alan Wilder
 Master Workshop in Film/TV Acting with Linda Lowy

Improv Training: David Razowsky, Jean Villepique, Rick Kuhlman with
 Second City Eric Hunicutt, James Grace, Irene White with
 IO West

Oregon Shakespeare Festival: *Acting* with Kimberly Scott, Stephanie Beatriz
 Movement/Stage Combat with Ken Roht, Christopher Duval
 Scene/Voice work with Tracey Young, Evie Peck

BA in Musical Theatre: California State University, Chico
MFA in Acting: Actor's Studio at Pace University (Spring 2013)

Special Skills

Dance (Beginning Ballet (1 year) and Modern (1 semester). Beginning/Intermediate
Tap and Jazz (2 years each), Movement (Some Stage Combat and Commedia Dell'Arte),
Improv (Instructor *Improve Your Improv* (Ink Blot Arts/CSU Chico) and Troupe Jar Full of Ham-
mers (1 year)), Singing (Musical Theatre, Pop, Country styles), Dialects (RP, Working Class
British, Polish), Basketball, Cart wheels, Back bends, Round-offs, Can ride a Bike.

Figure 9.4
Cindy Kay's resume

The Cover Letter

It is essential that you include a cover letter when submitting your headshot and resume to an agent, casting director, director, producer, or writer. The cover letter gives whoever receives your submission a way of discerning who you are, what you are looking for, and how to best make use of your submission. Without the cover letter, your headshot and resume will probably end up in the trash bin, not because they aren't good in and of themselves, but because it is just too much work to figure out who you are and what you are interested in. By not submitting a cover letter, you have also just proved you are unprofessional, that you have little respect for the persons to whom you have submitted your materials, as well as proving you don't understand the business and are too lazy to find out what the proper etiquette is. Not a strong start!

It is difficult to say what makes the perfect cover letter, so don't get paralyzed because you can't think of what might make the letter perfect. There are as many preferences as there are agents, casting directors, directors, and producers. A few things are standard: keep it short, perhaps two paragraphs of two to three sentences each. If this is your first submission to this person, you want to introduce yourself, promote yourself honestly, and describe your training and experience, where you are in your career right now, and where you would like to see yourself realistically in a year or two. If you do know some professionals in the industry, this would be the moment to mention your connection. In the first line. If you are related to someone, or worked with someone, or had a meeting with someone and they liked you, mention it. In the first line. If it isn't real or you don't have the connection, please don't put it down. If you do garner interest, follow-up calls *will* be made, and you don't want to be called out as a liar. Tell the truth. Always. If you are asking for a meeting, an audition, or for consideration regarding representation, ask for it respectfully without bragging or putting yourself down. No one wants to work with anyone who is an egomaniac, but neither do they wish to work with anyone who isn't confident and who doesn't have a strong sense of themselves and what they have to offer. You want the letter to give the reader a real glimpse of who you are in addition to the headshot and the credits listed on the resume, as well as give a reassurance that you get the business and understand how to work within it, one professional to another. You are marketing yourself—keep it real; share what you have to offer that is unique.

Consolidated information on all agents and casting directors in the U.S. major markets (which used to be published in the now-defunct Ross Reports) is available through Backstage.com under Call Sheet Online. You'll find this information under the subheading "Listings." Actors Access also has a listing of agents and casting directors. These listings provide information on agencies, areas of specialty within those agencies, and the agents who work within those specialized areas per agency. You can search by location, specialty, or both.

When mailing your packet, be sure to address agents who might have an interest in representing you given your experience and training. A generalized mailing is throwing away your time and money. Make it specific. Address the agents, casting directors, or other professionals by name on the envelope as well as on the cover letter and know the jobs they perform. Anything less is disrespectful to them and a waste of your time. Oh, and use professional-grade paper with a clear letterhead including your name, contact information, and union affiliations, if any. Avoid gimmicks like enclosing gum, glitter, or confetti.

If you are writing to invite casting directors or agents to see your work in a showcase, production, or cabaret act, make sure that they know where to pick up their *complimentary* tickets. If you invite people to come see your work, you must buy the tickets for them and for their guests or use any comps you receive to cover this. This is your invitation—they should never pay.

If a casting director, or an agent, come to see your show you should write a follow-up head-shot postcard the next day to say thanks for coming to see my performance. If you have sent materials to a casting director or an agent you should write a follow up head-shot postcard within a month to see if your materials were received. Write your note to a specific person asking a follow-up question regarding the business in general or your show in particular if it's a thank-you note. If anything has happened in your career in the time between the first mailing and now, mention it. Otherwise an inquiry and a thank-you-for-your-time. There's lots of advice on several online sites as well as in any number of books that might help you formulate these letters more specifically, but no one can write with your style and professional persona except you. Figure it out!

Web Sites

The following are some great Web sites for finding work, exploring agencies, finding casting directors, and discovering what is going on in the business not just in New York or Los Angeles, but in cities across the country. These sites can show you how to set up you own multimedia resumes, create Web sites, and submit yourself for work with or without representation.

Backstage.com (www.backstage.com)

This is a great Web site for actors. The Web site has breakdowns for markets around the country and has listings for agents and casting directors in various markets (Call Sheet Online). You can create your resume, post headshots, and submit yourself for work. Prices vary depending on the services you want to use. The advice columns are great, and the Web site is easily manageable. Great yellow pages.

Actors Access (www.actorsaccess.com)

Another great Web site for actors. This site is associated with breakdown services and agent and casting director information. Easy to put together a resume and upload reels for viewing. You can gain access to casting directors and agents as well as submit yourself for work as many times as you like by joining Shadowfax, an offshoot service. Prices range from free to sixty or seventy dollars for premium services. On this site you can also download the "sides," the pages you will be reading from in the audition, should you get the opportunity. Great columns. Really like Bonnie Gillespie's "The Actor's Voice."

Playbill (playbill.com)

Good site for finding information about theatre productions in all major markets across the country. Great articles and advice. A free list of employment opportunities.

Craigslist (www.craigslist.com)

Yes! You can find acting jobs on Craigslist! When Sarah Cuc, a former student, told me this, I was dumbfounded. But yes, it is true, and it is true that casting directors will post here. Note the disclaimer though. No one is vouching for the authenticity of these opportunities. Check to see if it is a legitimate call. Be wary of scams and unscrupulous opportunists.

Actors' Equity Association (AEA) (www.actorsequity.org)

This Web site allows you to see when various projects are being cast in a given city using AEA, and how you, a nonunion actor, can be seen by those casting. Read the listings and the rules and get seen. This is the theatre actor's and stage manager's union.

Variety (www.variety.com)

The trade paper for Hollywood. No job listings, but an overview of what is happening in the industry.

Here are a few more Web sites to explore. See if they serve your needs.

NYC Casting (NYCcastings.com)
LA Casting (www.lacasting.com)
Casting New York (CastingNewYork.com)
Now Casting (www.nowcasting.com)
Explore Talent (www.exploretalent.com)

Regional Combined Auditions

The following auditions and conferences are wonderful ways to find work. Research each one to see if you are interested, if you have the financial resources to get to the audition, and if you meet the qualifications to merit the audition. Carefully examine the specific requirements for each audition. Each has different requirements, deadlines, and dates. It's worth the trouble. You never know who will see you and like your work as a result of these auditions.

New England Theatre Conference (NETC)
www.netconline.org

New England Theatre Conference, Inc.
215 Knob Hill Drive
Hamden, CT 06518
Tel: (617) 851-8535
Fax: (203) 288-5938

The NETC Annual Theatre Auditions held in March each year provide performers opportunities to audition for Equity and non-Equity summer and year-round theatres, touring companies, theme parks, dinner theatres, outdoor drama companies, professional theatre training programs, festivals, and casting agents. Really good opportunities.

New Jersey Theatre Alliance (NJTA)
njtheatrealliance.com

New Jersey Theatre Alliance
8 Marcella Avenue
West Orange, NJ 07052
Tel: (973)731-6582
Fax:(973)731-5520

The New Jersey Theatre Alliance, the service organization for the state's professional (Actors' Equity) theatres, holds auditions in New Brunswick, NJ, in August. Equity and non-Equity

performers are seen. Over 25 professional theatres attend these auditions. An excellent, very competitive audition!

Southeastern Theatre Conference (SETC)
www.setc.org

Southeastern Theatre Conference, Inc.
P.O. Box 9868
Greensboro, NC 27429
Tel: (336) 272-3645
Fax: (336) 272-8810

The SETC holds fall and spring auditions. The spring auditions are the largest; approximately eighty-five companies see performers for seasonal and year-round work. They have specific criteria for each of the auditions. The fall auditions are seen by over thirty theatre companies. Go to their Web site to see how to apply and if you qualify. They also hold graduate school auditions and design/tech portfolio reviews and interviews at both the spring and fall auditions.

Straw Hat Auditions
strawhat-auditions.com

StrawHat Auditions
#315
1771 Post Road East
Westport, CT 0688
For automated telephone directions only, you may call (212) 346-1133.

Every spring in February or March, Straw Hat holds auditions in New York City for over forty theaters. Over the course of three days, nonunion actors audition for summer theater, and technical people post their material online and come in for interviews. Casting directors in New York sometimes attend as well as some TV shows. Go to the Web site—many actors apply; the process can take a while.

Theatre Bay Area (TBA)
www.theatrebayarea.org

Theatre Bay Area
1663 Mission St. #525
San Francisco CA 94103
Tel. (415) 430-1140

San Francisco has such a large theatre community that they hold three separate sets of auditions annually: South Bay Regional Auditions, North Bay Regional Auditions, and Bay Area General Auditions. On the Web site the guidelines for submission and a listing of who the auditors are at each audition are provided. They also have brush-up monologue services. You need to become a member of TBA to apply, but they see union and nonunion actors.

Unified Professional Theatre Auditions (UPTAs)

www.upta.org

Unified Professional Theatre Auditions
51 South Cooper
Memphis, TN 38104
Tel: (901) 725-0776
Fax: (901) 272-7530

This is a very well respected national audition for pre-professional (nonunion) and professionals (union) alike. Visit their Web site and see the list of theatres who come to these auditions to cast summer theatre, outdoor theatre, national tours, dinner theatres, theme parks, and other venues. Casting directors from New York and Los Angeles come to these as well as casting directors from other cities. Great audition to get into. The Web site is friendly and informative.

University and Resident Theatre Association (URTA)

www.urta.com

National Office and General Information
1560 Broadway
Suite 1103
New York, NY 10036
Tel: (212) 221-1130
Fax: (212) 869-2752

The University and Resident Theatre Association's National Unified Auditions primarily serve those students who are seeking admission into MFA graduate programs. The auditions are held first in New York City, then Chicago, and then San Francisco over the course of a couple weeks in late January and/or early February. A number of Shakespeare Festivals and resident theatres associated with the graduate schools also attend these auditions. Applications are generally in October, so it's best to get an early start.

Unions

Even if you aren't anywhere close to needing or wanting union membership, you should know what the actor unions are and what areas of an actor's work they cover.

Actors with union affiliations proudly list them on their resumes, generally right under their names, using the unions' acronyms. (If an actor is not in the union but is eligible to join, she may write the letter E after the union acronym, as in SAG E for Screen Actors Guild Eligible.) There are different unions for different contracts, media, and venues. Many actors belong to all four of the main actor unions in the United States. Explore the sites and set your sights on someday belonging to one or more of our industry's unions.

Actors' Equity Association (AEA; www.actorsequity.org) (see pg. 114)

This is the theatre actor's and stage manager's union. Explore this site and see what is being cast, find out how to become a member, and look at the different types of Equity contracts.

Screen Actors Guild (SAG; www.sag.org)

SAG claims exclusive jurisdiction over motion picture performances, including any television program shot on film rather than video-tape. SAG and AFTRA share authority of radio, television, Internet, and other new media. Again, check out the Web site and see what you need to do to become a member of this union.

American Federation of Television and Radio Artists (AFTRA; www.aftra.org)

AFTRA represents a wide variety of talent, radio and television announcers and newspersons, singers and recording artists, actors in radio and television, promo and voice-over announcers, and other performers in commercials. They also represent stunt persons and specialty acts. Check it out.

American Guild of Variety Artists (AGVA; www.agvausa.com)

This union represents performing artists and stage managers for live performances in the variety field. This includes singers and dancers in non-book shows, theatrical touring shows (like the Rockettes), theme park performers (think Disneyland), ice skaters, circus performers, comedians, stand-up comics, cabaret artists, club artists, lecturers, poets, spokespersons, and performers working at high-end private parties and special events.

Staying Current

Of course you know it all now and have no more need for training or class work.

Wrong.

You need to stay in shape. Dancers take classes to stay in shape. Baseball players have spring training and batting practice. Professional pianists practice every day, whether they are performing concerts or not. Basketball players practice layups and free throws. Boxers jump rope and work with a bag. Skateboarders take every opportunity to work on their balance and kick-flips. Swimmers do laps. Tennis players work on their backhand and their serve. Horseback riders work on cueing the horse correctly and deepening their seat. Golfers are constantly trying to improve their swing. Whether an amateur or a professional, committed athletes and artists, at the very least, maintain their skills, and the best of them keep developing their skills.

For the actor there are many ways to keep developing. There are classes in every market you enter. Sit in on classes till you find a teacher you feel will challenge you and create a safe working environment. Just attending classes and listening to the feedback others are getting is useful, but you need to get on your feet as well. Most cities have collectives of actors that work with one another and give and receive criticism from one another. Go to the Web sites and check out classes for acting, voice, and dance, and ask friends who have taken classes what the best classes were for them. Don't bother going to see any teacher who won't let you sit in on a few classes to see if the class and methodology is a good fit for you.

Another benefit of taking classes with well-established teachers is that these teachers have been in the business for a long time. They have been in the business long enough to know casting directors and agents and can prove to be a good reference for you should you work well in their class and earn their respect. Some casting directors offer useful workshops on auditioning Try to take a class offered by the casting director herself (*not* one of her assistants) to get the best skills advice

and feedback. Also, if you are hard working, prepared, creative, and professional, the casting director will recognize you and your picture/resume and remember you for future submissions.

Anytime you are studying and expanding yourself in some way, you are deepening the work itself as well as your commitment to yourself as an artist and professional. One way to loosen up and get into the moment is to try improv. Improv isn't a substitution for the textual analysis that must be done to serve a playscript well, but it can free you to discover your own impulses coming out of that study.

Here's what Dr. John Mayer, Chair, California State University Stanislaus has to say on the subject of improv. Dr. Mayer runs CSU Summer Arts workshops every summer and brings artists from such renowned companies as Steppenwolf and Second City to California to teach CSU students and faculty alike. He is an excellent actor himself and a great proponent of using improv to free the performer. He writes:

> *The purpose of improvisational training is to recapture or recreate in the actor a level of childhood naïveté and freedom that opens one up fully to impulse. Recapturing the unfettered freedom of childhood is the goal of any quality improvisational artist. "Live in the moment" is the battle cry of many acting teachers, and a strong base in improvisation helps an actor to best achieve that ability of "being present." Stanislavsky said he wanted his actors to be in a constant state of what he termed "creative bliss," and improvisation helps actors to attain the somewhat mystical level that the greatest acting teacher of the contemporary era wanted.*
>
> *The first rule that anyone learns in the course of their improvisational training is "never say no—always say yes!" Just like quality writing, it is about making the active choice whenever possible. No equals negative equals passive equals stop. On the other hand, yes equals positive equals active equals forward motion. Saying yes is what creates forward velocity in scene work, and it is an essential element in successful improvisation. Also, it is not just the "yes" response that is fundamental, but it is also about saying "yes, and," because "yes, but," is a negation of sorts. The "yes" and "yes, and," responses are the foundation for building texture in improvisational scene work.*
>
> *One learns early in improvisational training that it doesn't so much matter what choice you make, but more significantly what matters is the commitment to the choice that you do make. It is the job of the improvisational actor to take what is given to them by their scene partner(s) and to make it work. This is where saying "yes" can turn even the strangest or most mundane choice into a fully realized moment on stage. Over time, trained improvisers learn that to hesitate is to fail. Make a decision, say "yes," and don't look back are the keys to minimizing the potential for unsuccessful or struggling work in improvisation.*
>
> *One of my favorite adages from The Second City states, "You know you are getting better at improvisation when your percentage of failure decreases." This quote is comical in its very set-up. The ending double negative of "failure decreases," is not only funny, but also very insightful. The fact that those last two words assume failure is very freeing for the improvisational actor. Improvisational training teaches the actor to not be afraid of failure, but rather to accept its inevitability. Once an actor lets go of their need to always be right in everything they do on stage, and accepts the supposition that they will occasionally fail, they then can throw themselves into their choices full throttle and take their character development to new and exciting places without holding themselves back. As the saying goes, "get out of your*

own way." The biggest myth about improvisation is that the goal is to be funny. This could not be further from reality, because any great improvisational teacher will tell you that the best improvisation comes from one place and one place only, and that is truth. The purpose of improvisational training for the actor is to find the heart and honesty of each individual character they portray. It doesn't matter whether the character is a man who recently lost his family fortune, a woman who can never find her way, or a cucumber whose refrigerator is on the blink. The heart of any character portrayal regardless of whether human, animal, or humanized inanimate object is still the truth for that individual character, and where there is truth—pathos, sincerity and humor can be mined. Dave Razowsky, former artistic director of The Second City Training Center, Los Angeles says, "Release! Relinquish! Surrender!" In other words, let all preconceptions disappear and open yourself up to the essential truth in each of the characters you inhabit as an improvisational actor.

Of course, this rule is true for the characters that an actor depicts in scripted works as well. Utilizing improvisation can greatly enhance the choices that an actor makes while dealing with character development in the rehearsal process for a scripted play. The openness to and enhanced ability to access one's imagination that comes through a thorough improvisational training opens up a wide pantheon of options in every character that an actor plays. An actor will still deal from the given circumstances, those unchangeable elements that are written into a play; however, the texturing that can be done beyond the basic choices is what makes this kind of training so valuable.

I like what John Mayer says, and I think you might want to look at improv classes to free and open yourself to your impulses—to react immediately and directly with what you receive from your scene partner. The danger of improv is, of course, that you *only* listen to instinct and impulse and do not bring to the work all you have assimilated in service to a play. Both forms are rich and valuable but certainly not interchangeable. If you find yourself in an improvisation class where getting the laugh is the most valued outcome, leave the class. It won't help your work. Find the kind of teacher John describes: a teacher who is looking for the truth of the moment and the "yes, and" in the moment.

Conclusion

I've packed a lot of information into this chapter—information on how the business works and what the first steps into the business might look like. No one person has all the answers, and the exception always proves the rule, so you could do the opposite of what I've suggested and still make a great living as an actor. I beg you to do it. I haven't written any of this from a need to be right about the industry; I have written it to be useful and offer some ideas about how to begin your journey as a professional if you decide to embark on that journey. I have written it to be honest about how difficult it is and to give you a heads-up on easily avoidable mistakes that could cost you time, money, and enthusiasm for the work you love. I went around the country and interviewed people working in the industry now, some on the record and some off, and they answered me honestly about what their perspective was and what they thought young actors coming into the business needed to know. More than a few were relieved that someone was attempting to communicate the realities and sensibilities of the business to young actors coming out of college. Agents, casting directors, directors, and producers want actors to succeed, but they don't have the time to teach them. That isn't their job. I have tried to make it mine. Break a leg.